CW01020869

ON THE N

ON THE NEW

BORIS GROYS

Translated by G. M. Goshgarian

VERSO
London • New York

This English-language edition published by Verso 2014
Translation © G. M. Goshgarian 2014
First published as *Über das Neue* 1992
© Carl Hanser Verlag München Wien 1992

1 3 5 7 9 10 8 6 4 2

Verso
UK: 6 Meard Street, London W1F 0EG
US: 20 Jay Street, Suite 1010, Brooklyn, NY 11201
www.versobooks.com

Verso is the imprint of New Left Books

ISBN-13: 978-1-78168-293-7 (HBK)
ISBN-13: 978-1-78168-292-0 (PBK)
eISBN-13: 978-1-78168-661-4 (UK)
eISBN-13: 978-1-78168-294-4 (US)

British Library Cataloguing in Publication Data
A catalogue record for this book is available from the British Library

Library of Congress Cataloging-in-Publication Data
A catalog record for this book is available from the Library of Congress

Typeset in Fournier by Hewer Text UK Ltd, Edinburgh
Printed in the UK by CPI Mackays

Table of Contents

Note on the Text

The present book took shape in two stages. I initially wrote a text in Russian that Annelore Nitschke translated into German. Later, I thoroughly revised the contents of this first version and rewrote it directly in German – in the hope that this would make my thoughts clearer, but also with no little regret over the fact that Nitschke's lovely translation, for which I am very grateful, has become unreadable in its original form.

Many of the reflections in the present book were inspired by conversations with friends and acquaintances. I can name only a very few here: Eduard Beaucamp, Walter Graßkamp, Aage Hansen-Löve, Jürgen Harten, Ilja Kabakow, Olga Matic, Dmitri Prigow, Igor Smirnow, Renate Döring-Smirnow, Peter Steiner, Alexander Zholkovsky.

I would like to extend very special thanks to Prof. Fernando Inciarte for valuable advice on the revision of the book.

Introduction

In our postmodern times, as they are called, no subject seems as untimely as newness. The quest for the new is generally associated with utopia as well as with hopes for a new beginning in history and a radical transformation of the conditions of human existence in the future. It is precisely this hope which seems, today, to have almost completely disappeared. The future no longer seems to promise anything fundamentally new; instead, we imagine endless variations on what already exists. For many people, it is depressing to imagine the future as an endless reproduction of the past and present. For others, a new age in social and artistic practice is dawning, one liberated from the dictates of the new and from diverse future-oriented utopian and totalitarian ideologies. In any event, most contemporary writers hold that the problematic of the new has been almost entirely overcome.[1]

1 The term 'postmodernism' can be interpreted in many ways and is assigned very different meanings by different authors. In the present book, postmodernism is taken to mean fundamental doubt as to the possibility of historical novelty, a doubt associated with virtually all the authors of postmodernism – in opposition to modernism, with its orientation to the new.

Yet postmodernism does not signify the end or overcoming of modernity, but, quite the contrary, its impossibility. In that respect, postmodernism contrasts with modernism, which was oriented toward transgression, overcoming the old, and violating borders. Thus Hal Foster writes: 'Assailed though it is by pre-, anti-, and postmodernists alike, modernism as a practice has not failed. On the contrary: modernism, at least as a tradition, has "won" – but its victory is a Pyrrhic one no different than defeat,

2 ON THE NEW

Yet even if the new were in fact that hopelessly obsolete, post-modern thought could certainly take it as an object of reflection, since postmodern thought is interested in the obsolete. Indeed, there is, in a certain sense, nothing more traditional than an orientation to the new. Radical renunciation of the new and the proclamation of a new, postmodern age — which would necessarily be an unprecedented novelty in world history — consequently appear, on the face of it, suspiciously utopian. For one can discern, despite all, habits of

for modernism is now largely absorbed . . . But how can we exceed the modern? How can we break with a program that makes a value of crisis (modernism), or progress beyond the era of Progress (modernity), or transgresses the ideology of the transgressive (avant-gardism)?' (Hal Foster, 'Postmodernism: A Preface', in idem, ed., *The Postmodern Culture*, Port Townsend, 1985, p. ix).

Peter Halley defends the same position: 'One can refer to it as either post-modernism or as neo-modernism, but what is characteristic of this order is that the elements of modernism are hyper-realized . . . They are re-deployed in a system of self-referentiality which is itself a hyper-realisation of modernist self-referentiality — though it has now been detached from the modernist dream of revolutionary renewal . . . The vocabulary of modernism is retained, but its elements, already more abstract, are finally and completely severed from any reference to the real' (Peter Halley, 'Essence and Model', in idem, *Collected Essays, 1981–1987*, Zurich, 1988, p. 161).

In this sense, 'post' is the equivalent of 'neo'. Thus, on the subject of postmodern art, Dan Cameron, too, writes: 'As a result of this nonchalant application of the term "postmodern" to everything that displayed an unambiguous turn back toward past forms of expression, the prefix "neo" became the stylistic concept most widely used in the late 1970s and the 1980s . . . Although the artists who have inscribed "neo" on their banners have no theoretical position of any description whatsoever, the most conspicuous result of this development is the fact that artists were freed of the historical compulsion to produce stylistically innovative original art' (Dan Cameron, 'Neo-Dies, Neo-Das: Pop-Art-Ansätze in den achtziger Jahren', in *Pop-Art*, Munich, 1992, p. 264).

At the level of philosophical reflection, the postmodern impossibility of the historically new, which signifies the impossibility of modernism and, at the same time, the impossibility of overcoming it, finds its most compelling formulation in Jacques Derrida's conception of *clôture* [closure]. *Clôture* means that the epoch of the philosophical quest for truth has been closed off, the epoch of the constant innovation that went hand-in-hand with this quest — but in the absence of any possibility of overcoming that epoch, of springing its borders or transgressing its limits: 'Indeed, one must understand this *incompetence* of science which is also the incompetence of philosophy, the *closure* of the *epistémè*. Above all it does not invoke a return to a prescientific or infra-philosophic form of discourse . . . Outside of the economic and strategic reference to the name that Heidegger justifies himself in giving to an analogous but not identical transgression of all philosophemes, *thought* is here for me a perfectly neutral name, the blank part of the text, the necessarily indeterminate index of a future epoch of différance. *In a certain sense, "thought" means nothing.* Like all openings, this index belongs within a past epoch by the face that is open to view' (Jacques Derrida, *Of Grammatology*, trans. Gayatri Chakravorty Spivak, Baltimore, 1976, p. 93).

modernist thought in this postmodern belief that the whole of the future, from the present moment on, will forever manage without anything new, and that the new and the pursuit of it have now been overcome once and for all. That that which has existed will continue to exist means, among other things, that the individual quest for the new, a social orientation toward the new, and incessant production of the new will also continue to exist. Thus the modernist utopianism which never tires of proclaiming that one particular form of the new will reign unaltered through all future time has not been overcome simply because it has been replaced by the postmodern utopian belief that all future times will renounce everything new.

The peculiarity of the conception of the new prevalent in the modern period resides, after all, in the expectation that, eventually, something so definitively new will emerge that there can never be anything still newer thereafter, just the boundless dominion of this last of all innovations over the future. Thus the Enlightenment expected the dawn of a new age marked by uninterrupted growth and the supremacy of the natural sciences. The Romantics, in contrast, declared that faith in scientific rationality had been lost for good. Marxism, for its part, put its hopes in an endless socialist or communist future, while National Socialism looked ahead to the temporally unlimited domination of the Aryan race. In art, every modern school, from abstract art to surrealism, regarded itself as the last possible artistic approach. The current, postmodern notion of the end of history differs from the modernist one solely by virtue of the conviction that one need no longer await the ultimate arrival of the new because the new is already on hand.

In modernism, the proclamation of the new is, as a rule, ideologically associated with the hope of calling a halt to the march of time, which seems meaningless and purely destructive; or, at least, with that of assigning it a direction so that it can be portrayed as progress. Shrewd observers of modernism, however, long ago pointed out that modern cultural development is in the grip of an

extra-ideological compulsion to innovate. Thinkers, artists, and
writers are supposed to produce novelty just as, earlier, they were
supposed to respect tradition and conform to its standards.[2] In
modernity, the new no longer results from passive, involuntary
dependency on the march of time, but is, rather, the product of a
particular exigency and conscious strategy dominating the culture
of modernity. Thus creation of the new is also not an expression of
human freedom, as is often supposed. One does not, consequently,
break with the old by a free decision that presupposes human auton-
omy, gives it expression, or offers it social guarantees. One does so,
rather, only by complying with the rules that determine the way our
culture works.

Again, novelty is not discovery or revelation of truth, essence,
meaning, nature, or the beautiful after their occultation by 'dead'
conventions, prejudices, or traditions.[3] This very common and

2 The fact that, in modernity, the freedom to produce the new had long yielded to the compulsion
to produce the new was pointed out as early as 1954 by Wyndham Lewis in his book *The Demon of
Progress in the Arts*: 'Now, the proliferation of schools began with the bitter hostilities between the
classicists and the romantics at the beginning of the nineteenth century. This was a war between the new
and the old . . . This heterogeneity is not an explosion of rugged individualism, but, on the contrary,
quite the opposite. The personality is surrendered to some small well-disciplined groups. If the
contemporary scene could be confined to any one of these groups, it would seem a very homogeneous
period' (Wyndham Lewis in Julian Symons, ed., *The Essential Wyndham Lewis*, London, 1989, p. 176).
 Evoking Wyndham Lewis, Arnold Gehlen also notes, as early as 1960, the 'postmodern'
institutionalization of artistic innovation. He writes about the 'topicality of marginality' in new art:
'Yet, in the long run, individual artists could not have held out in the almost always precarious
position of isolation in which they soon found themselves. Here, fortunately, a *secondary
institutionalization* came about; it bolstered the artistic organism with a stable scaffolding of
international dimensions' (Arnold Gehlen, *Zeit-Bilder*, Frankfurt, 1960, p. 215).

3 For Derrida, for example, the new remains an effect of the *impossible* quest for identity
between signifier and signified after abolition of the différance that 'defers' the other of culture – in
other words, the quest for truth as experienced self-evidence: 'What exceeds this closure *is nothing*:
neither the presence of being, nor meaning, neither history nor philosophy; but another thing which
has no name, which announces itself within the thought of this closure and guides our writing here. A
writing within which philosophy is inscribed as a place within a text which it does not command.
Philosophy is, within writing, nothing but this movement of writing as effacement of the signifier and
the desire of presence restored, of being, signified in its brilliance and its glory' (Derrida, *Of
Grammatology*, p. 286).

apparently even indispensable glorification of the new as the true and as that which determines the future remains essentially bound up with the old conception of culture that has it that thought and art must adequately describe or mimetically represent 'the world' as it is; the truth criterion for such descriptions and representations is that they correspond to reality. This conception of culture is premised on the notion that man is ensured direct, unmediated access to reality as it is, and that correspondence or non-correspondence to reality can always be ascertained.⁴ Thus if art, for instance, no longer reflects the visible world, it should, by this logic, reflect a hidden, inner, true reality to maintain its right to exist. Otherwise, such art would simply be an unjustified, morally objectionable expression of a quest for newness for newness' sake.⁵

For Derrida, then, the will to truth continues to be the inward, driving force behind writing, in the form of a will for the other, the referent, or the text's signified, even if this will never leads to fulfilment. Here the will to truth is not opposed to desire, but is, rather, conceived as a specific form of desire, as phallo-logocentrism (see Peggy Kamuf, ed., *A Derrida Reader*, New York, 1991, pp. 313ff.). On the interpretation of the Enlightenment from this standpoint, with reference to Kant, see Jacques Derrida, 'Of an Apocalyptic Tone Recently Adopted in Philosophy', trans. John P. Leavey, *Oxford Literary Review*, 6 (1984), pp. 3–37. (Harold Coward and Toby Foshay, eds, *Derrida and Negative Theology*, Albany, 1992, pp. 29ff.).

The production of the text results from the constant deferral of desire, which, in its turn, is engendered by the text: by the promise of pure presence immanent in the text, necessarily suggested by it as a sign of presence *and* absence, that is, of différance: 'Without the possibility of différance, the desire of presence as such would not find its breathing-space. That means, by the same token, that this desire carries in itself the destiny of its non-satisfaction. Différance produces what it forbids and makes possible the very thing that it makes impossible' (Derrida, *Of Grammatology*, p. 143).

4 '*There is nothing outside of the text* . . . there have never been anything but supplements, substituting significations which could only come forth in a chain of differential references . . . And thus to infinity' (ibid., pp. 158–9).

5 Characteristically, Wassily Kandinsky, who is rightly considered to be an artist of the avant-garde par excellence, condemns the quest for formal-aesthetic originality or innovation in art as a purely commercial strategy and calls for an orientation toward content: 'Art, which at such times leads a degraded life, is used exclusively for materialistic ends . . . The question "What?" in art disappears *eo ipso*. Only the question "How?" . . . remains. This question becomes the artist's "credo". Art is without a soul.

'Art moves forward on the path of "How?" It becomes specialized, comprehensible only to artists . . . Since the artist on the whole needs to say little at such times, having already been singled out because of some small "idiosyncrasy" . . . a great number of outwardly gifted and enlightened

By now, many have rightly cast doubt on the possibility of such immediate access 'to things themselves'.[6] This idea is, however, basically irrelevant to the understanding and functioning of the new, because the entrenched, culturally anchored demand for newness suffices to explain its emergence in every individual case. The invocation of a quest to gain access to the hidden and extra-cultural thus becomes superfluous.[7] The new is new in its relation to the old, to tradition. There is consequently no need to refer to something hidden, essential, or true in order to understand it. The demand to produce the new is one that all must satisfy in order to attain the cultural recognition they desire. Otherwise, it would be

people descend upon this art that is apparently so easy to grasp' (Wassily Kandinsky, 'On the Spiritual in Art', in Kenneth C. Lindsay and Peter Vergo, eds. and trans., *Kandinsky: Complete Writings on Art*, The Documents of Twentieth Century Art, Boston, 1982, pp. 135–7).

6 Debate with Husserl's phenomenology as the most radical manifestation of the philosophical avant-garde has served as the main starting point for postmodern thought. This holds in particular for Derrida, who draws his central concept of 'presence' as the goal of classical philosophy from Husserl's philosophical project. Husserl writes, for example: 'It is the distinctive peculiarity of phenomenology to embrace within the sphere of its eidetic universality all cognitions and sciences, and, more particularly, with respect to everything in them which is an object of *immediate insight*' (Edmund Husserl, *Ideas Pertaining to a Pure Phenomenology and to a Phenomenological History, First Book,* The Hague, 1982, p. 142, no. 62). This immediate self-evidence is obtained by abstracting from all signifying systems, which, for Husserl, are necessarily obscure. Husserl thus arrives at the 'phenomenological attitude', which is, for him, 'the secret nostalgia of all modern philosophy' (ibid.).

Taking this radical stance and this longing as his starting point, Derrida formulates, on behalf of 'dead' writing, a critique of Husserlian *Lebendigkeit* and 'living presence' as the telos of phenomenology and philosophy. (See Jacques Derrida, *Speech and Phenomena and Other Essays on Husserl's Theory of Signs*, Evanston, 1973, p. 10.)

7 As is pointed out in n. 3 above, the quest for the other is prompted, according to Derrida, for example, by the textual unconscious; in this sense, its origins remain hidden for creators. Consciously, everyone seeks to attain the identical, but is in reality sent on his way by différance and, once on his way to the identical, led astray or 'deferred' by différance. Deconstruction alone reveals the unconscious work of différance, although, even after the work of deconstruction has been performed, a great philosophical or literary text retains all its grandeur as, now, a demonstration of the impossibility of its own project.

It is, however, equally possible – indeed, much more likely – that the creator of a work should from the outset consciously strive to write a new kind of text, rather than strive to attain the extra-textual self-same, the hidden, the true, being, the signified, or pure presence. If so, deconstruction runs the risk of unemployment.

pointless to occupy oneself with cultural matters. That one must seek newness for newness' sake is a law that prevails in postmodernity as well, now that all hopes for a new revelation of the hidden or for goal-oriented progress have been abandoned.

Many consider this quest for the new to be meaningless and, therefore, without value. For the question is whether newness has any meaning at all if it brings no new truth in its wake. Would it not be better to stick with the old?

To prefer the old to the new, however, is also to strike a new cultural stance; it means breaking the cultural rules that require us constantly to produce newness and, accordingly, forge the radically new. Moreover, what the old actually *is* remains unclear. In every period, the old must be re-invented; that is why all renaissances are simultaneously great renewals. The new is inescapable, inevitable, indispensable. There is no path leading beyond the new, for such a path would itself be new. There is no possible way of breaking the rules of the new, for these rules demand, precisely, to be broken. In that sense, the requirement to innovate is, if one likes, the only reality manifested in culture. For what we understand by 'reality' is the inescapable, inevitable, indispensable. Innovation is reality insofar as it is indispensable. Hence it is not things themselves, ostensibly hidden beneath their cultural descriptions and representations, which are real, so that one has to clear a path to them or penetrate them. Rather, the interrelations between cultural activities and products are real – the hierarchies and values that make our culture what it is. The quest for the new manifests the reality of our culture precisely when that quest is freed of all ideological motivations and justifications, and when the distinction between true, authentic innovation and untrue, inauthentic innovation is dropped.[8]

8 A fundamental distinction between authentic and inauthentic is also maintained by 'postmodern' authors, who no longer believe, as Kandinsky did, that the hidden, the substantial, the referent, or the 'what' can be represented in art, and insist that the transcendental signified eludes all such representational strategies. Yet the will to produce such a representation, the will to represent

8 ON THE NEW

To ask about the new is tantamount to asking about value. Why do we attempt to say something at all, to write, paint, or compose something that was previously not there? Where does the belief in the value of cultural innovation of our own come from, if we know

the hidden signified rather than differing only at the level of the 'how', continues to be regarded as a necessary condition for the creation of significant works.

Jean-François Lyotard describes, in a by now famous essay, 'The Sublime and the Avant-Garde' (in Andrew Benjamin, ed., *The Lyotard Reader*, trans. Lisa Liebmann et al., Cambridge, MA, 1989, pp. 196–211), the advent of a new work as an event in the Heideggerian sense (p. 197). The authentically new breaks with all programmes, classical and avant-garde alike – and brings with it the unexpected, the 'it happens' for which the avant-garde artist waits (ibid.). Here the 'it' in 'it happens' finds no definitive representation and can thus be identified with the sublime in Kant's sense: 'At the edge of the break, infinity, or the absoluteness of the Idea can be revealed in what Kant calls a negative presentation, or even a non-presentation. He cites the Jewish law banning images as an eminent example of negative presentation: optical pleasure when reduced to near nothingness promotes the infinite contemplation of infinity . . . Avant-gardism is thus present in germ in the Kantian aesthetics of the sublime' (ibid., p. 204).

The hidden signified is thus supposed to guide the artist even when it is sublime, that is, even when it is unrepresentable. The new must not be consciously planned within the framework of a novel, success-oriented strategy: 'Yet there is a kind of collision between capital and the avant-garde . . . There is something of the sublime in capitalist economy. It is not academic, it is not physiocratic, it admits of no nature . . . It is understandable that the art-market, subject like all markets to the rule of the new, can exert a kind of seduction on artists . . . It exerts itself thanks to a confusion between innovation and *Ereignis*' (ibid., p. 210). For Lyotard, this confusion between conscious innovation and unconscious event implies that consciously planned innovation, in its innovativeness, must necessarily lag behind the *Ereignis*, because no conscious innovation can be innovative enough or radical enough: 'The secret of the artistic success, like that of the commercial success, resides in the balance of what is surprising and what is "well-known", between information and code. This is how innovation in art operates: one re-uses formulae confirmed by previous success, one throws them off balance by combining them with other, in principle incompatible, formulae, by amalgamations, quotations, ornamentations, pastiche' (ibid, p. 210).

However, in drawing so sharp a distinction between event and innovation, Lyotard overlooks the possibility, which necessarily flows from this distinction, that the event for which the artist waits, if it is not governed by a conscious, innovative strategy, will bring, not something unprecedented, but, quite the contrary, something altogether banal, trivial, and unoriginal. That is what is in fact now happening to the artists, precisely, who served Lyotard as references when he was writing his essay: Barnett Newman and Daniel Buren keep repeating their once innovative gesture as an immutable sign of the irreducible sublime which, to be sure, provides them a solid commercial trademark and allows them to pursue a successful market strategy. Thus it is precisely the eventual [*das Ereignishafte*], repeated again and again, which may be understood as commercialization of a once innovative procedure.

Barnett Newman's postmodern commentary on the *Vir Heroicus Sublimus*, to which Lyotard makes special reference, may be found in Halley, *Collected Essays*, pp. 56ff. For further discussion of Lyotard's conception of the sublime, see Christine Pries, ed., *Das Erhabene*, Weilheim, 1989.

from the outset that the truth remains inaccessible? In our desire to be 'creative' ourselves, are we perhaps just succumbing to a diabolical temptation that we should in fact resist in order to maintain our integrity? To ask the question another way: What is the sense, what is the point of the new?

These questions are premised on a hitherto unquestioned conviction: namely, that the desire for the new is the desire for truth. Nietzsche long ago raised the question of the value of truth and, as well, of the will to truth. A cultural work's value is determined by its relationship to other works, not by its relationship to some extra-cultural reality, by its truth, or by a meaning. The inaccessibility of truth, the signified, reality, being, meaning, evidence, or of the presence of the present – an inaccessibility ceaselessly affirmed by contemporary postmodern thought – should therefore not be deemed a devalorization of all value and all newness. On the contrary, the inaccessibility of truth and the absence of meaning make the question of value and newness possible in the first place. The emergence of truth always simultaneously implies a destruction of value or of the cultural work that makes truth accessible. For truth confronts us with an impossible choice between absolute meaning and utter meaninglessness, both of which make the work itself superfluous. Only in the order of signification does a value hierarchy acquire its validity. And only in the order of signification can the question of the signifier of the present, the new, the actually existing, the true, the meaningful, the authentic, or the unmediated be posed: not the question of the immediate manifestation of the present in its metaphysical presence beyond all signification, but that of a signifier which can and should be invested with the value of designating, here and now, the presence of the present or tradition's other.

That the new is not a revelation of the hidden – in other words, an uncovering or a creation or a bringing forth of what lies within – further implies that, for innovation, everything is from the outset

open, unconcealed, visible, and accessible. Innovation does not operate with extra-cultural things themselves, but with cultural hierarchies and values. Innovation does not consist in the emergence of something previously hidden, but in the fact that the value of something always already seen and known is re-valued.

The revaluation of values is the general form of innovation: here the true or the refined that is regarded as valuable is devalorized, while that which was formerly considered profane, alien, primitive, or vulgar, and therefore valueless, is valorized. As a revaluation of values, innovation is an economic operation. The demand for the new thus falls into the category of the economic constraints determinant of the life of society as a whole. An economy is trade [*Handel*] with values within certain value hierarchies. This trade is required of all who wish to participate in the life of a society, of which culture is a part. Here the customary classification of values as material or spiritual is irrelevant: the claim that a cultural product has an ideal value that does not correspond to its material value in fact never means anything but that that product is overvalued or undervalued 'materially', and contains the implicit demand that we bring its material value into line with its ideal value.

Of course, the subordination of culture to economic constraints has always been denounced as the betrayal of its original mission: pursuing and revealing truth. But this denunciation is based on a fundamental misunderstanding. It springs from a conviction that the workings of the economic system are intelligible, that we can describe and systematize economic constraints, and, more generally, that the economy as such constitutes a system whose structure can be scientifically studied and described. Were that in fact the case, every cultural activity subject to economic constraints would be tautological and superfluous, because it would simply reproduce a system whose internal constitution and workings were already known. The new would then not really be new, but only a confirmation of the system, the market, and the prevailing relations of

production.[9] The belief that the economy can be described is, however, an illusion.

Every description of the economy is primarily a cultural act, a cultural product. As such, it is part of the workings of the economy and itself subject to its logic: every systematization of the economy is a trade [*Handel*] and is negotiated. It is impossible to take up a position outside the economy in order to describe or master it from without as a closed system. The dream of systematically describing and mastering the economy has animated nearly all modern utopias and provided the ideological basis for all modern totalitarian regimes. This dream appears to have seen its day. Critiques of the economy are negotiated in quite as economic a fashion as are defences, interpretations, or scientific explanations of it. The fact that we are all subject to the economy's laws and demands does not mean that we can discover those laws by taking our distance from economic constraints and observing them from the outside. It is not in our power to take such a distanced view. The only possible way to understand the economy is to take an active part in it. Only by taking innovative action in line with its demands can we learn what those demands are. For, often, what proves to be innovative is something quite different from what we originally believed. And, in this regard,

9 Art is for Theodor Adorno always negative and changing, as it is for Lyotard: 'If the utopia of art were fulfilled, it would be art's temporal end . . . A cryptogram of the new is the image of the collapse; only by virtue of the absolute negativity of collapse does art enunciate the unspeakable: utopia' (Theodor W. Adorno, *Aesthetic Theory*, eds. Gretel Adorno and Rolf Tiedemann, trans. Christian Lenhardt, Minneapolis, 1997, p. 32). Unlike Lyotard, however, Adorno does not differentiate at the ontological level between two origins of the new. For him, such a distinction between the authentic and the inauthentic is always only strategic and conditional; the authentic figures, in a certain sense, as secondary: 'If, however, originality arose historically, it is also enmeshed in historical injustice, in the predominance of bourgeois commodities that must touch up the ever-same as the ever-new in order to win customers. Yet with the growing autonomy of art, originality has turned against the market where it was never permitted to go beyond a certain limit' (ibid., p. 172). Art's utopian dimension is accordingly also assigned its origins in the market and becomes a kind of perverted market strategy. This type of radicalizing reading of utopia as, not an alternative to the market, but, rather, a particular way of pursuing market strategies, is discussed in Fredric Jameson, *Postmodernism, or The Cultural Logic of Late Capitalism*, Durham, 1991, especially pp. 55–66 and 260–78.

cultural innovation is perhaps the best means of investigating the
logic of the economy, because it is, as a rule, the most self-consistent
form of innovation, the best thought through and the most explicit.

Culture is, thanks to its dynamism and capacity for innovation,
the realm of economic logic par excellence. In that sense, to invoke
economic logic is by no means to present a reductionist interpreta-
tion of culture. For culture, so regarded, is not conceived as some
sort of superstructure, the external expression of hidden economic
necessities whose hidden truth can be scientifically described – as in
Marxism, for example. That kind of reductive understanding of
culture stems, first and foremost, from a reductive conception of the
economy. Economic logic is manifested, with sufficient particular-
ity, in cultural logic as well. Culture is therefore quite as
indispensable as the economy itself. The economy of culture is,
accordingly, not a description of culture as a representation of
certain extra-cultural economic constraints. Rather, it is an attempt
to grasp the logic of cultural development itself as an economic
logic of the revaluation of values.

Moreover, the economy, in the sense just indicated, is not the
same thing as the market. It is older and more comprehensive than
the market, which itself represents only a specific innovative modu-
lation of the economy and thus cannot, without certain reservations,
serve as a clearly identifiable source of innovation. The economy of
sacrifice, expenditure, violence, and conquest has to be taken into
consideration as fully as the economy of commodity exchange.[10] In
what follows, an attempt will be made to describe a few essential

10 Georges Bataille, for example, uses Marcel Mauss's example of the potlatch (Marcel Mauss,
The Gift: The Form and Reason for Exchange in Archaic Societies, trans. W. P. Halls, New York, 1990)
to formulate a general theory of the gift and the sacrifice that is intended to serve as an alternative to
ordinary commodity exchange of the kind designed to ensure self-preservation. When someone
accepts a donation or a sacrifice, the giver or the one who sacrifices acquires power over the receiver
(Georges Bataille, *The Accursed Share*, trans. Robert Hurley, New York, 1991). These ideas of
Bataille's have been further developed by Jean-François Lyotard in *Libidinal Economy*, trans. Iain
Hamilton Grant, London, 1993.

orientations and strategies of the cultural economy, that is, the economy of the reevaluation of cultural values. These descriptions do not form a closed system; they are directed against such closed descriptive systems of hidden extra-cultural determinations.

While theory and art are described below mainly as ways of operating with cultural values, this of course does not mean that a particular economic logic of innovation can exhaustively account for their contents. In his work, every theoretician or artist treats extremely diverse problems of his day, universal human conditions, or his narrow personal concerns, obsessions and idiosyncrasies. They invite sharply differing interpretations of his creations, but do not ever authorize definitive judgement of them. However, none of these many diverse aspects of cultural works accounts for their value; they are not, in other words, what actually motivates us to pay attention to them. All works of art and thought would justify such investigations and interpretations, inasmuch as all have personally, socially, or, in general, theoretically and artistically relevant aspects. Yet research and criticism inevitably confine their interest to a few outstanding works, although it would be impossible to demonstrate that their content is more meaningful than that of all others. A central question therefore arises: What is the source of a cultural work's value?

Arguably, a work of art is valuable if it successfully follows an artistic tradition of recognized value. When it does, a new work of art is made to conform to certain criteria and patterned after certain models so that it may count as a valuable work of art. The same holds for theory: a work of theory is expected to take its place in a tradition that confers value on it, to possess a logical structure, to provide annotations, and to be cast in a certain language simply in order to be perceived and acknowledged as a work of theory.

But what is the basis for the value of a work that breaks with traditional models?

The traditional answer is that such innovative works refer not to the cultural tradition, but to extra-cultural realities. This answer

seems plausible at first sight, because, if the world is divided up into culture and the real, what does not look like culture can only be the real. The external criteria of form, rhetoric, and normative adaptation to cultural tradition are then replaced by the criteria of truth or meaning, that is, reference to an extra-cultural truth said to be hidden behind cultural conventions. The work of art or theory is now no longer interrogated and judged on the basis of its conformity to the cultural tradition, but, rather, with respect to its relationship to extra-cultural reality.

This, however, gives rise to an ambivalence that has, historically, increasingly called the concept of truth into question. In order to designate, represent, describe, or manifest extra-cultural reality, a cultural work has first of all to distinguish itself from it. This distance from reality, which identifies a work as belonging to culture, is the necessary condition for the resemblance to extra-cultural reality that attests that work's value. The value of an original, innovative cultural work is thus still principally defined by its relation to the cultural tradition – even when its departure from this tradition is justified with reference to its truth, its relationship to the real.

The art of the modern period, which has at least since the Renaissance broken with the tradition preceding it in the interests of mimetically adequate, true representation of the real, also distanced itself in the twentieth century from faithful reflection of external reality, after this had become a cultural convention in its turn. Following an initial period in which many continued to interpret avant-garde art as a reflection of an inner, hidden reality and the pursuit of a quest for truth, the artistic utilization of ready-mades – direct citations of extra-cultural reality – practised in the arts since Marcel Duchamp has called the concept of truth into radical question. By directly citing the real itself, the work of art becomes true in an altogether trivial way, for its correspondence to outer reality is now necessarily given. In this case, the relationship

to truth relativizes the difference between a work of art, which reflects reality from a privileged position, and an ordinary thing taken from reality itself. The question of the value of the work remains unsolved, as before. It becomes evident that this question cannot be answered by falling back on the real and that a work's truth cannot account for its value. The question of a work's value remains, therefore, the question of its relationship to tradition and other cultural works.

Like twentieth-century art, various modern and, especially, postmodern theories take the unconscious as their main theme: they speak about something that is hidden and unnameable, to which they do not stand in a relationship of truth. Whereas earlier theories of the unconscious still claimed to think it as something that had hitherto simply remained unthought, postmodern theories talk about the unthinkable, the radically other, the inconceivable. If, however, it is no longer possible to give a theoretically adequate description of extra-cultural, unconscious reality because that reality eludes every such description, then the fundamental distinction between theoretical and non-theoretical language vanishes as well, since the other is now equally inaccessible for every type of language. Postmodern theoretical texts do indeed make use of speech forms that function like linguistic ready-mades – or direct citations from the reality of logically non-normed, unformed conscious life.[11] Here, again, we confront the question of the value

11 At least since Freud, specific situations from daily life have been taken up in theoretical texts, where they function as models for understanding the 'whole'. Wittgenstein constantly uses this method in his *Philosophical Investigations*; he speaks, in this connection, of 'pictures' that guide the understanding: 'I wanted to put that picture before him, and his *acceptance* of the picture consists in his being inclined to regard a given case differently . . . I have changed his *way of looking at things*' (Ludwig Wittgenstein, *Philosophical Investigations*, 4th ed., trans. G. E. M. Anscombe, Oxford, 2009, p. 63e, n. 144). Good examples of this are provided by the texts of Roland Barthes (Roland Barthes, *Mythologies*, trans. Annette Lavers, New York, 1972) and Jean Baudrillard (Jean Baudrillard, *Symbolic Exchange and Death*, trans. Hamilton Grant, London, 1988, both of which are composed as a series of such everyday images accompanied by interpretations that make these images images of the whole.

of such theoretical texts, which, once they give up their truth claims, can only be evaluated in the context provided by all other theoretical texts. Thus neither innovative art nor innovative theory can be described and justified on the basis of its relationship of signification to reality or – but it comes to the same thing – to truth. The question is therefore not whether they are true or untrue, but, rather, whether they are culturally valuable.

To answer that question, we need to turn back to the idea with which we began, the one from which the question of truth as a relationship to extra-cultural reality sprang. Reality is complementary to the cultural tradition: what is not culture is real. Reality is profane if the cultural tradition is normative. The new work that does not resemble cultural models is for that reason recognized as real. The reality-effect or truth-effect of a cultural work consequently originates in a specific way of interacting with tradition. Hence innovation is an act of negative adaptation to cultural tradition.

Positive adaptation consists in fashioning a work to resemble traditional models. Negative adaptation consists in fashioning a work not to resemble them, in setting it in contrast with them. In both cases, the work stands in a determinate relationship to tradition, whether positive or negative. Extra-cultural reality, or the profane, is in both cases utilized only as raw material. Abandoning traditional models transforms profane things no less than positively adapting them to tradition does. For, put to cultural use, these things are purged of everything that makes them resemble traditional models 'in reality': ready-mades always appear much more profane and real than reality itself.[12] The central question

12 When Jean Baudrillard talks about the hyperreality of the modern world, which simulates the real and thereby makes it realer than the real itself, he puts the whole world as a ready-made in the context of art: 'Disneyland exists in order to hide that it is the "real" country, all of "real" America that *is* Disneyland . . . Disneyland is presented as imaginary in order to make us believe that the rest is real, whereas all of Los Angeles and the America that surrounds it are no longer real, but belong to the hyperreal order and the order of simulation' (Jean Baudrillard, *Simulacra and Simulation*, trans. Sheila Faria Glaser, The Body, In Theory: Histories of Cultural Materialism, Ann Arbor, 1994, p. 12).

when it comes to assessing the value of a cultural work is, consequently, its relationship to the cultural tradition: how successful its positive or negative adaptation to that tradition is. The turn toward extra-cultural reality is merely one historical phase of a negative adaptation, which, in its turn, has models in the cultural tradition itself.

In the pages below, therefore, we shall take art as our guiding thread. For at the core of our discussion is not the question 'what is?' or 'what is true?', which bears on the relationship to nature, reality, or the real, but, rather, the question of how an artistic or a theoretical work must be made in order to count as culturally valuable. For there are theories about the indescribable, uninterpretable unconscious, and there are also works of art which rule out the question of truth as a mimetic, reflective relationship to the real, however it may be conceived – yet which most assuredly have cultural value. Let us add that these works cannot be left out of account on the grounds that we disagree with them or do not accept them as works of art. The mere fact that they exist in a culture requires that we conduct a fresh inquiry into the mechanisms of cultural production as a whole.

The question about a work's value is, moreover, in a certain respect even older than the question about truth as the work's relationship to the real. The latter question grows out of a revolt against tradition that tradition itself demands from the start – this demand alone endows every revolt with its cultural value. Only when a given work acquires cultural value does it also become interesting and relevant for interpretation – not the other way around. Innovation and the cultural value deriving from it, then, give a theoretician or an artist the right to present his personal, profane, and 'real' concerns to society. Society takes less interest, or even none at all, in other people's concerns, although those concerns may be no less important or urgent in and of themselves. Every cultural work carries out a revaluation of values that also valorizes

its author's profane, or real, personality.[13] That is why we shall be primarily concerned with the cultural-economic logic of the revaluation of cultural values, which alone establishes the conditions for an overview of reality and the question of truth as a relationship to reality.

13 See Boris Groys, 'Die künstlerische Individualität als Kunsterzeugnis', in *Über die Wahrheit in der Malerei*, Vienna, 1990, pp. 55–60.

PART I

THE NEW IN THE ARCHIVE

1

The New between Past and Future

The demand for the new arises primarily when old values are archived and so protected from the destructive work of time. Where no archives exist, or where their physical existence is endangered, people prefer to transmit tradition intact rather than innovate, or else to appeal to principles and ideas which are regarded as independent of time and, in that sense, always immediately accessible and unchanging. Such ostensibly atemporal principles and ideas are posited as 'true' in hopes that they will subsist or be rediscovered even if their cultural anchorage is destroyed. Classical art obeys certain canonical rules or else appeals to the mimetic representation of nature in order to reflect, as faithfully as possible, a nature whose essential aspects are regarded as immutable. Thinking is, accordingly, expected to respect a mythical tradition or the invariable laws of logic. Only when the social and technical means for preserving the old appear to have been secured does interest in the new arise, for it then seems superfluous to produce tautological, derivative works that merely repeat what has long been contained in archives. Thus the new ceases to represent a danger and becomes a positive demand only after the identity of tradition has been preserved – not by the putatively ideal permanence of truth, but by technical arrangements and media – and after it has been made accessible to all.

In classical antiquity and the European Middle Ages, an orientation to the new was usually condemned: it was believed to be simply a concession to the power of time, which gave rise to deviations from the models handed down by oral or written tradition. Thought's chief mission was to offer permanent resistance to the march of time, supposed imperceptibly to destroy the memory of tradition, and to preserve an ancient heritage, protecting it as far as possible from deforming innovations. Thus the new could be conceived of only as deformation or as an error committed involuntarily, out of forgetfulness or under the pressure of changed circumstances. In this perspective, active insistence on the new could be understood only as amoral accommodation to the frailties of human memory or the exigencies of secular power.

Today it is widely held that the attitude toward the new changed completely in modernity, which is supposed to have celebrated it without reserve.[14] The change was in fact not as radical as it might

14 Hans Robert Jauß relates the transition to modernity and the positive appreciation of the new to the 'quarrel of the ancients and moderns' in mid-eighteenth-century France (H. R. Jauß, 'Ästhetische Normen und geschichtliche Reflexion in der "Querelle des Anciens et des Modernes"', in Charles Perrault, ed., *Querelle des Anciens et des Modernes*, Munich, 1964, pp. 8–64). For Jauß, however, the definitive turn toward the new begins only with Baudelaire, whose aesthetic connects *modernité* with *nouveauté* and revalorizes 'transitory beauty' as well as fashion (H. R. Jauß, 'Der literarische Prozeß des Modernismus von Rousseau bis Adorno', in Reinhart Herzog and Reinhart Koselleck, eds., *Epochenschwelle und Epochenbewußtsein*, Munich, 1987, pp. 258ff.). It is true that Jauß already detects a radical demand for the new and a concomitant devalorization of the old in Christianity, arguing that the new continues to function as an ideal in all European culture; however, this demand is, in his view, still 'domesticated' by the claim that the God of the Old Testament is identical with that of the New (H. R. Jauß, 'Il faut commencer par le commencement!', in ibid., pp. 563ff.).

It may, however, be objected that, in Baudelaire as well, the new is still in every sense domesticated, since every new thing contains, in Baudelaire's estimation, an immutable element of eternal beauty: 'This is in fact an excellent opportunity to establish a rational and historical theory of beauty, in contrast to the academic theory of a unique and absolute beauty; to show that beauty is always and invariably of a double composition, although the impression that it produces is single . . . Beauty is made up of an eternal, invariable element, whose quantity it is excessively difficult to determine, and of a relative, circumstantial element, which will be, if you like, whether severally or all at once, the age, its fashions, its morals, its emotions' (Charles Baudelaire, *The Painter of Modern*

seem. Thought in modernity, unlike thought in most earlier periods, set out from the assumption that universal truth could manifest itself not just in the past, but in the present and future as well. In other words, it assumed that truth announced itself in reality, beyond tradition, as meaning, essence, being, and so on. Hence modern man tended to expect and hope that this new truth would reveal itself to him and deliver him from his earlier errors. Even in modernity, however, this truth that revealed itself in time was conceived as eternal and extra-temporal. Once unveiled, consequently, it became something to be permanently preserved for the future. That is why this future was, in modernity, generally conceived of as the past had been imagined earlier: as harmonious, immutable, and subordinate to the one truth. The utopianism of modernity was, in its fashion, a conservatism of the future. It is no accident that this utopianism approved the destruction wrought by wars and revolutions. Such violent destruction of the historical archives was incapable of jeopardizing the newly discovered universal truth; it could only free it from the burden of the past and purify it, because, if the locus of truth is the real itself, then the disappearance of tradition could, at the very least, do the truth no harm. For this reason, modern ideologies, from the moment they came into power, always adopted extremely conservative positions, like those that prevailed in the Soviet Union not so long ago. They had attained truth and their triumph had called an end to history; nothing new was now possible. With that, however, the most archaic structures of thought were immediately revived.[15]

Life and Other Essays, trans. Jonathan Mayne, 2nd ed., London, 1995, p. 3). The aesthetic tradition, to which every work of art necessarily refers, is thus still conceived, not as historical, but as 'eternal beauty' in Baudelaire.

15 On the connection between the Russian avant-garde and socialist realism, see Boris Groys, *The Total Art of Stalinism: Avant-Garde, Aesthetic Dictatorship, and Beyond*, trans. Charles Rougle, Princeton, 1992.

Acceptance of a truth which reveals itself in time even radicalizes, in a certain sense, that truth's claim to originality and anteriority. This modern conception of the truth may already be found in Plato: the soul remembers the truth to which it had access even before it came into the world, before the beginning of any tradition, before the beginning of the world as such. The new truth here turns out to be still older and more original than any tradition explicitly present in culture. This conception of the new truth as a truth more original still than any oral or written cultural tradition is also widespread in modernity. The philosophy and literature of modernity are both in constant pursuit of something that cannot be relativized in the course of time: they seek the basic logical forms and structures of perception, language, the aesthetic experience, and so on. Nietzsche and Freud, for instance, work with material that comes from ancient myths; Marx calls for a return, at a new stage of development, to an original society without private property. The art of modernity turned to the culture of primitive peoples, the infantile, and the elementary.[16] There was no substantial change, in modernity, in the conception of the new as something anterior to all historical time, or in the demand that the truth be more original than all the errors that succeeded it.

Descartes' *cogito ergo sum* is generally considered to mark the beginning of modern philosophy. With that as his motto, Descartes set out to position himself beyond the limits of everything that could be called into doubt and, consequently, prove impermanent in historical time; his aim was to found a methodology thanks to which the future could be organized on unified, rational, universal, immutable bases.[17] The most influential

16 The avant-garde's orientation to the primitive is well known. For a critical account, see Arnold Gehlen, *Zeit-Bilder*, Frankfurt, 1960, pp. 144–9.

17 The path that leads from the utopia of the total destruction and renewal of the world to the limited utopia of the *ego cogitans* in Descartes is particularly conspicuous in the following passage: 'Thus we see that buildings undertaken and carried out by a single architect are generally more

modernist movements in the arts pursued the same goal: suffice it to consider the radical methodological doubt as to the permanence of historical art forms that Malevich or Mondrian, for example, expressed by means of art itself. Both these painters sought to establish the structure of any possible picture beyond all the historically determined pictorial forms and to declare the formal structure thus revealed for the first time to be the universal artistic style of the future.[18]

The thinking and culture of the modern period are happy to contrast themselves with the past, but reluctant to contrast themselves with the future, which they conceive of as the domain of their unlimited expansion. The future is here regarded as a straightforward continuation of the present, just as, earlier, the present was regarded as a straightforward continuation of the past. The same holds for the theories of the modern period that seek to integrate the demands of historicity as fully as possible.

To be sure, since Romanticism and the collapse of Hegelian historicism at the latest, an influential philosophical current has contended that an extra-historical truth and a stable, rationally

seemly and better arranged than those that several hands have sought to adapt, making use of old walls that were built for other purposes . . . Similarly, I conceived, peoples that were once half-savage and grew civilized only by degrees, and therefore made their laws only insofar as they were forced to by the inconvenience of crimes and disputes, could not have such good public order as those that have observed, ever since they first assembled, the decrees of some wise legislator . . . True, we do not observe that all the houses of a city are pulled down merely with the design of rebuilding them in a different style and thus making the streets more seemly; but we do see that many men have theirs pulled down in order to rebuild them . . . By this parallel I became convinced that it would not be sensible for a private citizen to plan the reform of a state by altering all its foundations and turning it upside down in order to set it on its feet again, or again for him to reform the body of the sciences or the established order of teaching them in the schools; but that as to the opinions I had so far admitted to belief, I could not do better than to set about rejecting them bodily, so that later on I might admit to belief either other, better opinions, or even the same ones, when once I made them square with the norm of reason' (René Descartes, 'Discourse on the Method', in idem, *Philosophical Writings*, trans. E. Anscombe and P. T. Geach, London, 1954, pp. 15–17).

18 On that which transcends time in art, see Kazimir Malevich, 'God Is Not Cast Down', in idem, *Essays on Art*, trans. Xenia Clowacki-Prus and Arnold McMillin, vol. 1, Copenhagen, 1968.

organized, utopian future are unattainable. This acceptance of the historical, however, is as a rule bound up with the claim that every-thing historical is singular, unrepeatable, incomparable, ephemeral.[19] Yet, where comparison is lacking, the new becomes impossible. True, an uninterrupted dynamic and incredible tension and activity then prevail, but this incessant, uninterrupted movement remains monotonous and has no value at all: no clichés are as stable and monotonous as Romantic clichés. The Romantic utopia is a utopia of movement and singularity that likewise proffers itself outside the archives as permanently open and accessible. As such, it does not essentially differ from the classical utopia of eternal truths.

This fundamental modern utopia remains decisive in Marxism, existentialism, hermeneutics, psychoanalysis, life philosophy, structuralism, the Heideggerian school, and deconstruction, to name just some of the philosophical currents that have followed in Hegel's wake. All of course produce discourses that make it possi-ble to describe truth's historical relativity. These discourses themselves, however, are not conceived of as historically relative. In this connection, it is basically irrelevant to what extent each particular discourse contends that the inner logic of historical change can be described and mastered or, on the contrary, to what extent the possibility of description and mastery is denied. It is precisely the reference to the essential hiddenness and difference of 'Being' and the 'Other', responsible for historical change according to Heidegger or the theorists of French poststructuralism, which makes it possible to pursue the conversation about this hidden 'Other' indefinitely, and thus to occupy the whole horizon of the

19 'This absolutization of the "now", which transforms it into the passing "instant", the poetological structure of the "epiphany", may everywhere be regarded as a characteristic feature of modern literature' (K. H. Bohrer, *Plötzlichkeit: Zum Augenblick des ästhetischen Scheins*, Frankfurt, 1981, p. 63). See also Jean-François Lyotard, 'Newman: The Instant', in Andrew Benjamin, ed., *The Lyotard Reader*, Oxford, 1989, pp. 240ff.

future.[20] Where the object of discourse is constantly slipping away, the discourse itself proves endless: the endlessness of interpretations, textuality, or desire exceeds any particular historical present or future. Even when the theme of such discourse is radical finitude and différance, as in Derrida, for example, it is impossible to bring that discourse to an end, hence to determine its limits and differentiate it from something else that might limit its expansion in time.

The other that is here made responsible for historical change may be named nature, history, life, desire, class struggle, race instinct, technology, language, the call of being, textuality, or différance. Common to all these terms, however, is the reference to something extra-cultural, something that culture does not know or that conceals itself from culture, something that is not controlled by culture and thus determines it. Some believe they can detect this Other in Hegel's dialectical spirit; then there are those, such as Heidegger or Derrida, who prefer to invoke the Other that is in principle hidden or, rather, constantly hides itself. However, to the extent that the Other – i.e., this or that working of time – acquires the status of independent reality, the capacity to govern culture from within, to renew it, and thus to determine it, the philosophical discourses and artistic practices that appeal to the Other advance a claim to privileged status in the cultural context and thus, ultimately, a claim to dominate culture. Regardless of the way these discourses and practices invoke the other – positively or negatively, directly or indirectly, celebrating it or seemingly denying it – they define themselves as, basically, meta-cultural and dominating the future. They appeal to time itself and consequently regard themselves as immune to the historical change that occurs in time.

20 For Derrida, there can be no end to deconstruction, because it is itself this end: 'And whoever would come to refine, to say the finally final [*le fin du fin*], namely the end of the end [*la fin de la fin*], the end of ends, that the end has always already begun, that we must still distinguish between closure and end . . .' (Jacques Derrida, 'Of an Apocalyptic Tone Recently Adopted in Philosophy', in Harold Coward and Toby Forshay, eds., *Derrida and Negative Theology*, Albany, 1992, pp. 48–9).

The march of time is not, however, the hidden cause of the changes in values in which the times find expression, as the nice phrase goes. The logic of the revaluation of values mandates the new even when the times by no means call for it.[21] This logic is an economic strategy that consciously and artificially produces new times. Even that which comes about more or less unconsciously in time becomes a cultural value only by virtue of this logic. Value hierarchies are not automatically altered by changing times; rather, temporal processes are positively or negatively utilized by operations with values in the supra-temporal perspective of the cultural archives and the comparisons they make possible.

21 For Baudrillard, fashion is a 'flotation of signs' that has no stable reference, not even in time (Jean Baudrillard, *Symbolic Exchange and Death*, trans. Hamilton Grant, Los Angeles, 1993, pp. 92–3).

2

The New Is Not Just the Other

Underlying the notion that the historically new manifests itself in culture only as a consequence of the action of an extra-cultural other is a sort of Newtonian conception of the mechanics of cultural movement. A body in motion left to itself, according to Newton, will move uniformly in a straight line. A change in speed or direction means that something outside it has impinged upon it. Similarly, it is assumed that if nothing impinged upon the movement of a culture, it would, thanks to inertia, simply perpetuate existing tradition. A culture is forced to abandon the automatic reproduction of traditional patterns only as a result of a hidden influence exercised by God, nature, a particular author's irreducibly extra-cultural individuality, the power of the unconscious acting through that author, or difference. Were man not 'alive' – that is, different with respect to every 'dead' culture – he would, on this view, be indiscernible from a machine that operates permanently on the same programme until it stops working.[1] It is this conception of culture as the sum of inalterable patterns and their stereotypical reproduction which gives rise to the appeal to God,

1 Such cultural programmes are described as 'discursive formations' in, for example, Michel Foucault, *The Archaeology of Knowledge and the Discourse on Language*, trans. A. M. Sheridan Smith, New York, 1972, pp. 31–9.

being, life, or difference, all of which secretly reprogramme culture, as it were, thus bringing forth the new. The source of the new can accordingly only be a forgetting of the cultural tradition and a renunciation of the sum of prejudices, lifeless conventions, and outmoded forms, as well as the annunciation of the other as such. Here, too, is the source of postmodern scepticism as to whether the new is possible at all in the highly mechanized culture of our time. If the sources of bare life have dried up and the forgetting of cultural tradition – supposed to trigger the remembering of an original, extra-cultural real and its immediate, unreflected manifestation – now seems impossible, then it should also be impossible for the genuinely new to emerge.

With respect to tradition, however, the new is never just something other. Rather, it is always also something valuable that a particular historical period privileges, assigning the present precedence over both past and future. Therefore, even if the new is conceived of as something that proceeds from the other's influence on culture and tradition, it cannot just remain a symptom of the other. It must, rather, reveal the other itself that influences culture, must make it more accessible, more plainly visible, easier to understand. That is why modernity pays the closest possible attention to the theories of nature, desire, or the unconscious that speak of the other, and to art that endeavours to make the other manifest. If the other itself absolutely refuses to reveal itself in the new, the new dissolves the mass of the others; history dissolves in the play of differences.

That is also a source of poststructuralist reservations about the new. Although the other continues to produce effects, those effects remain hidden; and although the culturally other is constantly produced, it fails to gain the status of something valuable. The discourse about the hidden nature of the other then becomes the last cultural phenomenon that can lay claim to such status. Every additional instance of the new turns out to be arbitrary and

superfluous, because it can under no circumstances manifest its hidden source.[2] Since the hidden other manifests itself no more plainly in one concrete difference than in any other, all differences eventually converge in an undifferentiated mass. The fantasy of the other that earlier, in modernity, served as a source of cultural optimism now becomes a source of cultural pessimism. The difference resides less in an underlying predisposition than in the fact that the other presents itself, as time goes on, as ever more hidden, ever more remote, ever further off in the future. It presents itself ever more radically as the other and as ever harder to capture in a form of the new.

To be sure, poststructuralist or postmodern theories about the self-hiding other have maintained an orientation to the new. Society has perceived them as something new and they themselves assert their newness vis-à-vis earlier theories. What is new about them is precisely the contention that the other hides itself and prevents any substantial statement about itself. Yet this purely negative definition of the other is naturally only possible and meaningful when we also take into account the whole history of earlier attempts to define it positively. If there is nothing to say about the other, then we should, basically, not talk about it. We should not even talk about the fact that we should not talk about it, as Wittgenstein nevertheless continued to do.[3] From the moment that postmodernity, as an ideology, really seizes the masses, the desire to talk about the hidden nature of the other disappears; there remains only the undifferentiated, 'pluralistic' mass of existing differences, among which we can make no meaningful choices at all. This is the situation in which

2 *Clôture* [closure] (see Introduction, n. 1) designates precisely this inaccessibility of the radically other.

3 'What we cannot speak about we must pass over in silence' (Ludwig Wittgenstein, *Tractatus Logico-Philosophicus*, trans. D. F. Pears and B. F. McGuinness, Routledge Classics, London, 2001, p. 89). On the problem of not-speaking, see Jacques Derrida, 'How to Avoid Speaking: Denials', in Harold Coward and Toby Foshay, eds., *Derrida and Negative Theology*, Albany, 1992, pp. 73–142.

culture finds itself today, after the postmodern critique of the 1960s
and 1970s. There no longer seems to be anything identical, nor
anything other, that might be interesting, relevant, and valuable,
and might stand over against the self-same as an essential differ-
ence. Everything has been dissolved in the play of partial
differences.

Yet, in actual practice, culture deems certain differences and not
others interesting and valuable, as it always has. In other words, it
continues to define certain differences as new and relevant and
others as trivial and irrelevant. That is why there is no denying the
problems involved in choosing certain cultural works for archives
such as libraries, museums, or film libraries, and all the attendant
phenomena of fashion, social success, and prestige. Thus critics of
these archives and the cultural privileges associated with them
repeatedly try to show that cultural differences between various
socially unrecognized groups and the established archives are too
important to be ignored.[4] This spawns, for example, the cultural
critiques proffered on behalf of women and ethnic or social minori-
ties, as well as particular writers' and artists' efforts to highlight
their own individuality and provide theoretical substantiation of the
value of their works, with an eye to building up a myth about them-
selves and gaining access to the archives. In all these cases, the
group's or author's differences from the surrounding field are iden-
tified as especially significant, and their claim to cultural
representation in the established archives is derived from it.

Today, however, when no further intra-cultural difference is
authorized to represent the other as such; when the self-sameness of
all differences underpins everything, just as, earlier, the self-same-
ness of the same did; and when every cultural activity has this

4 On postmodern theories of the politics of representation, see the sections 'Cultural Politics'
and 'Gender/Difference/Power' in Brian Wallis, ed., *Art after Modernism: Rethinking Representations*,
New York, 1984, pp. 295–434, and Barbara Kruger and Phil Mariani, eds., *Remaking History*, Dia Art
Foundation Discussions in Contemporary Culture, no. 4, Seattle, 1989.

utterly undifferentiated cultural pluralism as its horizon, the new still continues to be distinguished from the merely different. How does this distinction come to be made? To put the question another way, how is culturally valuable difference distinguished from culturally valueless difference?

3

The New Has Its Origins Neither in the Market nor in Authenticity

Strategies for the attribution of cultural privilege are today usually characterized as market strategies pure and simple, effects of a market economy that requires that new products be turned out endlessly in order to generate ever-higher profits. The socially privileged, high-value status of certain discourses and works of art is wholly ascribed to their authors' (and their authors' managers') successful marketing or institutional policy. The result of such policies has, on this view, nothing to do with the actual nature of the discourses or works of art involved. On this analysis, every reference to cultural, aesthetic, or content-related criteria may be dismissed as more advertising that impresses only the ignorant public.[1]

The interpretation of the new as the product of a market orientation is hardly a new idea. In modernity, too, the reproach that newness is just a bid for money and success dogged the new from the very start.[2] Here innovations that have emerged under the

1 On 'authenticity' as a marketing strategy, see Jean Baudrillard, *The System of Objects*, trans. James Benedict, London, 1996, pp. 76–84.

2 On the marketing strategy of the historical avant-garde, see Yves-Alain Blois, 'La leçon de Kahlweiler', *Les Cahiers du Musée national d'art moderne* 23, 1988, pp. 29–56.

influence of the heterogeneous real or the other are held to be authentic and aimed against the ruling social system, while non-authentic innovations dictated by market strategies alone are held to stabilize that system. However, from the standpoint of postmodern criticism, which denies that the other as such can appear at all, every innovation may be considered inauthentic. The lone exception is, perhaps, the attempt to produce social criticism through art or theory, yet this attempt, too, is condemned as commercialization as soon as it meets with a modicum of success. An orientation to the new now seems to be not just impossible, but even undesirable, for the further reason that it has shed its former role as a form of political opposition.

The interpretation of the market as the motor of innovation is in one respect better than traditional analyses that continued to cling to mimetic truth-criteria even after belief in the possibility of immediate access to the real had been challenged – that is, once the observer of a work of art could no longer compare it to what it was supposed to represent, or once a theory appealed to the unconscious, so that the reader could not verify it by comparing it with processes that had taken place in his own consciousness. The conception of culture as mimesis is so deeply rooted in culture itself that art and theory are almost automatically perceived as linguistic instances, signs, and images. Even if the assumption is that these signs cannot adequately represent what they designate, namely, the reality hidden behind them, or the other, and that they hide this real further, rather than reveal it, they are nonetheless interpreted as signs of unrepresentability, radical alterity, or the sublime. Thus a special 'authentic' quality continues to be ascribed to cultural products: mimetic representation is beyond their reach, to be sure, but they at least have every intention of attaining it.[3] Authenticity is

3 In this case, authenticity functions as intensity, that is, as an experience of the libidinous body beyond subjectivity, the limits of the body, or particular organs and forms. On intensity in this

accordingly understood as the involuntary failure of a mimetic intention – as the mimesis of the non-mimetic. A certain inferiority complex of modern culture vis-à-vis the tradition finds expression here: the new, mimetically unverifiable forms are interpreted as the effect of an accident in reality itself. On this view, an artist or a theoretician has made a sincere effort to represent reality in the traditional sense; the effort has failed; he now presents a picture of his defeat; this defeat, however, is a faithful picture of reality, with its intrinsic cruelty.[4]

Modernist criticism is characterized by the conviction that authentic discourses or works of art differ from inauthentic ones by virtue of their peculiar radicalness, depth, persuasive power, or originality. Even postmodern authors who, like Lyotard, tend to equate 'capital flows' with 'flows of desire' draw this distinction.[5] In other words, the planning, strategically operative understanding is taxed with a basic inability to produce genuine newness on the grounds that it is dominated by considerations of success and profit. The morally motivated rejection of everything new by means of which archaic consciousness sought to maintain an immediate connection to the past is also observable in the enlightened consciousness of modernity, with the difference that this moralistic

sense, see Jean-François Lyotard, 'The Tensor', in Andrew Benjamin, ed., *The Lyotard Reader*, trans. Lisa Liebmann et al., Oxford, 1989, pp. 1ff. According to Lyotard, intensity is 'incomparable' and 'immeasurable', and the objective of works of art or theoretical texts is 'the instantiation of intensity' (Jean-François Lyotard, *Libidinal Economy*, trans. Iain Hamilton Grant, New York, 2004, pp. 162–3, 246).

4 Thus Derrida depicts Rousseau as an authentic seeker of truth, whose quest is, however, inscribed in textuality. Similarly, Paul de Man constantly calls attention to the 'blind spot' around which every text constitutes itself precisely when it insists on its authenticity: 'Here the consciousness does not result from the absence of something, but consists of the presence of nothingness. Poetic language names this void with ever-renewed understanding . . . This persistent naming is what we call literature' (Paul de Man, *Blindness and Insight*, Minneapolis, 1983, p. 18).

5 Lyotard sets out to show, in *Libidinal Economy*, that 'capitalization' and 'labour' do not result from a repressive 'reality principle' that would inhibit the free flow of libidinal fluxes, but, rather, that this interruption is itself libidinous and productive of *jouissance*, and thus part of the 'libidinal economy' (Lyotard, *Libidinal Economy*, p. 222–3).

critique today bears, not on all forms of newness, but only on those judged inauthentic, which is to say those that do not appeal to origins and the original. The distinction, characteristic of modernity, between authentic newness on the one hand and, on the other, an inauthentic newness supposed to be simply the product of a morally objectionable 'pursuit of newness for newness' sake' shapes many judgements about philosophy or art even today. In practice, however, it proves impossible to distinguish authentic from inauthentic newness. Every new thing is ultimately determined by the extent to which the historical comparison that the archives make possible distinguishes it from the old. This implies, however, that the process by which new is distinguished from old is rational and controllable. For, contrary to the common assumption, the authentically new does not arise through a kind of self-forgetfulness. From the Enlightenment on, the creator of a work has been confronted with the demand to cast off all traditions, prejudices, tricks of the trade, and forms of external, rational control in order to allow hidden forces to take charge, whether these forces be inspiration, nature, desire, life, pure reason beyond the reach of all traditional truths, or the impersonal forces of language itself. The creator of the new is thus left alone with the real itself or the 'inner necessity' that dictates his creation, as Kandinsky, for example, puts it.[6] But where is the guarantee that these 'authentic cultural products' will still be judged new after comparison with already existing culture? Does this externally identifiable newness, insofar as it exists, not mean that the creator's self-forgetfulness was not total after all and that she rather carefully calculated the place her cultural product would take among all the others? Indeed, if critics can apply certain criteria to compare, from without, new cultural productions with those that already exist, in order thereby to define

6 Wassily Kandinsky, 'On the Spiritual in Art', in Kenneth C. Lindsay and Peter Vergo, eds., *Kandinsky: Complete Writings on Art*, The Documents of Twentieth Century Art, Boston, 1982, pp. 213ff.

their relative newness – or non-newness – then it is safe to assume that artists or writers also can. References to authenticity thus ultimately turn out to be no more than a kind of advertising and marketing strategy intended to invest certain artists with a special aura. These references are primarily utilized to shield mediocre works with little cultural originality from critical evaluation. All such attempts lead only to pointless mutual recrimination and the emergence of a host of cliques, each of which considers itself authentic and all the others inauthentic.

The fact is that an honestly, authentically produced work can, on comparison, turn out to be altogether trivial and unoriginal. The opposite conviction is part and parcel of a residual modernist ideology, the still active belief that the real is diverse in and of itself and that people are different by nature. If everyone, so this argument runs, sincerely tried 'to be herself', she would automatically, in the end, differ from everyone else. Every human being differs at any given moment, it is further maintained, from what she was the moment before. A human being would accordingly produce something new every minute if only she hearkened to her desires, vital impulses, and intuitions. Just as the instinctive conviction prevails, in modernity, that outmoded culture is the mechanical realm of sameness, so it is just as uncritically assumed that the other, hidden, extra-cultural real is the realm of the difference that automatically guarantees novelty. This conviction sprang up partly as a result of the fact that earlier periods never did succeed, despite their best efforts, in preserving tradition, the self-same, and truth intact. This failure was blamed exclusively on the real itself, which was said constantly to exercise its hidden influence on culture, although the opposite might just as well be assumed: that the reasons for the failure lay in culture itself. The currently prevailing conception of the real as the realm of the rule of difference can stake no better claim to truth than did earlier doctrines about an identity guaranteed by God, spirit, or the idea.

We can, then, wholeheartedly endorse the critique of the modern conception of authenticity carried out, in our day, in the name of the market, for that critique regards cultural products as, not signs of a hidden reality, but values in an economic whole that cannot be grounded by an appeal to such a hidden, imaginary reality. The only problem here is that postmodern, post-authentic thought generally continues to appeal to culture's other; now, however, it is no longer the inner, hidden other, but the external market situation. Whereas earlier, authentic production of the new was usually depicted as a wholly passive operation consisting only in rejection of the old – of tradition, schools, and 'prejudice' – it now appears that the inauthentic new is also passive. Reading the many critiques of the commercial orientation of the new, we might well suppose that nothing is easier than to create something new: one need only let oneself be permeated by the evil spirit of profit, cast truth and morality to the winds, chase single-mindedly after success, and the new will materialize all by itself. The notion that newness can be easily produced flows from the mentality of times gone by, in which tradition was beset by multiple temptations and possible deviations and one had only to make up one's mind to succumb to those temptations.

The common reference to the market thus remains within the horizon of a mimetic conception of culture, in which culture is supposed to reflect market activity and laws. The economic logic of the revaluation of values is, however, the logic of culture itself. Culture is always already a value hierarchy. Every cultural act confirms this hierarchy, alters it, or, as happens in most cases, does both at once. Hence a cultural-economic investigation need not treat the market as an extra-cultural reality. Theories and works of art are negotiated on the market in accordance with the value that cultural events attribute to them. An actually won or anticipated position in the cultural archives is the greatest incentive for the commercial market as well, for such a position is regarded above all

as a solid investment. That is reason enough to assert that culture is not a reflection of external market activity, since a cultural work's market price decisively depends on its longevity, which is guaranteed by the cultural archives.

4

The New Is Not Utopian

Neither the modern appeal to a hidden inner reality nor the post-modern invocation of the laws of the market can, as we have seen, provide a satisfactory answer to the question of the nature and sources of the new. It follows that orientation to the new is the economic law governing the workings of the cultural mechanism itself, and that we should not seek explanations for newness that are based on an extra-cultural other. A normally functioning cultural mechanism constantly produces newness. To understand its nature, therefore, we have to study the intra-cultural demands and expectations with which artists, theoreticians, critics, and historians are all equally confronted.

The new must be distinguished from the utopian. In other words, the new stands in opposition to the future as much as to the past. Authors living in a technologically archived culture such as ours − in contrast to those who lived in more troubled times and cultures − no longer endeavour, as a rule, to ensure that their views or artistic methods become compulsory or, at least, will exercise a decisive influence in the future. A theoretician's or an artist's approach to the problem of the truthfulness of his statements or methods has been completely transformed as a result. If we followed a contemporary theoretician's discourse or adopted an artist's newly created method as if it were a universal

42 THE NEW IN THE ARCHIVE

truth, we would only provoke their indignation: they would take this as an accusation of servile imitation and would feel that their own cultural originality was in jeopardy. Here we can indeed discern a basic difference between the self-perception of an author of our day, in particular, and the standard that prevailed throughout the history of culture down to very recent times. Earlier, every innovator sought to gain universal recognition for his ideas and wanted as many people as possible to share them; he hoped that they would help shape the course of the future, that they would remain unchanged in the future, and that his name would come to symbolize the future. Hand-in-hand with this utopian wish for an absolute future for his ideas went the panic-stricken fear that they might be completely lost for the future if they proved untrue, foolish, and wrong. Modern innovators' extreme, often totalitarian attacks likewise find their explanation in this desire and this fear.

Today, a given author's historical memory is preserved thanks less to the unconditional triumph of his ideas than to the universal system of the archives in the form of libraries and museums that keep and disseminate information about him. In this situation, it is no longer a triumph for an individual author when society recognizes his ideas as true; it is, rather, an existential danger, for this means that his ideas will lose value as a result of their massive dissemination and that their author will lose his singular place in the system of historical memory. Conversely, the fact that certain ideas are deemed untrue by no means blots them from historical memory: they need only be recognized as original. The measure of the success or failure of theories and methods today depends on their relationship to the cultural economy's other theories and methods, not the relation they bear to a utopian, extra-cultural reality.

It is no accident that nearly every contemporary author modifies his methods and ideas as soon as they come into wide circulation and stubbornly insists that his artistic or theoretical practice cannot

be reproduced or repeated.[1] This rejection of an orientation to universality and reproducibility goes considerably deeper than the external crisis of modern utopianism. It is not just, nor even primarily, due to the fact that utopias have proven to be altogether unrealizable, or realizable only in the form of dystopias. Rather, no one now wants to entrust his originality to the future or to let others trespass on the cultural domain that he has wrested from the past. Although the philosophy and art of our day sometimes still create the impression that they are in quest of a universal truth that is open, acceptable, and even valid for all, the prevailing trend has philosophers and artists endeavouring to depict the originality of their theoretical discourse or artistic practice as unrepeatable for all time. This quest for intra-cultural originality differs from the pursuit of originarity, which was conceived of as proximity to the origin and conformity with an extra-cultural real supposed to be both impersonal and universally valid and, at the same time, individual and singular.

In recent years, modernity's conception of originarity has been subjected to a comprehensive critique carried out with the help of various methods of intertextual analysis.[2] Thus it is not hard to show that every author always works with quotations drawn from

1 Thus Derrida writes about 'the obvious fact . . . that deconstruction is inseparable from a general questioning of *tekhné* and technicist reasoning, that deconstruction is nothing without this interrogation, and that it is anything *but* a set of technical and systematic procedures . . .' (Jacques Derrida, 'Mnemosyne', trans. Cecile Lindsay, in idem, *Memoires for Paul de Man*, The Wellek Library Lectures at the University of California, Irvine, 2nd ed., New York, 1989, p. 16). In a different context, Igor Smirnow points out that the Freudian doctrine of the Oedipus complex positively calls for its rejection by future generations, because it is a doctrine of the rejection of paternal authority (I. M. Smirnow, 'Edip Freida i Edip realistov', in *Wiener Slawistischer Almanach* 28, 1991, p. 5).

2 'Is the space between texts not in fact the space of memory? Does every text not modify the space of memory by modifying the architecture in which it takes its place? . . . The space of memory is inscribed in the text in the same way as the text is inscribed in the space of memory. The text's memory is its intertextuality' (Renate Lachmann, *Gedächtnis und Literatur*, Frankfurt, 1990, p. 35). On the problematic of intertextuality in the fine arts, see Rosalind E. Krauss, *The Originality of the Avant-Garde and Other Modernist Myths*, Cambridge, MA, 1988.

already existing culture and can therefore make no claim to origi-
narity. Yet it is precisely work with existing texts and images which
makes it possible expressly to demonstrate the intra-cultural origi-
nality of one's own work. Not only do the art and theory of our
day, in practice, not renounce originality when they negate the
originary; they demand originality all the more insistently. The
result is that this demand itself appears more clearly and is easier to
assess.

The tendency to protect oneself from the future by emphatically
insisting on one's own originality has led, in particular, to a situa-
tion in which no one today talks about the new, whereas everyone
talks a great deal about the other. The observation that one's own
discourse is different from everyone else's rests on the hope that the
alterity, individuality, and specificity of this discourse can be
preserved in the future as well and will not be dissolved in the
vagueness of a newly constructed doxa. In question here, to repeat,
is not so much the more vigilant morality of contemporary authors
who no longer wish to succumb to the blandishments of totalitari-
anism as the fact that, in our day, it has simply become strategically
inexpedient to lose the exclusive rights to one's own ideas. The
reason is that their permanent preservation in historical memory is
no longer ensured by the fact that many people come to believe
them, as was the case in the age when the major religions were
founded and even in the Enlightenment. Rather, the preservation of
ideas is now ensured by an ideologically neutral, purely technical
system in which a certain quota of cultural information is stored,
disseminated, and handed down to the future. It is above all work
that has proven its specificity, originality, and individuality which
has the best chance of being included in the quota.

5

The New as Valuable Other

The transition from the modern discourse about authenticity to the postmodern discourse about alterity is, as we have seen, justified at a certain level. Yet discussions of it always ignore an important consideration: namely, that the concept of the other is value-neutral. Whereas equality between people, cultural forms, ideas or languages was once justified by postulating a certain underlying identity, postmodern theory proclaims equality without identity, that is, equality amid alterity. Actual cultural practice, however, refutes this conception of the equality of the diverse as a new brand of utopia.

Some differences are perceived as valuable and culturally relevant even today – they define the socially recognized newness and originality of a cultural product in comparison with all others – while other differences appear to be irrelevant and without value. It may of course be objected that the cultural relevance or irrelevance of the different is a matter of interpretation, so that differences which, say, earlier seemed irrelevant suddenly take on new value in the light of new interpretations. Yet an interpretation, too, is a cultural product, one that is archived in the form of a text. If an interpretation seems new and valuable, this has certain consequences for the work interpreted – not the other way around. An interpretation reveals nothing one did not know earlier. Simply, the value of that which is interpreted changes.

The aestheticization of reproductions of old artworks in contemporary art might be cited as an example. The differences between reproduction and original earlier seemed to be without value at the purely aesthetic level; now they suddenly acquire new relevance. Whereas we once primarily collected originals in the archives and considered copies and reproductions of them irrelevant, we now register all the transformations that make the reproduction process a process of production, so that the alleged copy is regarded in a new light as an original image.[1] Moreover, we register the reproductivity that operates at the heart of every original cultural production and determines it. Out of these insights, there have emerged complex theories about the secondariness that precedes originality and the reproductivity that proceeds productivity.[2] Only because these theories are considered new and valuable are the corresponding differences recognized and the corresponding copies and reproductions archived from the new standpoint. Producing a new interpretation thus amounts to creating a new work. This means, in turn, that only those differences that have been made valuable are deemed valuable. Once made valuable, however, they possess a value that distinguishes them from mere alterity.

It can therefore be said that equality of the different is basically quite as utopian and ideological as the equality based on self-sameness defended in an earlier day. The new is not just the other, it is

1 Walter Benjamin describes the transformation that the work of art undergoes as a result of its reproduction as the loss of its aura. See Walter Benjamin, 'The Work of Art in the Age of Mechanical Reproduction', in idem, *Illuminations*, trans. Harry Zohn, New York, 1969, pp. 221–4.

2 Thus Baudrillard defines the simulacrum as one such reflection of reality which is 'more original' than reality itself: the 'order of simulation' differs from imitation and production in that, in the simulacrum, reality is dominated by the code (Jean Baudrillard, *Symbolic Exchange and Death*, Los Angeles, 1993, p. 50). Baudrillard writes, for example, that 'the very definition of the real is *that of which it is possible to provide an equivalent reproduction* . . . At the end of this process of reproducibility, the real is not only that which can be reproduced, but *that which is always already reproduced*' (ibid., p. 73). Baudrillard can, to be sure, only surmise the existence of such an occulted simulative code; he cannot really describe it.

the valuable other – the other that is judged valuable enough to be preserved, studied, glossed, and criticized, so that it will not have disappeared a moment later. The differences resulting from the passage of time, the constant temporal displacement of meaning, do not yet signify the new. They are involuntary, bearing witness only to human memory's incapacity to span time, to make the past present. Here, time and its power are the other. The new, however, emerges in a cultural comparison made in the context of technical and public memory, is voluntary, and basically represents an effect of this memory's longevity. The appeal to the extra-cultural difference and the extra-cultural other that are supposed to provide guarantees for intra-cultural newness is therefore quite as wrong-headed as the earlier appeal to the ontologically identical that was supposed to guarantee social unity. The utopia of the other and the original is swallowed up by the mass of the trivial, hackneyed, and stereotypical, just as the utopia of the identical and the unified disintegrates in the mass of concrete differences. The new is not a by-product of the historical march of time, of the rise of new generations, or of 'natural' differences in language, desire, or social rank: these differences, which do indeed exist, may perfectly well be considered trivial and thus not deserve to be called 'new'. To attain high value-status, such trivial individual peculiarities must first be interpreted anew and integrated into cultural memory.

The new is distinguished from the merely different, then, in that it has been set in relation to the valuable and old preserved in the social memory. It is a question, here, of a special kind of cultural operation that cannot be reduced to external, natural, contingent differences of one kind or the other. It is thanks to this operation and this operation alone that the new has a chance of being integrated into the socially guaranteed historical memory. The new is a cultural-economic phenomenon; hence it cannot be based solely on individual memory and the individual power of discrimination. The new is new only when it is new, not just for, a given individual

consciousness, but with respect to the cultural archive. Not only authors, but, in equal measure, their critics have access to this historical memory. One can accordingly judge the new individually and, at the same time, engage in public discussion of it.

6

The New and Fashion

The new usually makes its appearance in history as fashion. Fashion is ordinarily condemned even more radically than mere pursuit of the new. A common form of this condemnation is the oft-heard disparaging remark: 'Oh, that's just a fashion.' It means that the cultural phenomenon in question has no historical staying power, is transitory, and will soon be succeeded by a new fashion. Fashion should indeed be condemned if one believes that thought's only task is to ensure that truth revealed in the past remain unchanged. It should likewise be condemned if one believes that the goal of thinking is to discover a new universal truth capable of completely determining the future.

For fashion is radically anti-utopian and anti-totalitarian: its constant shifts attest that the future is unpredictable and cannot escape historical change and that there exist no universal truths that might completely determine the future. Fashion was therefore condemned in ancient times, and modernity condemned it, too. Fashion continues to be condemned even in contemporary postmodern ideology, which proclaims a new age of pluralist alterity: if everyone is only partially different from everyone else and all are nevertheless equal, then fashion violates this seeming equality by singling out this or that partial difference as more essential and valuable than all the rest.

All condemnations notwithstanding, fashion has left a deep mark on intellectual and artistic life. Indeed, the system of historical memory, toward which every act of theoretical or artistic production is ultimately oriented, follows fashion, since it preserves, from each period, what was in fashion or became fashionable later, when new intellectual and artistic fashions emerged. Contrary to common opinion, then, precisely that which is in fashion today has the best chance of being preserved tomorrow – as, not eternal truth, but the durably preserved characteristic feature of a particular period. The new functions in history first and foremost as fashion because fashion is the name for radical historicity – not the historicity that a particular theoretical discourse takes for its subject, but, rather, the historicity of all the discourses that propose to say something about the historical. Every theory of history stands in constant danger of losing the characteristic of newness and being forgotten by history. What is the point of a theory of historicity if no library wants to hold the book in which it is expounded? What is the point of a theory of desire that no one desires to read and study because it is no longer in fashion?

Wyndham Lewis once rightly pointed out that, in modernity, the fashion compulsion replaced the tradition compulsion. New cultural trends are no indication that individual freedom has triumphed; rather, they create new – albeit relatively minor, temporally limited – homogeneities, social codes, patterns of behaviour, and the new group conformity that goes hand in hand with them.[1] This description is of course accurate, but means only that fashion establishes an inequality between values that allows us to draw a sharp distinction between 'our' values and 'other' values: when we do, some individual differences are defined as

1 Wyndham Lewis defines fashion as the supreme value for modern art: 'Each artist conforms to one or another of the violent orthodoxies of the moment. Women are obedient to the annual fiats of fashion from Paris, and an artist has no more individuality' (Julian Symons, ed., *The Essential Wyndham Lewis*, London, 1989, p. 179).

especially valuable and decisive, to the detriment of others. Fashion thus makes possible an elitist social attitude, a value hierarchy, and a system of criteria considered valid by a particular group. This short-term value system is the enabling condition for both a smooth continuation of old value hierarchies in new forms and a cultural critique that today marshals the same arguments against elitist fashion which, yesterday, were directed against established tradition.

Newness and fashion may thus be understood as contrary to the modernist utopia of identity and, simultaneously, the postmodern utopia of alterity. The new is more valuable than the merely different; it lays claim to social significance and aspires to being the truth of its time. The new claims the right to be preserved for the future by the mechanisms of cultural memory. At the same time, however, it lays no claim to absolute significance, truthfulness, and universality; indeed, it does not at all want this universality, since it fears for its own historical originality. The orientation to the new that is the sign under which, in actual practice, contemporary civilization lives, excludes the one, the identical, and the universally valid; but this orientation does not signify arbitrariness, capriciousness, or aimlessness. The new appears only rarely. It is hard to introduce something into historical memory, and nothing guarantees success. The new never emerges passively and automatically from the forgetting of a past culture or from inner devotion to a hidden reality, to what 'has always already been'; but neither does it emerge from the opposite, from amorality, greed, or heightened ambition. Rather, the new results from certain cultural-economic strategies of the revaluation of values that presuppose familiarity with actual cultural mechanisms and the principles of their operation. For newness presupposes that one can guess which difference from tradition, the old, and the pre-existent will be invested with value in each concrete period, giving this difference the chance to accede to cultural memory.

Above all, however, the new allows an individual author to proffer his own life as a value in historical time, freeing himself from the power of the past; universalistic, future-oriented utopias; and the indifferent present with its myriad differences which, basically, mean nothing to anyone. In many respects, contemporary man is a victim of the theory of original difference. He has been poisoned by the suggestion that, in the absence of all effort, he is already unique, different from all other men at a certain extra-cultural, authentic level of life. That is why he constantly feels a certain frustration attendant upon the inevitable realization of his actual, insurmountable cultural banality. The fact is, however, that banality is the normal state of human existence, whereas cultural originality is the product of very special efforts, the meaning and purpose of which are not immediately obvious to those who do not work professionally in the cultural field.

7

The New Is Not an Effect of Original Difference

Structuralist and poststructuralist theories, too, reinforce the conviction that many have of their pre-established individuality. Although these theories do not believe in 'subjectivity', they postulate, as the unconscious or unthought of every conscious strategy, a finite or an infinite system of differences by means of which, they think, such a strategy acquires its individuality to begin with.[1] These theories are, however, just theories; they cannot really prove that the systems and structures they describe do not owe their emergence to this very description, but, rather, precede and make possible all description and investigation. It can only be suspected or postulated that the undescribed or unthought is already structured.

Beyond identity and difference lies the realm of the undifferentiated, indifferent, arbitrary, banal, nondescript, uninteresting,

1 When, therefore, individuality in the sense of subjectivity is not regarded as the source of the other, the text plays this role. It is accordingly not possible for an individual to remain identical, because signs and time produce the unconscious even when the 'subject' wishes to be self-identical: 'Thus one takes into account that the absolute *alterity* of writing might nevertheless affect living speech, from the outside, within its inside: *alter it* [for the worse]. Even as it has an independent history . . . in spite of the inequalities of development, the play of structural correlations, writing marks the history of speech' (Jacques Derrida, *Of Grammatology*, trans. Gayatri Chakravorty Spivak, Baltimore, 1976, p. 314).

negligible, non-identical, and non-different.² The comparison –
that is, identification or differentiation – takes place explicitly in the
cultural archives or does not take place at all.³ The history of culture
is the history of such identifications and differentiations. For that
reason, the new in culture precedes the different and is not a mani-
festation of the different. For that reason, again, the history of
culture cannot be dissolved in the play of differences. That play is

2 This profane realm is already characterized by Plato as follows: 'Are you also puzzled,
Socrates, about cases that might be thought absurd, such as hair or mud or dirt or any other trivial and
undignified objects? Are you doubtful whether or not to assert that each of these has a separate form
distinct from things like those we handle?

Not at all, said Socrates. In these cases, the things are just the things we see; it would surely be too
absurd to suppose that they have a form . . . Then, when I have reached that point, I am driven to
retreat, for fear of tumbling into a bottomless pit of nonsense.

That, replied Parmenides, is because you are still young, Socrates, and philosophy has not yet taken
hold of you so firmly as I believe it will someday. You will not despise any of these objects then' (Plato,
'Parmenides', trans. Francis Macdonald Cornford, in Edith Hamilton and Huntington Cairns, eds., *The
Collected Dialogues of Plato, Including the Letters*, Bollingen Series 71, Princeton, 1961, p. 924).

3 Poststructuralist theory remains consistently ambivalent in defining the archive. On the one
hand, it constantly underscores the materiality of signs. In this sense, signs are not determined, for
poststructuralist theory, by any 'ideal' presence in the individual or collective soul; rather, all signs
constitute, materially, an archive – or, better, *the* archive. Michel Foucault writes: 'The positivity of
a discourse . . . characterizes its unity throughout time, and well beyond individual *oeuvres*, books,
and texts' (Michel Foucault, *The Archaeology of Knowledge and the Discourse on Language*, trans. A. M.
Sheridan Smith, New York, 1972, p. 126). He goes on to say of such discourses that 'all these systems
of statements (whether events or things) . . . I propose to call *archive*. By this term I do not mean the
sum of all the texts that a culture has kept upon its person as documents attesting to its own past, or as
evidence of a continuing identity; nor do I mean the institutions, which, in a given society, make it
possible to record and preserve those discourses that one wishes to remember and keep in
circulation . . . The archive is first the law of what can be said, the system that governs the appearance
of statements as unique events. But the archive is also that which determines that all these things said
do not accumulate endlessly in an amorphous mass . . . nor do they disappear at the mercy of chance
external accidents . . . The archive is that which . . . at the very root of the statement-event, and in
that which embodies it, defines at the outset *the system of its enunciability*' (ibid., pp. 128–9).

Thus the archive is defined, on the other hand, as a system of signs all of which are, albeit
material, inscribed on a hidden support that is not preserved anywhere, is indestructible, and can be
called up at any time. However, such a support can only be conceived or imagined; in no case can it
be materially produced. Thus there arises, in Foucault, a contradiction between the materiality of
signs and the indestructible ideality of their support – or their archive.

In the present book, by contrast, the archive is conceived of as really existing – and, in that sense,
as constantly threatened by destruction. It is therefore finite, exclusive, and limited, with the result
that not all possible utterances can be found formulated in it in advance.

itself the product of one particular historical innovation, one particular new discourse about the identical and the different. It must not be supposed that everything is, from the outset, inherently comparable or has already been compared. What has not been explicitly described and differentiated must be regarded as undifferentiated: an inner, hidden, unconscious, primary process of differentiation that precedes all conscious action is a fiction. It occurred to no artist before Duchamp to compare the *Mona Lisa* with a mutilated reproduction of it;[4] before Derrida, no one compared, at a theoretically pertinent level, masturbation with thinking.[5] Every occurrence of the new is basically the making of a new comparison of something never compared until then, because it never occurred to anyone to draw the comparison. Cultural memory is the remembering of these comparisons, and the new accedes to cultural memory only if it constitutes, in its turn, a new comparison of this kind.

All innovation notwithstanding, the realm of the banal, arbitrary, and indifferent always subsists, for no innovation can accomplish an exhaustive differentiation and classification. That is why the historical shift in fashions does not lead to the sheer infinity of progress without a goal, but, rather, leaves everything exactly where it was. Thus anyone who wishes to work and produce in the cultural realm is basically in the same position as all other cultural producers before and after him. Indeed, an awareness that this is one's point of departure is precisely what the tradition transmits

4 Thierry de Duve argues that Duchamp has, thanks to the technique of such comparisons, given art the name 'art', in contrast to 'painting' or 'sculpture': 'With each aesthetic judgment, it was the name that was in question. The judgement "This is beautiful" had subtly taken on the enunciative form "This is painting" . . . In folding the name back on itself, Duchamp shows us this pictorial nominalism, which does not belong to him alone but rather to the history to which he himself belongs' (Thierry de Duve, *Pictorial Nominalism: On Marcel Duchamp's Passage from Painting to the Readymade*, trans. Dana Polan, Theory and History of Literature 51, Minneapolis, 2005, p. 189).

5 Derrida discusses this comparison in his theory of the supplement, taking Rousseau as his example (Derrida, *Of Grammatology*, pp. 141ff.).

above all else. The new is produced and acknowledged as such, that is, as something simultaneously different and culturally valuable, on the basis of determinate traditional, intra-cultural, cultural-economic criteria. Conformity with these criteria of the revaluation of values, not with the extra-cultural, the hidden, or the other, guarantees the social status of the new — in particular, of a new truth.

8

The New Is Not a Product of Human Freedom

The rejection of an orientation to truth must not be understood 'nihilistically' here, that is to say, as a claim that cultural privileges are attributed to certain discourses or artistic practices in purely arbitrary fashion. The attribution of such privileges is not the expression of a human – let alone superhuman – freedom which, say, determines a value by an act of the will for which there is no rational foundation, and ascribes it to existing cultural attitudes.[1] Every innovation results from a new interpretation, a new contextualization or decontextualization of a cultural attitude or act. The belief in an ineffable decision welling up from the depths of human freedom presupposes, in contrast, that we assume the existence of a hidden reality – even when it is now conceived of as absolutely free nothingness.[2]

With sufficient cultural experience, an individual, whether he is a producer or consumer of the new, can appreciate something new as truly new, interesting, original, significant, and valuable before it

1 A new existential decision with regard to the interpretation of being and the value of individual things is only possible in the form of a new text – as a text by Søren Kierkegaard, Jean-Paul Sartre, or Albert Camus.

2 On the theme of nothingness in modern art, see Eberhard Roters, *Fabrication Nihili, oder die Herstellung von Nichts*, Berlin, 1990, and Karsten Harries, 'Das befreite Nichts', in *Durchblicke: Martin Heidegger zum 80: Geburtstag*, Frankfurt, 1970.

has achieved genuine social success and acquired power and social recognition. On the other hand, the existence of an individual capacity to recognize the new means that the new necessarily contains something that inevitably brings it success in a given culture, whatever the power structures that back or oppose it. Here, we shall try to reconstruct the logic of the cultural economy and the criteria by which a particular cultural activity is, independently of any relation to power or the revelation of a hidden truth, recognized as new, original, and successful. In other words, our objective is to understand why certain new comparisons, identifications, and differentiations are acknowledged by society and integrated into historical memory, constituting, in their turn, the criteria by which truth and power, the different and the identical are defined.

In the context of modernist utopianism, artists and thinkers feel superior to society because they believe that they have, in their inner creative freedom, a special relationship to the truth, one ordinary members of society lack. In reaction to this modernist claim to exclusivity, it has become commonplace in our day to rank the interpretation and reception of philosophy and art, their social utilization and consumption, higher than philosophical or artistic production itself: if in philosophy and art, just as in the world in general, only inevitable individual differences and peculiarities matter, then the meaning and value of these differences and peculiarities can and must be determined by society alone, not by their bearers. The recipient's freedom, understood as the freedom to interpret and consume, takes precedence over creative freedom. In fact, however, every professional artist or theoretician seeks to anticipate the public reaction to her work. The public reception of her cultural practice is thus partly under her control, although that control naturally does not represent the kind of dictatorship over social taste and social life to which many artists and theoreticians of modernity aspired.

In what follows, we look more closely at the cultural-economic logic to which any production of the new as a revaluation of values

is necessarily subject. The material for this discussion of the problem of the new is taken from art and theory, because it is primarily in those two domains that the procedures of identification and differentiation occur in explicit fashion. In the natural sciences or technology, popular opinion has it that innovation is dictated by objective economic or scientific needs. The idea that here, too, newness is produced for newness' sake will seem far-fetched to many. Yet it could of course be shown – indeed, already has been repeatedly shown – that the utilitarian nature of the new in the natural sciences and technology is an illusion, and that technology itself engenders the new needs that it goes on to satisfy in new ways.[3]

3 Thus Paul Feyerabend sets out to show that modern science does not intend to produce a universally binding, 'true' description of the world, but, rather, that it puts different, mutually incompatible programmes to work (Paul Feyerabend, *Against Method*, London, 1975, p. 188).

PART II

STRATEGIES OF INNOVATION

9

The Value Boundary between the Cultural Archive and the Profane Realm

Every culture may be said to be hierarchically structured: everything in it has a value determined by its place in the hierarchy of cultural values. Such a hierarchy is constituted, first and foremost, by what may be called an organized or structured cultural memory. In the culture of our day, it comprises libraries, museums, and other archives. This materialized cultural memory is in the keeping of various institutions that are likewise hierarchically structured; they see to it that it is preserved intact and that new, relevant cultural paradigms are selected for inclusion, but also that cultural paradigms considered outmoded or less relevant are removed. Every cultural tradition has, of course, its own system of memory and conservation, as well as its own principle of selection. Furthermore, no culture is homogeneous in and of itself: each culture consists of various subcultures, each with its own priorities, systems of conservation, and principles of selection. Hence every cultural hierarchy is relative. At the same time, we can observe, today, a gradual universalization and formalization of cultural archives worldwide. Increasingly, a unified system — encompassing museums, libraries, and other institutions for the preservation of cultural information — is detaching itself from concrete national cultures and establishing a common stock of works deemed culturally valuable and worthy of preservation.

We can meaningfully discuss the new only in the context of the archives constructed in conformity with this value hierarchy. The new is conceived of or interpreted as different from, yet as valuable as, that which has already been incorporated into the technically organized cultural memory. The basic principle governing the construction of the cultural archives is that they necessarily integrate the new and ignore the derivative. Organized cultural memory rejects as superfluous and redundant everything that merely reproduces what already exists.

We may call the domain comprising all the things that are not included in the archives the profane realm. The profane realm is extremely heterogeneous, since it is made up of a great variety of things and a great variety of customary ways of utilizing them. Things in the profane realm are not deliberately conserved; unless they are saved from destruction by chance, they eventually disappear. They are not, at any rate, recognized as important, representative, valuable, and worth keeping by the institutions which see to it that cultural values are collected and preserved. The profane realm consists of everything that is valueless, nondescript, uninteresting, extra-cultural, irrelevant and . . . transitory. Yet it is precisely the profane realm which serves as the reservoir for potentially new cultural values, since it is the other with respect to valorized cultural archival materials. The source of the new is, therefore, the valorizing comparison between cultural values and things in the profane realm. This comparison is usually not drawn at all; failure to draw it is, indeed, constitutive of the profane realm. Thus the mechanisms of the new are those governing the relationship between valorized, hierarchically organized cultural memory on the one hand and, on the other, the valueless profane realm.

Here the concepts 'cultural archive' and 'profane realm' refer to each other and are complementary. We can readily imagine different value hierarchies, cultural or of some other kind, in which cultural values would be distributed in a completely different way.

For Europeans, for example, the discovery of America was the opening up and valorization of a profane realm. For the American cultures of the time, this event meant an irruption of the profane into their cultural archives, that is, profanation and partial destruction of them. Innovation is thus often also an exchange [*Handel*] between two or more value hierarchies, each representing a profane realm for the other(s). In order to grasp the nature of this exchange, we shall first discuss the simpler case of innovation within one particular cultural hierarchy.

Every actually constituted cultural hierarchy is of course open to criticism. One can always say that it is completely unjustified and that the distinction between profane things and the cultural values it seeks to preserve is purely arbitrary and lacks all theoretical legitimation. But such a critique would not prove very effective if it remained at that general, vague level, because, in a completely trivial way, it would always be right. In fact, no cultural hierarchy can be theoretically legitimized, if legitimation is taken to mean, as it usually is, reference to the reality underpinning the cultural hierarchy, the thing itself, or meaning – for a reference of that kind leads straight to the cultural hierarchy's other. To be sure, a general critique of existing hierarchies is also incapable of legitimating its own claims to cultural value by invoking a reference of that kind.

To formulate this critique concretely, we would first have to compare concrete profane things with concrete cultural values. For example, we would have to confront Leonardo da Vinci's *Mona Lisa*, as Marcel Duchamp did, with its mutilated reproduction, which is basically a piece of trash, in order to show that it is just a question of two different visual forms, so that we have no fundamental, essential criteria with which to distinguish these forms on the basis of their value, and cannot have any such criteria. Hence we must say that this piece of trash is just as beautiful as the *Mona Lisa*,[1]

1 See Thierry de Duve's interpretation of the utterance 'This is beautiful' (chapter 7, n. 4).

and, consequently, consider every hierarchizing value distinction between the two images to be an ideological fiction designed to justify the domination of certain institutions of cultural power.

The newness of these comparisons resides in the fact that, thanks to them, two things ordinarily assigned different values and so treated as simply incomparable are situated at the same value level. After the comparison, which, from the start, equates the two images, it will of course necessarily appear that they are just different and that there exists no procedure that might justify the superiority, in terms of hierarchy and value, of one over the other. Ultimately, we will prove unsuccessful even in the often gleefully undertaken attempt to show that the mutilated reproduction is in fact more valuable than the *Mona Lisa*, because it represents more 'real life' more authentically.

This comparison will nevertheless not lead to the abolition of the value hierarchy as such; its result will simply be that the trashy reproduction, regarded as a new object, gains access to the system for the preservation of culture. As a result of this comparison, the reproduction is valorized and transformed from a profane object into a cultural value since, owing to the fact that it is a mechanical reproduction and also to the obscene caption and other defacements, it presents itself as the other, but also, thanks to a certain critical interpretation, as similar to existing cultural values. Yet this valorization in no way affects the basic distinction between valorized cultural memory as such and the profane realm as such. In other words, the fact that this successful comparison has been made across the value boundary does not efface that boundary: the fate of all other mutilated reproductions and many other profane things will in no way be altered by it. Relativizing the value boundary in one place and establishing equality between cultural values and profane things in one particular respect cannot abolish the cultural hierarchy as such. It just partially modifies it.

The latent possibility of overcoming hierarchical value boundaries by comparing cultural values with profane things has often led to the 'nihilistic' conclusion that these boundaries are in fact merely illusionary.[2] A distinction must, however, be drawn between the possibility of making such a comparison and actually making it: while it is theoretically conceivable that all valuable cultural objects could be compared with all profane things, that is not feasible in actual finite cultural practice as it takes place in time. The *Mona Lisa* can be compared with a piece of trash and the latter can be integrated into culture as a result. The boundary running between valorized culture and the profane realm could, however, be definitely effaced by this operation only if it could be shown that one had attained, with this comparison, the most extreme profaneness or 'essence' of the profane on the one hand and, on the other, the supreme cultural value or 'essence' of culture. But that cannot be shown, for no appeal to the hidden, comprehensive essence can legitimize such a claim here.

We cannot affirm that there is and can be nothing more profane than a mutilated, defaced reproduction. It is by no means out of the question that, eventually, a still more radically profane object will be found. We do in fact find instances of such a profaner profaneness in more recent periods of art history.[3] Yet we can also not affirm that the devalorization of the *Mona Lisa* is a devalorization of culture in the full range of its possibilities, a devalorization of culture's 'essence': neither the partial equalization of valorized culture and the profane realm nor the partial overcoming of the boundary between them ever signifies the advent of universal

2 In 1923, Nikolai Taraboukine wrote: 'The present-day world confronts the artist with demands that are completely new; it expects him to produce not only "paintings" or "sculptures" for the museum, but objects whose form and addressee justifies them at the social level' (Nikolai Taraboukine, *Le dernier tableau: Du chevalet à la machine*, Paris, 1972, p. 48).

3 See Boris Groys, 'Das leidende Bild', in Peter Weibel and Christian Meyer, eds., *Das Bild nach dem letzten Bild*, Cologne, 1991, pp. 99–104.

equality. Hierarchized structures and value boundaries always subsist; the possibility of innovation therefore subsists as well.

The complete overcoming of cultural value boundaries was once commonly envisaged as a demonstration of the underlying identity of all things; being, nature, reason, spirit, language, and the unconscious are some of the names for this hidden identity that overcomes all value hierarchies. We have already noted that this argument is too general and insubstantial to stand. Equally unsatisfactory is the other, postmodern and poststructuralist strategy which contends that we can, if not overcome, then at least deconstruct all hierarchically constructed oppositions by dissolving them in the infinite play of differences.

Let us, however, return to our example of the piece of trash. Let us imagine that, after the first piece of trash, we had taken a second and a third. They would all perhaps differ in colour, form, and substance. In that sense, no piece of trash can be *the* piece of trash that manifests the 'essence' of trash. On the other hand, the existing differences would quite obviously not be relevant enough to be valorized as new. For the comparison of different pieces of trash would not be new, unlike that between the *Mona Lisa* and a piece of trash. Such a comparison – just like the comparison of different Renaissance paintings – does not violate cultural value boundaries and is thus trivial. In contrast, the comparison between the *Mona Lisa* and its defaced reproduction is, as an innovative gesture, unique. The comparison of another Renaissance picture with its defaced reproduction would, again, be trivial – insofar as it was not conceived of, and explicitly interpreted as, ironic appropriation of Duchamp's gesture.[4] Cultural mechanisms thus distinguish sharply enough between culturally relevant and culturally irrelevant difference. This distinction is here not that between an 'essential' and an

4 For an example of the appropriation of Duchamp's *Fountain*, see Sherrie Levine, *Katalog*, Zurich, 1991.

'apparent' difference, but between a value difference and a simple difference at the same value level, a difference that only further interpretation could invest with value. The postmodern critique of metaphysics, then, changes nothing in the really existing cultural value hierarchy. Nothing guarantees the infinity of differences, just as nothing guarantees the infinity of identity. Our experience of art shows that every new cultural gesture very quickly loses its newness and, all differences of detail notwithstanding, soon becomes monotonous and trivial: a truly infinite movement of difference would be boring and inconsequential.

Many contemporary theories of difference invoke the concept of the text when they affirm that everything is differentiated and that there are no value differences between the cultural and profane realms. The commonly cited example is not the image, but the book, which is compared with every possible profane sign classifiable as writing; every traditional hierarchical formation is supposed to be overcome in the process. The theoreticians of poststructuralism thereby seek to overcome the boundaries of the individual book and dissolve it in an anonymous textuality. This theme appears in Michel Foucault, Roland Barthes, and Jacques Derrida.[5] The book, considered as a unity in the keeping of a library, loses its exclusive,

5 Michel Foucault attempts to abolish the frontiers between the important and the unimportant in a work – and, in the process, to abolish those between what is reproduced in book form and manuscripts, as well as the frontiers of the individual book as such: 'The frontiers of a book are never clear-cut: beyond the title, the first lines, and the last full stop, beyond its internal configuration and its autonomous form, it is caught up in a system of references to other books, other texts, other sentences: it is a node within a network' (Michel Foucault, *The Archaeology of Knowledge and the Discourse on Language*, trans. A. M. Sheridan Smith, New York, 1972, p. 23).

For Derrida, the very concept of the book stakes an illegitimate claim to truth that calls for deconstruction: 'The Model of the Book, the Model Book, doesn't it amount to the absolute adequation of presence and representation, to the *truth* (*homoiosis* or *adequatio*) of the thing and of the thought about the thing, in the sense in which truth first emerges in divine creation before being reflected by finite knowledge?' (Jacques Derrida, *Dissemination*, trans. Barbara Johnson, New York, 2004, p. 33). Furthermore, 'the effacement or sublimation of seminal *différance* is the movement through which the left-overness [*restance*] of the outwork gets internalized and domesticated into the ontotheology of the great Book' (ibid., p. 34).

privileged, valorized place in culture, and the writing in it comes to be involved in the play of differences alongside all other signs. This overcoming of the boundaries of the individual book forgets, however, that every book exists in numerous exemplars containing the same text. The edition of a book thus becomes something super-fluous and – with respect to its identically repeated text – purely profane, and is therefore left out of account in the concepts of textu-ality or writing.[6] The supposedly infinite play of differences or textuality here finds its limit in the technical mass reproduction of books, which is theoretically bracketed out. We shall not discuss this problem at length here, but simply glance at it in order to illus-trate the following point: there is no possible way of completely eliminating the profane, whether by valorizing it as a whole or by devalorizing cultural values as a whole. Something is always left completely outside identity as well as difference – in the profane. This, however, means that there is no overcoming or dissolving all value differences, inasmuch as the value hierarchy refers precisely to that which cannot be compared, given that such comparison would be unusual, indecent, and altogether unthinkable – albeit, at the same time, required by the logic of cultural economy.

Every historically concrete comparison between the valuable and the profane has always been limited in space and time, and it is precisely these comparisons which are deemed valuable and gain admission to the cultural archives. Cultural values are nothing more than archived memories of events in the history of the revaluation of values. The cultural memory [*Gedächtnis*] that stores the remind-ers [*Erinnerung*] of these re-valuating comparisons shows that there have actually not been very many of them and that, of these few events, not all have enjoyed the same success. Of course, it also shows that it is always possible to overcome inequality, hierarchy,

6 Thus the 'Babylonian library' imagined by Borges, which serves many postmodern theories as a model, contains all possible combinations of letters, but, in each case, in a single exemplar.

and differences in value or, to put it another way, to fabricate a utopia. However, only domains limited in space and time are appropriate for such a gesture; they are usually forged by individuals for themselves and cannot be extended to society at large. Every innovation always bears on a sharply limited fragment of culture and a sharply limited fragment of the profane realm. Its fruits must therefore always be extremely limited and individual. The fact that total utopia is unrealizable means, however, that the total anti-utopia capable of excluding every limited innovation is also unrealizable. The personal domain for innovation that has been wrested from existing hierarchies is in fact sufficient for the artist or theoretician, given his finite lifespan. By means of innovation, artists and theoreticians also overcome the value boundary within themselves, between the human being who belongs to the profane realm and the subject of valuable cultural activity. In the process, they produce homogeneity between their own lives and the historicity of culture.

10

Innovation as Revaluation of Values

Comparison across the value boundary can, obviously, be equally well conceived as a devalorization of cultural values or a valorization of the profane. Historically, innovation is often initially understood as a devalorization of values before it gains acceptance as a new cultural value. Thus Duchamp's blasphemous profanation of the *Mona Lisa* was first interpreted as the end of valuable art and the irruption of profane, valueless non-art. Historically, then, the overall cultural-economic strategy of the revaluation of values is not immediately grasped in all its dimensions; rather, different historical periods perceive different facets of it. This throws up the question as to why an innovation ultimately leads less to devalorization of culture than to valorization of the innovation itself.

Devalorization of existing cultural values is one necessary aspect of the innovative gesture – exactly like valorization of the profane. But every individual innovation obeys the economic logic of culture itself. In that sense, every innovation embodies this logic and must meet the corresponding cultural criteria. If an innovation is success-ful – if, that is, it applies this logic consistently – it is admitted into the cultural archives. This means, however, that a place in those archives is not obtained through the power of innovation as such, but, rather, thanks to innovation's capacity to perpetuate the logic of culture. If innovation devalorizes certain cultural values, it does

not detract from them: da Vinci's *Mona Lisa* is, after Duchamp, as greatly admired as it was before. In exactly the same way, this gesture of Duchamp's does not valorize any defaced reproduction of just any classical picture: similar reproductions continue to be valueless. Only a particular work of Duchamp's is valorized and preserved – the reproduction of the *Mona Lisa* which he personally defaced and which is considered a reminder of his innovative gesture. What is archived, then, is only that which was valorized by innovation; it is archived as evidence of this innovation, and only as such does whatever was innovatively valorized have, not just personal value for the artist himself, but also value for cultural memory as a whole. Innovative valorization of the profane is thus by no means arbitrary or a matter of caprice.

Culturally valorized memory as a whole consists of evidence of individual innovations that have an exemplary character – and do not serve only as values to be innovatively devalorized or as objects of criticism. It is true that an innovation is constituted above all by the egalitarian gesture which brings about the equality between valorized culture and the profane realm. Culture, however, invests this gesture itself with value a priori; culture itself calls for it, and it is, for culture, a value as such. Here culture is only seemingly overcome, criticized, and devalorized. In fact, every innovation realizes the cultural-economic programme and helps ensure the expansion, topicality, stability, and effectiveness of both valorized cultural memory and the hierarchically structured institutions that administer this memory and guarantee its proper functioning.

That is why it is pointless to repeat and answer the oft-posed question as to why these comparisons that innovatively devalorize or valorize are made at all – in other words, what the meaning of innovation is. The question about the meaning of innovation is, again, a question about the relationship that this innovation bears to extra-cultural reality; as such, the question already belongs to the

economy of innovation. It is not the meaning of innovation which is relevant to culture, but, rather, its value.

As is well known, a common answer to the question about the meaning of innovation has it that the profane realm maintains constant pressure on privileged culture, thus forcing that culture to incorporate it. If the profane is taken to be reality, that is, culture's real, active other – as it usually is – the implication is that life or the real keep breaking into culture and modifying it. Culture would really prove, in that case, to be a projection of libidinous desire, class interests, or the will to power.

There is, however, no direct connection between the pressure exerted by the profane and the attribution of cultural value. Naturally, culture can be destroyed from without and cultural memory can be obliterated.[1] However, to the extent that the cultural mechanism remains in force, it operates in relative independence of any direct external pressure. A profane phenomenon can be valorized only when it is taken up in cultural memory in accordance with the latter's rules. This of course does not mean that the cultural mechanism works all by itself and that human beings are merely its servitors. The point here is, rather, that the attribution of cultural value and archivization come about only when certain conditions of cultural-economic logic are fulfilled, conditions that are to a considerable degree flexible and heterogeneous in their turn. They are, at any rate, independent of any subjective

1 To be sure, the possibility of total destruction or apocalypse is denied by poststructuralist theory, which takes the endlessness of textuality as its premise. Thus, for Derrida, the end of the end or apocalypse of the apocalypse is always already taking place in textuality – as is also, in this sense, the apocalypse of the Enlightenment, itself regarded as one form of apocalypse: 'There is light, and there are lights, the lights of reason or *logos*, that are not, for all that, some other thing' (Jacques Derrida, 'Of an Apocalyptic Tone Recently Adopted in Philosophy', in Harold Coward and Toby Forshay, eds, *Derrida and Negative Theology*, Albany, 1992, p. 51).

In the concept of endless textuality, however, the inner contradiction between the materiality of signs and the imaginary nature of their endless support continues to make itself felt. We have already noted its presence in the Foucauldian concept of the archive (see Chapter 7, n. 3).

motivations that would make it possible to fulfil them, even if these conditions cannot be described and catalogued from the outside, but depend on the way the cultural value boundary runs at a given moment. Innovation can be catalysed by a noble desire to ensure, out of sheer compassion, that the profane and despised attain the status of cultural values. It can just as well spring from pure careerism and a will to power, or, again, from a combination of idealistic and egoistic motives. For culture as a whole, in any event, all that matters in each individual instance is that the value boundary separating cultural memory from the profane realm was successfully crossed and that an innovation occurred as a result.

11

Innovation and Creativity

Innovation is, to sum up, the revaluation of values, a repositioning of individual things with respect to the value boundaries that separate the valorized cultural archives from the profane realm. In this perspective, innovation appears to differ from the ordinary concept of creativity, which envisages a creative effect of extra-cultural forces as the source of the new. The explanations of human creativity familiar from the past were usually tied in with theories that explained how things in general originated, how the world was created, and how culture made its appearance in the world. Man's creativity was explained on the basis of his implication in the universal process of the origin of the world, a process beyond his influence and control. For this reason, the concept of creativity always presupposes something mysterious, sublime, obscure, irreducible, or heterogeneous that is ostensibly at work deep within man – all very inadequate evocations of a hidden other to explain cultural creativity.

Classical theories of creativity are primarily based on theological doctrines of God's creative power, above all the Judeo-Christian doctrine of the creation of the world out of the void or an original chaos. Many artists of the classical avant-garde in fact set out from this dogma in reflecting on their own creativity. Malevich talks about his creation of the suprematist world out of the void. The

constructivists and Dadaists in Russia, Germany, or France also talk about the void as the origin of their creative work.[1] Even when the void is not conceived as being at the origin of the creation of completely new things, it is often held to be, in an existentialist spirit, the source of the absolute freedom of choice thanks to which the world is repeatedly endowed with new meaning. Precisely the most radical and, in a sense, most consistently atheistic programmes of the European avant-garde happily grant artists the divine privilege of creating things out of the void.

Another common theological model of the creation of the world goes back to Plato and the neo-Platonic tradition in Christian theology. According to this model, God created the world as an external, material realization of eternal, immutable ideas perceptible to him from within. In the classic avant-garde, this model of artistic creation as inner perception and its revelation to the outside world was prevalent, thanks especially to Kandinsky and Mondrian, who borrowed it above all from a theosophical tradition directly traceable to neo-Platonism and Gnosticism.[2]

Artistic creation is sometimes also understood as a spontaneous, unconscious manifestation of life as such. Here the creative act is preceded by neither a certain inner perception nor a certain act of the will: the new appears as the result or effect of a pure, unreflected, unconsciously motivated act. Its origin may be ascribed to nature or desire, the Freudian libido, the powers of language, or the law of inner form. In every case, a privilege is conferred on special states such as dreams, ecstasy, suffering, or joy, which are deemed to be the origin of art.[3] But the universal, total indifference

1 'The god is dead. A world collapsed. I am dynamite. World history divides into two parts. There is a period before me. And a period after me' (Hugo Ball, *Der Künstler und die Krankheit: Ausgewählte Schriften*, Frankfurt, 1984, p. 41).

2 On the significance of theosophy for the emergence of the historical avant-garde, see Maurice Tuchman and Judy Freeman, eds., *Das Geistige in der Kunst*, Stuttgart, 1988.

3 Antonin Artaud writes: 'The truth of life lies in the impulsiveness of matter. The mind of man has been poisoned by concepts . . . But only the Madman is really calm' (Antonin Artaud, 'Manifesto

of a person lost, as it were, in nirvana, a pure seeing or hearing or pure apprehension, can also constitute one of these privileged states where control by the conscious mind has been suspended, making possible the emergence of universal, unconscious powers that create the new via man.[4]

The critique brought to bear in our time has rightly challenged the notion that man can effectively create new things out of the void or some hidden source immediately accessible to him. Thus the

in Clear Language', in Susan Sontag, ed., *Antonin Artaud: Selected Writings*, trans. Helen Weaver, New York, 1976, repr. Los Angeles, 1988, p. 109). It follows that matter, here, is intended not conceptually, but, rather, as *physis* that acts by way of human beings.

Heidegger formulates the question of the origin of art in similar fashion, arguing that the definition of art cannot be conceptually derived (Martin Heidegger, 'The Origin of the Work of Art', trans. Albert Hofstadter, in David Farrell Krell, ed., *Basic Writings from* Being and Time *(1927) to* The Task of Thinking *(1964)*, 2nd ed., London, 1993, p. 144). The work of art opens our eyes to 'the thing's thingly character' (ibid., p. 161). Art is, consequently, originary because it does not depend on the conceptual code: 'Art is truth setting itself to work' (ibid., p. 162). As is well known, Heidegger takes as his example Van Gogh's painting of a pair of worn-out shoes, which, on his reading, alludes to peasant life and shows the work of the earth itself.

In his commentary on Heidegger's text, Jacques Derrida criticizes him for assigning Van Gogh's painting a particular history as well as a particular interpretation that reduces the painting to an illustration. The same picture could be interpreted differently – psychoanalytically, for example. Moreover, the two shoes painted by Van Gogh do not necessarily form a *pair*, a circumstance that invalidates Heidegger's interpretation (Jacques Derrida, *The Truth in Painting*, trans. Geoff Bennington and Ian McLeod, Chicago, 1987, pp. 257).

Fredric Jameson compares Van Gogh's shoes to Andy Warhol's in order to demonstrate that Warhol intended to show, precisely, the artifice, stylization, artificiality, secondariness, and code-bound character of his own shoes. These are all attributes that rule out the 'originality' of the work of art in Heidegger's sense. See Fredric Jameson, *Postmodernism*, Durham, 1991, pp. 6–9.

Striking in this whole polemic is the fact that the only question ever posed in it bears on what a painting represents and the fact that the represented has been interpreted. However, what is decisive about a work of art is the question as to why it represents one particular thing and not another. Yet to answer this question, we have to consider the artist's strategy, not with respect to a reality understood in this or that way, but with respect to the other paintings with which the artist identifies or from which he takes his distance: here, what is represented serves this strategy only as a means.

4 Thus Susan Sontag argues that we should renounce all interpretation of art in favour of pure perception: '*Transparence* is the highest, most liberating value in art – and in criticism – today. Transparence means experiencing the luminousness of the thing in itself, of things being what they are . . . Once upon a time (a time when high art was scarce), it must have been a revolutionary and creative move to interpret works of art. Now it is not . . . In place of a hermeneutics we need an erotics of art' (Susan Sontag, *Against Interpretation and Other Essays*, New York, 1966, pp. 13–14).

different theories of intertextuality have shown that the new is always made out of the old: quotations, references to the tradition, modifications and interpretations of what already exists. From this, however, it has often been concluded that there are no authors and nothing at all new in culture. Since culture is exclusively concerned with modifying what already exists, we need not appeal to anything outside it to explain it; in particular, we need not appeal to man as its creator. Whence the famous 'death of man', which structuralism and poststructuralism have proclaimed time and again.[5]

This reflection does not, however, take sufficient account of the fact that the cultural utilization of things already stored in cultural memory is a process fundamentally different from the use of things from the profane realm in a cultural context. If no sign can make 'essence' manifest and all signs refer only to each other, as Derrida presents the matter, these signs taken together do not for that reason alone constitute a homogeneous field – an infinite play of differences in which the road leading from one sign to another is always practicable. The break between signs and meaning is not the only one there is. Different signs also have different values: they are separated from each other by value boundaries, which often block passage from one to the next. Such a passage has, in many cases, to be constructed, and, to construct it, there is a need for man, who knows the logic of the violation of borders and obeys it.

In any case, we can say about all the above-mentioned theories of creativity that they appeal to certain specific powers – understanding, spirit, life, desire, language, textuality, or différance

5 'One thing is in any case certain: man is neither the oldest nor the most constant problem that has been posed for human knowledge . . . As the archaeology of our thought easily shows, man is an invention of recent date. And one perhaps nearing its end . . . then one can certainly wager that man would be erased, like a face drawn in sand at the edge of the sea' (Michel Foucault, *The Order of Things: An Archaeology of the Human Sciences*, World of Man, trans. Alan Sheridan, New York, 1973, pp. 386–7). For Derrida, man is always already at his end: 'Man, since always, is his proper end, that is, the end of his proper' (Jacques Derrida, 'The Ends of Man', in idem, *Margins of Philosophy*, trans. Alan Bass, Chicago, 1982, p. 134).

— supposed to operate beyond both the culturally valorized and the profane and, therefore, to transcend the boundary between them. In other words, these theories posit a principle that is given independently of all cultural value; as *tertium comparationis*, it makes possible endless comparison between cultural memory and the profane realm. Individual innovation is then conceived of as revelation and manifestation of this principle.

It might be said, for example, that everything in the world is just trash; given this extremely broad definition of things, the *Mona Lisa* and the piece of trash would be equivalent. Similarly, it might be said that culture and the profane alike are only manifestations of being, life, desire, the forces of production, or difference. One consequence of this definition would be to devalorize culture as a 'mere' manifestation of thought or of the unconscious and to valorize the profane as a manifestation of exactly the same sort; the upshot would be equality between the two. The guarantor of this equality would be a particular work of art in which the principle in question finds immediate expression, or a particular theoretical discourse taking this principle as its subject. Thus one can say about Renaissance art, for example, that it discovered nature as such, since Renaissance paintings crossed the border between the sacral realm, traditionally reserved for the portrayal of Bible stories, and the realm in which the events of everyday life take place. Similarly, one can say that surrealism shows the unconscious to be the common basis for traditional art, individual visions and dreams, and primitive art.

Thus the theories of creativity ascribe universal meaning to a particular strategy of comparison that compares the culturally valuable and the profane in a very particular relationship and in narrowly restricted domains of both the cultural and the profane. Since such meaning is attributed to the principle that here serves as *tertium comparationis*, that principle is also regarded as the origin of the innovation, as if Renaissance paintings were, so to speak, produced

by nature itself or the surrealists' paintings were immediate manifestations of the unconscious as such. An absolutely privileged position is thus attributed to direct manifestations of the third, creative principle, which becomes the universal equivalent for the comparison of anything with anything else. The boundaries between the valuable and valueless disappear; they are abolished by the revelation of what had previously been hidden, which transcends value.

The proclamation of a point of comparison independent of 'conventional' value boundaries and hierarchical limits is premised on the claim that the works of art and theoretical discourses in which this principle ostensibly manifests itself annul value hierarchies. It would, however, be easy to show that neither art nor discourse can afford to annul value hierarchies that way. Both contain diverse elements from the valorized cultural tradition and the profane realm alike; these elements are external to one another and stand in a strategic reciprocal relationship. Thus we can find, in a Renaissance painting, traditional motifs and modes of representation as well as evocations of everyday, profane reality. These two levels are not so closely meshed as to be indistinguishable; on the contrary, they can always be discerned. Indeed, it is precisely their autonomy and discernibility that guarantees the tension between them – and guarantees, at the same time, that it can be overcome; this tension constitutes the painting's strategy of innovation. The same holds for a surrealistic picture: it is explicitly based on certain cultural models and, simultaneously, displacements in the way they are used that demonstrate what is commonly known as the work of the unconscious.

All works of art and all theoretical works are internally divided. Preserved in them are two value levels that never completely fuse. Neither theory nor a work of art is, therefore, a creative manifestation of a hidden reality transcending all values. Both art and theory derive their effects, not from an external, value-free

principle, but from the tension between the different value levels that they embrace: the greater the tension, the greater the effect. That is why a particularly powerful aura surrounds precisely those works in which the highest possible cultural aspirations are combined with the most profane, insignificant, valueless things. These are the works that are perceived as radically new and have the best chance of being admitted to the cultural archives. When the aspirations are scaled down or the valorized elements of the profane are too reminiscent of already valorized tradition, the tension subsides – and the work is no longer perceived as truly interesting or new.

From this standpoint, we can discern the function of the old theories of creativity in the overall economy of innovation: they underwrite claims to the highest possible value. In that sense, they are a constitutive part of such claims and thus fully justified. Theories of creativity set the new work, which can look or sound extremely profane, in relation with the loftiest cultural values; only in that way do they generate the tension constitutive of it. The fact that modern art requires explanation has often been decried as a defect; critics repeatedly demand that we just look at art and enjoy an immediate experience of it.[6] However, an immediate experience of that sort remains without effect, since what is visible in the work is usually, in its external profanity, already familiar to the observer. Without the tension between the visible and the commentary, the work does not function at all.

6 The ambivalent problematic associated with the fact that modern art requires explanation is addressed by Arnold Gehlen in particular: 'The meaning that could no longer be unambiguously read off the picture itself established itself *alongside it in the form of commentary*, of writing about art and, as everyone knows, as chatter about art' (Arnold Gehlen, *Zeit-Bilder*, Frankfurt, 1960, p. 54). In Gehlen's view, art should not deny that it requires, in principle, explanation; it should, rather, openly acknowledge the fact: 'We would like to enter a plea for a "conceptual painting" that incorporates into the conception of the picture a thesis about its raison d'être and, in the framework provided by such a thesis, gives itself a theoretically informed account of its means of representation and formal principles' (ibid., p. 162).

A certain explanatory model fulfils the same function in the economy of theory formation. When 'everything' is explained with reference to one basic principle, that principle must be of the highest value. The requisite inner tension comes about when this principle is drawn from the profane realm. Theories that refer, for example, to the market, power, sexuality, or ordinary language derive their appeal from this constellation. New theories are always theories that take their principles from the profane, while simultaneously conferring on them the functions of a universal explanation – a position traditionally occupied by the highest, most valuable principles.

The foregoing also holds for discourses about artistic and theoretical works. In cultural practice, the only interesting, innovative interpretations of a theory or work of art are ultimately those that embrace both the valorized and profane levels. To say about a classical work of art such as the *Mona Lisa* that it is a manifestation of the transition to commodity production and the commercial consumption of art is interesting because this interpretation puts valorized and profane cultural judgements in reciprocal relation. In this sense, it would also be interesting to say that the *Mona Lisa* simply presents one particular combination of lines and splotches of colour, bringing it into relation with abstract art, or that it manifests perverse, decadent desire in a special way, a reading that would establish a relation to surrealism. The number of such interesting interpretations is doubtless quite high, but by no means infinite. All these explanations are already well known, and it is hard to add an interesting new interpretation that would relate the culturally valorized and the profane in the *Mona Lisa* in a new way – just as hard as it is to produce a new work of art. This also means, however, that while one can certainly conceive the 'infinity' of interpretations that people like to talk about in our day in particular, one cannot actually realize it.[7] The system of interpretations is therefore itself

7 'The world [has] become "infinite" for us all over again, inasmuch as we cannot reject the

archived and administered by the system of the corresponding, hierarchically structured social institutions, such as universities or academic presses and libraries.

Thus both levels, culturally valorized and profane, are to be found in the same work of art, inseparably bound up with one another, to be sure, yet not fused in an organic whole. They can be so clearly discerned in the work that they cannot be dissolved in the infinity of differences and interpretations without leaving a remainder. The value dichotomy is not even abolished in the individual work of art or in discourse. On the contrary, it is precisely this dichotomy which constitutes the inner tension of innovation. In time, this tension diminishes, the innovation is archived and valorized, and value boundaries shift. Eventually, the next innovation comes due.

possibility that *it may include infinite* interpretations. Once more we are seized by a great shudder' (Friedrich Nietzsche, *The Gay Science*, trans. Walter Kaufmann, New York, 1974, vol. 5, p. 336, no. 374).

12

Marcel Duchamp's 'Ready-Mades'

To conceive of innovation as a shift in the boundary separating the valorized, archived cultural tradition from the realm of profane things naturally brings to mind, above all else, the aesthetic of the ready-made and, in particular, the works of Marcel Duchamp. This indication should not, however, be taken to mean that we here intend to analyse or generalize Duchamp's method for producing the new as merely one specific method that might be practised alongside others, even if that is a tempting idea, since Duchamp and his heirs were very concrete artists with individual programmes and problems. Even less is this indication to be understood as a claim that the aesthetics and methodology of the ready-made are superior to all others. On the contrary, everything we have said so far should make it clear, above all, that the strategy of innovation practised by Duchamp is universal and informs every innovative act, independently of the way Duchamp himself applied it to attain his specific artistic goals.

While Duchamp's artistic practice has been well known for quite some time and may be said to have served, especially in the past few decades, as one of the main reference points for contemporary art or, at least, contemporary Western art, its theoretical implications have yet to be fully drawn. The technique of the ready-made is still understood as one particular artistic technique among many others,

as if these other artistic practises utilized other innovative procedures. However, the use of ready-mades, that is, of certain familiar objects from daily life, was for Duchamp simply a way of pointing up the nature of a procedure that had always been applied everywhere – in the production of the new not only in art, but in culture generally. Duchamp chose to make no changes in the physical appearance of the profane object he used, because he wanted to show that that object's cultural valorization was a process distinct from its artistic transformation. For when a culturally valorized object can be physically distinguished from ordinary everyday things, there arises a psychologically altogether understandable temptation to pass this physical difference off as the reason for the difference in value between the 'artistic object' and those everyday things. When, however, one refrains from physically transforming the object, the question of the principle behind the revaluation of values is posed in suitably radical form.

Nietzsche was the first to posit the revaluation of values as the principle informing cultural innovation. The power of his thought consists not least in the fact that he set out to justify no new philosophical principles with his critique of the philosophical tradition, but, rather, sought philosophically to valorize a particular, already existing extra-philosophical life praxis. In that sense, Nietzsche's thought and Duchamp's art both exemplify the breakthrough that made possible an understanding of cultural innovation; Duchamp was the more self-consistent of the two to the extent that Nietzsche continued to postulate life, the Dionysian, or the will to power as a hidden reality that manifests itself as such through its own creativity. Hence Nietzsche conceived of his own critical project as the revaluation, not of certain culturally archived values, but of all values – that is, as a unique historical event rather than as the economic logic of a recurrent process of innovation.

For Duchamp, in contrast, there is nothing outside the valorized context of art or profane reality that could be made manifest

or 'realized'. Rather, there is only the possibility of re-valuating already existing things: Duchamp calls himself a 'man without an unconscious'.[1] If we take him seriously, we cannot refer to any hidden unconscious forces or principles in interpreting his art. On the contrary, we have to ask ourselves what taking his conception of innovation seriously means for interpretative discourse itself. An interpretation that sets out from this conception will no longer be a reading of Duchamp, but an interpretation of all other art in the light of his discovery. It will, moreover, be an interpretation of interpretative theoretical discourses from the standpoint of this discovery.

In other words, this interpretation will seek, in every innovative work of art and innovative theoretical discourse, the answer to the question as to what kind of cultural-economic logic brought forth these cultural phenomena, what profane things were revalorized in each case, how the comparison was made, and how it redrew the boundary between valorized culture and the profane realm. Duchamp's own artistic production can of course be similarly analysed, since its results, too, are finite and concrete.

Duchamp once said that he wanted to teach artists to think. It is time for non-artists, too, to learn to think with his help.

The advantage of the ready-made consists in the fact that both value levels are clearly displayed in every individual work. If a particular object is taken from the profane realm and unambiguously identified as such, but then placed in the context of valorized culture, all illusions about an organic synthesis of the valorized and the profane are ruled out. Likewise ruled out is a reference to some other, third principle that might encompass both and manifest itself in the work in an unmediated way. Both of the ready-made's conceptual levels are suggested in equal measure by the valorized

1 See Hans Richter's film *Dreams That Money Can Buy* (1946–7), in which, among other things, Duchamp's 'rotoreliefs' are shown.

and the profane, but these levels by no means fuse, are not sublated, and do not form a unity. Their irreconcilability continues to determine the way the work is received.

The technique of the ready-made came in for frequent comment in twentieth-century criticism. A systematic overview of these commentaries is, however, neither possible nor desirable in the framework of the present book. In order to better grasp the process of innovation, it suffices to single out certain aspects of these interpretations.

The ready-made is usually interpreted as a sign of the total freedom of the artist, who is supposedly free to put anything he cares to in an artistic context and thus valorize it. The work of art ceases to distinguish itself materially or qualitatively from any other thing. None of the traditional criteria of performance, beauty, or expressivity now apply. Whether something is classified as art or non-art is the result, in the final analysis, of a decision freely taken by the artist or certain social institutions concerned with art, such as museums, private galleries, art criticism, or academic art history.

It is above all in studies by Arthur Danto (*The Transfiguration of the Commonplace*) and George Dickie (*Art and the Aesthetic: An Institutional Analysis*) that the ready-made is discussed from the standpoint of the distinction between art and non-art. The discussion bears mainly on the question as to whether everyday objects can, without undergoing any change in form, be considered art. Both Danto and Dickie think they can. For Danto, art is distinguished from non-art by authorial intention and the attendant possibility of interpreting that intention. Because an artist calls a particular object a work of art and handles it accordingly, it acquires a new dimension – it becomes the manifestation of an artistic idea, individual intention, and personal style. Art here continues to be conceived of as a sign of authorial intention, as that which reveals the hidden and manifests inwardness, and the whole line of argument aims to show that the art of the ready-made also meets such

requirements.[2] For Dickie, too, works of art are manifestations or signs of concealed intentions — no longer, however, individual or authorial intentions, but, rather, social and institutional ones.[3]

Now the question 'What is art?' and the question of the relationship between the valuable and the profane are not identical. Nothing is easier than to produce art that can unambiguously be identified as such; indeed, such art is constantly being produced. It is, however, not deemed valuable and worthy of admission to the museum if it is not original or innovative. Instead, it is treated as kitsch. In contrast,

2 Arthur Danto defines the work of art as the expression of an authorial intention, that is, of subjectivity, significance, and meaning; he thereby forges an expressivist theory of the ready-made. He writes, for example, that 'to see [a work of art] as an artwork . . . is like going from the realm of mere things to a realm of meaning' (Arthur Danto, *The Transfiguration of the Commonplace: A Philosophy of Art*, Cambridge, MA, 1981, p. 124). Here the author's original intention is defined as style: 'Style is the man himself. It is the way he is made, as it were, without the benefit of having acquired something else' (ibid., p. 201). Danto compares aesthetic to ethical style: 'To be kind is to be creative, to be able in novel situations to do what everyone will recognize as a kind thing' (ibid., p. 202).

3 For George Dickie's 'institutional analysis', the distinction between what is and is not art is made by the 'artworld', defined as a system of institutions such as galleries, museums, art journals, and so on: 'The institutional theory of art may sound like saying, "A work of art is an object of which someone has said, I christen this object a work of art"' (George Dickie, *Art and Aesthetics: An Institutional Analysis*, Ithaca, 1974, p. 49). 'In itself', a work of art is indistinguishable from an ordinary thing. Hence Dickie rejects attempts to justify works of art through reference to their authors' intentions, to which they supposedly give expression, as they were once supposed to give expression to the outside world: 'From the point of view of the institutional theory, both the imitation theory and the expression theory are mistaken as theories of art' (ibid., p. 51).

However, the problem is displaced onto the definition of the artworld, which immediately loses its institutional boundaries in order to integrate the individual, institutionally independent artist: 'In fact, many works of art are still seen only by one person – the one who creates them – but they are still art. The status in question may be acquired by a single person's acting on behalf of the artworld and treating an artifact as a candidate for appreciation' (ibid., p. 38). The absence of clear boundaries characteristic of the artworld is then explained away as its 'Byzantine complexity' and 'frivolity': 'The artworld does not require rigid procedures; it admits and even encourages frivolity and caprice without losing its serious purpose' (ibid., p. 49).

The work of art is therefore still an 'expression' of the free will and understanding, and even of frivolity. The basic intention of the institutional theory is acceptable: for that theory, a work of art has above all to be set in relation to already existing art if it is to count as a work of art at all. However, the operation of placing-a-work-in-the-tradition cannot be arbitrary or external to its form, structure, and self-interpretation. It is the work of art 'in itself' which has to be brought into relation with the tradition; only after that can the success of this operation be institutionally evaluated and guaranteed.

the art of Duchamp or Andy Warhol, the two artists Danto mainly has in mind, is valuable precisely because it cannot effortlessly be recognized as art. When Danto and Dickie want to prove that this art, too, is art like any other, they ignore the problematic nature that confers value on it: they treat it as something banal and make its success unintelligible. If art becomes art thanks only to the artist's intention or its institutional valorization, it becomes impossible to understand why artists constantly seek to call that intention and valorization into question, why they do not just content themselves with doing business as usual. For innovation is imposed by cultural-economic logic, which incessantly devalorizes art that looks like art. Thus to prove that the art of the ready-made is also art is not to do it any favours.

Only the inner tension between, on the one hand, the profane nature of a certain object, disposition, attitude, or fate, and, on the other, the attendant artistic or theoretical claim invests an innovation with a value that distinguishes it from the profane realm, and also from the mass of non-innovative, trivial art that complies with the prevailing definition of art. Only art that eludes all unambiguous classification as art or non-art is admitted to the archive – art that neither meets the traditional criteria for art nor unambiguously belongs to the profane realm, while incorporating traits of both and taking their interrelationship as a theme. A work of art or a theory which makes that relationship a theme obeys, in doing so, the cultural-economic logic of the revaluation of values. Only by coming forward as historical agents of this logic do its authors prove worthy of the archive. Their other personal intentions, concerns, feelings, or strategies are irrelevant in this regard, although they can certainly add to the charm their works have for prospective consumers.

As has been noted, the transgression of value boundaries in this process is always provisional, although Duchamp's innovative gesture has been interpreted by many as the definitive revaluation

of values. Tellingly, this interpretation of the ready-made has repeatedly, over the years, grounded alternating positive and negative appreciations. Initially, Duchamp's contemporaries thought that his ready-mades heralded the 'end of art'. They took the act of assigning one or another profane thing the same value as valorized works of art to be, above all, a way of declaring not only all the art of the past, but also all the artistic practice of the present, to be useless and without value.[4] Accordingly, the acceptance or rejection of Duchamp's ready-mades indicated the extent to which the author judging them was prepared to make a revolutionary break with art as such, accept the radical abolition of all hierarchical and value distinctions, and come to terms with the profane realm's total absorption of art.

In time, however, as Duchamp's ready-mades and the aesthetic of the ready-made in general began to assume a place of honour in art history, interpretations of them put the accent less on the devalorization of art than on the valorization of the profane; increasingly, therefore, a pessimistic tone gave way to a distinctly optimistic one. The ready-made now seemed to offer the possibility of raising the profane realm as a whole to the level of valuable art, a procedure similar to the one nineteenth-century naturalism had also mobilized, albeit in aesthetically much more radical and technically much simpler form. For the American pop art of a later day, for example, the technique of the ready-made by no means attested the end of art as such, but bore witness to the end of Old World hegemony over art and the dawn of a new period under the lead of American art, which was introducing testimonials from the contemporary visual world into the artistic tradition. Thus the ready-made was now becoming a positive sign of the artist's total freedom to determine what was valuable and what was valueless, a freedom supposed to

4 Such an assessment may be found in, for example, Hans Richter, *Dada-Kunst und Antikunst*, Cologne, 1964, pp. 212ff.

symbolize the liberal-democratic subordination of all value hierarchies to a single individual's will to decide.[5]

It gradually appeared, however, that by no means all ready-mades could really take their place in an artistic context. Since by this time artists had already been declared free, and objective criteria of quality, value, hierarchy, and so on had supposedly been abolished, the natural conclusion was that art dealers', museum curators', and art collectors' intrigues decisively shaped the choice of ready-mades: these people, the argument ran, deliberately limited the number of objects in order to send their prices skyrocketing. Duchamp himself had already said, without adducing specific arguments, that he wanted to limit the number of ready-mades. People now took his statement as a sign of careful commercial calculation. If all things are basically equal, then their de facto inequality could only be the result of profane manipulations. In time, therefore, artists began either consciously to deploy what they believed to be the right commercial strategy or to interpret the ready-made, not as the end of art, but as a permanent critique of the social mechanisms of valorization. In contemporary art, these two approaches are usually combined, so that the critique of the commercialization of art coincides with a search for the optimal commercial strategy.

In this line of interpretation, freedom, as the universal basis for comparison, guarantees the status of the ready-made. Freedom is here taken to be either the individual's existential freedom or the freedom to make social and political decisions; so conceived, it can be restricted only from without. Yet the aesthetic of the ready-made has long since ceased to appear original or innovative. Duchamp not only opened up a new possibility for artistic creation; he simultaneously eliminated it, inasmuch as the art in which his conception

5 Characteristic in this regard is the ambivalent description of Andy Warhol's strategy as a displacement of the methods of commercial art onto high art in Benjamin Buchloh, 'The Andy Warhol Line', in Gary Garrels, ed., *The Work of Andy Warhol*, Dia Art Foundation Discussions in Contemporary Culture, no. 3, Seattle, 1989, pp. 52ff.

was realized necessarily appeared conventional, trivial, and uninteresting. To hold open, despite all, the path down which Duchamp had struck, people generally shifted the discussion from the plane of cultural-economic innovation to that of personal contents.[6]

Contemporary criticism seeks out, above all else, the hidden, unconscious, libidinal factors that are said to have dictated Duchamp's choice of ready-mades. It is true that we can easily interpret his choice of a urinal for *Fountain,* and other of his ready-mades as well, both in a psychoanalytic context, broadly understood, and also, with an eye to his close ties to the surrealists, in the context of their common interest in the objet trouvé.[7] When we do, it appears that the choice of ready-mades was by no means free, but was, rather, dictated by the mechanisms of desire and fetishistic fixations, so that transgression of the value boundary between valorized art and the profane realm here becomes no more than a secondary effect of the secret labour of desire, not a strategic goal defined from the very outset. This displacement of the basis for comparison from the plane of conscious strategy to that of the unconscious and desire also apparently explains why it has proven possible to continue producing ready-mades after Duchamp.

If we assume that every ready-made simply represents the profane realm as such, then there can indeed be only one ready-made: any thing at all can, in the context of art, represent the whole profane realm. A single ready-made, such as Duchamp's *Fountain,* would suffice to prove that value hierarchies have been abolished, and would mark, as one likes, the end of art or the end of the profane. It

6 Thus Thierry de Duve, following the Freudian tradition, seeks to read works of art as sacral texts. Hence he interprets Duchamp's work, in line with Lacanian theory, as 'the rhetoric of subjection to the signifier . . . where the practice of the subject-artist is reformulated in a similar way' (Thierry de Duve, *Pictorial Nominalism: On Marcel Duchamp's Passage from Painting to the Readymade,* trans. Dana Polan, Theory and History of Literature 51, Minneapolis, 2005, p. 161).

7 For a reading of Duchamp in the context of the surrealist theory of the unconscious, see Rosalind E. Krauss, *The Originality of the Avant-Garde and Other Modernist Myths,* Cambridge, MA, 1988, pp. 196–209.

is a different story if ready-mades manifest artists' hidden desires, their unconscious rituals and fetishistic fixations. In that case, the profane realm, ceasing to be homogeneous, becomes the unconscious's field of articulation. It is no accident that Duchamp's ready-mades failed to spark a broad artistic movement for a long time, although a rather large audience was already familiar with them. It was not clear how, if at all, Duchamp's method could be pursued. The diverse theories of the unconscious and, especially, structuralism and then poststructuralism finally pointed the way.

For structuralism, all the things in the world appear as signs of certain hidden systems, patterns of meaning, structures, myths, rituals, and languages. The profane realm consequently loses its neutrality and, simultaneously, the sharp border marking it off from valorized cultural memory is blurred. Robert Filliou once noted that Duchamp's *Fountain* could very well have had a determinate cultural meaning in a different culture.[8] On this interpretation, the ready-made allows artists to create their own myths by way of the mechanisms of the unconscious or to expose hidden social myths: in the ready-made, the unconscious, not freedom, serves as the *tertium comparationis* guaranteeing its unity. Thus, for example, Joseph Beuys, Mario Merz, Robert Filliou, Marcel Broodthaers, Christian Boltanski, Jannis Kounellis, or Rebecca Horn forge, with diverse variants of the aesthetic of the ready-made, their own semi-mythological spaces, in which diverse profane things take on symbolic, magical, or erotic meanings. Hans Haacke uses the same aesthetic as social critique. As for Andy Warhol's works, those of the Russian soz-art artists, and Jeff Koons's ready-mades, they can all be understood as variants of social criticism and, at the same time, the creation of a personal myth, since personal myth is here made of the stuff of social myth.

8 See the catalogue of an exhibition in the Ludwig Museum in Cologne: *Übrigens sterben immer die Anderen: Marcel Duchamp und die Avantgarde seit 1950*, Cologne, 1988, p. 284.

In this form, Duchamp's aesthetic of the ready-made – considerably modified, of course – became, for all practical purposes, the determinant aesthetic of our time, since it offered art the possibility of once again becoming powerfully expressive, individual, and rich in content. Duchamp himself wanted to reduce all levels of expressivity and to introduce into the valorized cultural context an object that, situated as it was outside the artistic tradition, did not belong to the complex system of cultural associations, meanings, and references. This strategy typified the classic avant-garde in general, which preferred to make use of non-traditional, profane objects in order to demonstrate the artist's unlimited freedom to endow them with a new meaning that he himself had devised in the here and now. However, because structuralism, psychoanalysis, Wittgenstein's theory of language and other, comparable theories operating with the concept of the unconscious in one way or another have convincingly shown that there exist no neutral, purely profane things and that everything has meaning, even if it is not apparent to a superficial gaze, the original avant-garde's orientation toward a pure, meaningless thing uncontaminated by culture would no longer seem to be possible in our day and age.[9]

The upshot is that the conception of art that has appropriated these theories is today basically back in the same situation in which it found itself before the avant-garde. Art is once again understood and described in terms of artistic individuality and expressive power, the significance of the ideas it expresses, the richness of the individual world it creates, and the uniqueness and depth of the individual artistic experience that finds expression in it. In this perspective, the technique of the ready-made turns out to be a new version of the international art salon, reminiscent of the late nineteenth-century French salon; that is, it turns out to be a summa of

9 Roland Barthes, *Mythologies*, trans. Annette Lavers, New York, 1972, offers one of the earliest semiotic descriptions of everyday life.

certain professional modes of expression that do not fundamentally differ from the expressive modes of traditional painting or sculpture. Today it is a question, as it was yesterday as well, of expressive power and richness of content. The sole difference is that these goals are now attained by way of a particular strategy for selecting objects from the profane world, not by their representation on canvas or in stone.[10]

On the other hand, now that the idea that the whole world is made up of signs has become a generally admitted ideologeme, it can of course no longer be seriously argued that artistic strategies are, today as well, dictated by the unconscious alone. The surrealists had already made the unconscious the explicit subject of their quite conscious artistic practice. When an artist today thinks about the objects with which she wishes to work, she begins by looking around in order to survey what has already been done and what her contemporaries are doing, and then seeks out her own domain of sign-objects and her own working method. Asked why she works with these particular objects and not others – why she uses car wrecks rather than smashed dishes, for example – a contemporary artist usually answers that she is 'interested in' these objects. This explanation may be interpreted however one likes, but what it actually means is that the artist has chosen one particular domain of objects for herself because other artists are not yet working with it. The principle of newness, then, continues to operate here as well, since something is chosen that has not yet acquired artistic status.

10 The following sentence, for example, shows how the ready-made aesthetic can be 'metaphysically' misinterpreted: 'That observation served as our guiding thread in choosing the works for this exhibition; it shows how Beuys, with his categorical rejection of all instrumental reason bent exclusively on exploiting nature, sought to grasp nature under the sign of *poiesis* – *poiesis* understood as production and advent of truth, not as pure making' (Armin Zweite, preface to the catalogue for the exhibition 'Joseph Beuys: Nature. Matter. Form', in *Kunstsammlung Düsseldorf*, Düsseldorf, 1992). As if artistic production as such were not aesthetic exploitation of nature, as if it were not instrumental reason, as if one could detach art from the history of reason, as if art as *technè* were technique's other.

This newness, however, is not the radical avant-garde newness of an earlier day, since it is a question of the supplementary valorization of a certain object that is part of an already culturally codified realm – not of the discovery of new profane things outside cultural tradition. In the same way, many artists of the past took an interest in horses and cows, others in cityscapes, and still others in still lifes with venison.

Yet it would surely be unfair to reduce contemporary art's innovative power to such trivialities. By using already familiar objects, and, moreover, applying a procedure no longer considered provocative, art today diverts the observer's attention from these objects in order to direct it toward the context in which they appear. New art after Duchamp is concerned with the previously neglected social, political, semiotic, or mass-media context of art. An artist's choice of object is, accordingly, not dictated by personal preference, but is subject to cultural-economic logic: this choice is supposed to draw attention to contexts, which previously as well, of course, were spotted or suspected behind pictures or in their shadows, but not judged valuable or worthy of artistic representation.

For example, appropriationists such as Mike Bidlo or Sherrie Levine use reproductions of familiar works of art in their artistic practice, valorizing them as ready-mades. These reproductions are neither mutilated nor defaced. Earlier, they were not regarded as different from the original and, therefore, were also not felt to be valuable. Only after Walter Benjamin formulated his theory of reproducibility did this difference come into view.[11] Today, we are

11 Thus Arnold Gehlen, in line with André Malraux's conception of the 'musée imaginaire' or 'musée de la reproduction', regards the reproduction of art, precisely, as the 'abstraction of something "purely artistic"', liberated from all authorial intention and all aura. 'In light of this abstraction', Gehlen writes, 'the individual work of art is no longer capable of saying anything at all; it has the terrifying charm of form emptied of its content, and one can use it to no other end than to infect oneself with an unknown virus, the way the expressionists used masks from the Congo' (Arnold Gehlen, *Zeit-Bilder*, Frankfurt, 1960, p. 48). With that, reproduction once again becomes artistically active and productive.

capable of reflecting on the difference in value between original and copy, even if the artist does not damage the work in any way. That has led to the possibility of recognizing the valueless copy as a culturally autonomous phenomenon. Here we may, moreover, quite rightly speak of the original discovery of a new profane realm that is still more profane than Duchamp's mutilated reproduction of the *Mona Lisa*, since classic 'first-generation' ready-mades still bore a relation to the artist's direct, active intervention in a way those of subsequent 'appropriationist' generations no longer do. In appropriationist work, the effect involuntarily produced by reproduction is reinterpreted as a going beyond the original, hence as a new artistic value. A direct, formative intervention by the artist is replaced by the corresponding interpretation.

This interpretation is premised on the theories of the sign and the unconscious. These theories invest mere things with the dignity and value of the sign – while also making an explicit theme of the materiality or thing-like nature of traditional signs. In so doing, they utilize the same innovative procedure as modernist art: the thing becomes an unconscious sign and the sign becomes an unconscious thing.[12] Artistic practice and theoretical discourse are thus shaped by exactly the same strategies of innovation, that is, by strategies of valorization of the profane and devalorization of tradition. Art, accordingly, cannot appeal for its ground and legitimization to a theoretical discourse that supposedly describes hidden reality: that would be simply to repeat a strategy of innovation that is an artistic strategy as well. For the same reason, theoretical discourse cannot base itself on one or another artistic practice as if that

12 Thus Roland Barthes writes: 'At whatever level we occupy, in this operation of reading the object, we discover that meaning always traverses humanity and the object through and through. Are there objects outside meaning, *i.e.*, limit cases? I do not think so. A non-signifying object, once it is assumed by a society – and I do not see how it could not be – functions at least as the sign of the insignificant, it signifies itself as non-signifying' (Roland Barthes, *The Semiotic Challenge*, Berkeley, trans. Richard Howard, 1984, pp. 188–9). The interpretation of all objects as signs is, let us add, a consequence of the semiotic emphasis on the materiality of all signifiers.

practice were something objective. This, however, also means that innovation cannot be explained as the effect of certain hidden principles or forces: the description or revelation of these forces is always itself an occurrence of a similar strategy of innovation, and thus an instantiation of one and the same cultural-economic logic.

13

Negative Adaptation

To understand better the strategy of innovation, we have to pay particular attention, in the framework of the aesthetic of the ready-made, to the way an object is actually transferred from the profane context to the valorized context of art. It is often supposed that the profane object is simply transferred from one institution to another – that Duchamp's urinal, for instance, was simply brought from the marketplace to the art exhibit. The conclusion that then forces itself on us is that the work of art as such is not the locus of innovation, which is, rather, constituted by various external factors merely manifested in the work. The revaluation of values is accomplished, however, only by an interpretation immanent to the work as such. Such interpretation stands in a necessary relation to its object and is thus an integral component of the innovative work; it is, so to speak, visually integrated into the artistic object itself. Here we should note, for instance, that Duchamp turned the urinal he had acquired upside down before it became *Fountain*. He thereby set his object in opposition not only to the valorized artistic tradition, with its historically developed stylistics of fountains, but also to urinals considered as objects of daily use.

But turning a urinal upside down does not only signify that it has been stripped of its function and thus transformed into an object of contemplation; the new form that results also calls up a series of

purely cultural associations. Thus many of Duchamp's contemporaries detected, in the form of his *Fountain*, the outlines of the iconic Madonna or the image of the seated Buddha that is widespread in the East and was then very popular in the West as well.[1] Specifically, the image of Buddha was used to denote perfect indifference to all values – a form of contemplation that ceases to distinguish between the important and the unimportant. Insofar as Duchamp's *Fountain* evokes the image of the seated Buddha, it also solicits interpretation as a sign of the revaluation of all values. Hence we may say that *Fountain* contains, at the visual level as well, elements that put it in a certain valorized cultural series. Among them are all the erotic associations this object calls up; they refer us less to the unconscious than to the discourse about the unconscious that had already been sufficiently valorized by Duchamp's day, and also to the surrealists' artistic practice. Similar cultural references may be discerned in other of Duchamp's works.

As we showed above, a work by Duchamp always includes references at two levels. One points to the valorized cultural tradition; the other points to the profane, valueless realm that is associated with 'the real itself'. Thus the reference to the established high tradition in the defaced reproduction of the *Mona Lisa* is confronted with facetious defacements and obscene captions reminiscent of the graffiti seen in big cities. *Fountain* stages a similar confrontation still more subtly, associating, in a single work, the high tradition of contemplative, all-embracing indifference with modernity's anonymous industrial mass production. The presence of both these levels in one and the same work of art generates a tension that constitutes the work's value.

Fountain continues the tradition in two different ways. To begin with, Duchamp chose, from the wealth of available everyday things, a urinal, an object that makes the most radical possible

1 See William A. Camfield, *Marcel Duchamp: Fountain*, Houston, 1989, pp. 29ff.

break with the high cultural tradition. At the time, people still wanted, as a rule, to counter aesthetically the cold functionalism of industrial production by going back to the artistic tradition of craftsmanship. The avant-garde, in contrast, proclaimed this cold functionalism to be a new aesthetic.[2] As a socially repressed object, a urinal was not, on the face of it, produced to be aesthetically admired. Thus it was, at the formal level, the most consistent possible representation of the new functional aesthetic. In Duchamp's day, a urinal accordingly offered, aesthetically speaking, even better than an automobile or airplane could, a clearly defined alternative to received criteria of value.

For Duchamp, the choice of a urinal was therefore neither free nor arbitrary nor dictated by his unconscious, but, rather, strategically necessary. It presupposed the existence of a museum in which different, contrasting aesthetic styles from various periods were preserved and historically compared. This inevitably spawned the task of defining the present, in its turn, as one particular style among those compared in the museum, so as to secure a permanent place in it for this present in general and for oneself as its representative. One's own, living present accordingly comes to be regarded, in this quasi-archaeological or museum-defined perspective, as already dead, exotic, and foreign – as, precisely, a ready-made.[3] Choice based on the principle of aesthetic contrast, foreignness, exoticism, or difference is, consequently, a specific form of adaptation to the tradition established by the museum – a choice which, however, perpetuates tradition not positively, but negatively or contrastively. Negative adaptation to the tradition, moreover, obeys perhaps even

2 See, for example, Nikolai Taraboukine, *Le dernier tableau*.

3 Duchamp took much of his inspiration from Raymond Roussel's novels, which contain, among other things, descriptions of the exotic use of everyday objects in mysterious rituals: 'It was basically Roussel who was responsible for my Verre "La Mariée mise à nu par ses célibataires, même". It was his *Impressions of Africa* that indicated, broadly, how I should proceed' (Marcel Duchamp, *Du champ du signe: Ecrits*, Paris, 1975, p. 173).

stricter rules than positive adaptation does, because, in negative adaptation, the only profane objects that can be chosen are the ones that stand in the most radical contrast to traditional precedents, which is to say the ones that the artist makes the most valueless and profane. Only such negatively normative, negatively adapted, or negatively classic works of art can serve as signifiers of the present, can denote the presentness of the present. The sign of the present is thus not a 'true' or an 'authentic' or a 'spontaneous' manifestation of presentness or the reality or the real, but a work produced in accordance with certain rules of negative normativity.

At the same time, tradition is positively prolonged in *Fountain*. By means of a system of cultural references – whether to Buddhist iconography or erotic, 'taboo', and, consequently, sacralized connotations – Duchamp's ready-made lays claim to a positive relationship to the high cultural tradition.[4] Only with this claim does the contrast of aesthetic values itself acquire its full intensity: an object of daily life that could stake no such claim stands no chance of being included in a comparison with traditional artworks with a view to bringing out an aesthetic contrast. Innovation accordingly means a strategy that links a positive to a negative continuation of the tradition in such a way as to formulate both the continuity and also the break with the greatest possible clarity and intensity.

The work of art thus becomes, for a moment, a locus in which hierarchical differences disappear, traditional value oppositions lose their validity, and the power of time – in the guise of a contrast between the valuable past and valueless present and future – is overcome. This gives rise to the experience of being outside time,

4 The surrealists repeatedly took the equation of the sacred with the violation of taboos (including all social taboos) as an object of their theory and practice. See especially Roger Caillois, *Man and the Sacred*, trans. Meyer Barash, Champagne, 2001, as well as Georges Bataille, *Literature and Evil*, trans. Alistair Hamilton, London, 2001. For a critical analysis, see Jean-Michel Heimonet, *Politiques de l'écriture Bataille/Derrida: Le sens du sacré dans la pensée française du surréalisme à nos jours*, Paris, 1990.

of ecstatic delight over a realized utopia, of freedom and magic omnipotence, which accompanies the successful, that is, radically innovative cultural act. At the same time, however, the ready-made shows that the utopia in question is a very narrowly restricted one and that the work of art is no philosopher's stone thanks to which the urinal could really be changed into gold, as many utopian dreamers imagined. The profane is not wholly overcome as a result of its integration into the valorized tradition: at any moment, the urinal can be turned right-side up again, removed from the art exhibit, and used as it was originally meant to be. The real, indestructible synthesis of the valorized and the profane does not come about; the principle of comparison does not manifest itself in the artist's 'creativity', and there exists, consequently, no universal guarantee of equality. Furthermore, the aesthetic of the ready-made explicitly presupposes the existence of an institutionalized, socially secured system for preserving things, in order to ensure at least relative historical stability for innovation, which is finite by nature. For there is no obtaining this guarantee by any appeal to the transcendent, immortal, or universal.

This does not only apply to the aesthetic of the ready-made in its pure form; we can, with good reason, make the same claim about all innovative art – including the art that seemingly stands in sharp contrast to this aesthetic. Malevich's famous *Black Square*, for example, refers to the most general form of the image as such and is, in a certain sense, an image of the image or (for Malevich, it comes to the same thing) an image of the original black chaos that precedes every act of seeing. Malevich here refers to the valorized cultural tradition of mystic contemplation, Platonism and its love of geòmetry, and the Christian icon.[5] Thus the high cultural tradition that

5 'But there is no icon on which the holy is a zero. The essence of God is zero salvation . . . If the heroes and saints were to become aware that the salvation of the future is zero salvation, they would be confused with reality' (Malevich, *Suprematism: Die Gegenstandlose Welt*, trans. Karsten Harries, Cologne, 1962, p. 57). Malevich's suprematism sought to rescue the hero and saint from their

remains in the background in Duchamp is foregrounded in Malevich. At the same time, however, *Black Square* is a profane geometrical figure that refers, first and foremost, to the world of profane technology, technical constructions, and standardized mass production. In other words, it is a ready-made.

The inner tension in *Black Square* stems above all from the comparison of these two hierarchically distinct levels in a single work of art. Here a further effect results from the fact that the hierarchical relationship between these levels looks different when observed from different cultural perspectives. For traditional high-minded thought of Platonic provenance, today's soulless technology naturally appears profane. In contrast, for 'enlightened', technicized consciousness, the Platonic tradition of mystic contemplation, which was especially closely associated with theosophy and other occultist schools when *Black Square* was conceived and painted, can seem, precisely, profane, retrograde, and irrelevant. *Black Square* thus lends itself to radically different interpretations, depending on the cultural perspective in which it is viewed. Yet these many interpretations are not arbitrary, for they are all reactions to a determinate innovative and, therefore, interpretable operation that Malevich himself has realized in this work. Thus his painting displays the same valuable and valueless levels, and the same tension between them, as Duchamp's ready-mades.

In the heyday of the classic avant-garde, the most radical definition of art as a direct manifestation of hidden reality was perhaps Kandinsky's. Kandinsky's own paintings, as he understood them, evoke the various spiritual states directly expressed in them; yet we can obviously just as well take these paintings to be meaningless, random accumulations of splotches of colour.[6] The latter reading

confusion with a new icon of zero-salvation. Malevich's suprematism sought to deliver the hero and saint from their confusion by mobilizing a new icon of zero-salvation.

6 In explanation of his own paintings, Kandinsky proffers a terminology of colours and forms that is borrowed from the theosophical tradition. Wassily Kandinsky, 'On the Spiritual in Art', in

of them, however, by no means contradicts the first: had Kandinsky sought only to produce an art of emotional empathy, absolutely nothing would have prevented him from utilizing the quite traditional, conventional means that had already been successfully applied to that end. For Kandinsky, however, abstraction signified not just one more means of reproducing the personal originality of his individual mental universe, but also the possibility of integrating something new into the tradition: random, non-mimetically motivated combinations of colours and forms that would earlier have belonged to the profane realm, would have been dismissed as besplattered rags and thrown away. It is only this innovation which makes Kandinsky's natural personality, that of a living human being, interesting – not the other way around. His innovative strategy cannot, therefore, be attributed to his creative personality, which would have attracted no attention in the absence of this innovative process and would have remained a matter of merely personal interest, a possibility Kandinsky himself mentions early in *On Spirituality in Art*.[7] The oft-drawn contrast between the aesthetic of the ready-made and a supposedly alternative expressionist aesthetic thus proves rather unconvincing in practice. On the contrary, only the aesthetic of the ready-made plainly reveals, for the first time, the truly innovative components of the expressionist aesthetic.[8]

Similar innovative strategies may already be observed in the impressionists' art. They combined renewal, that is, the profanation of pictorial motifs, with a new and, consequently, profane conception of coloured surface and visual illusion. The accompanying reference to tradition appears most clearly in Édouard

Kenneth C. Lindsay and Peter Vergo, eds. and trans., *Kandinsky: Complete Writings on Art*, The Documents of Twentieth Century Art, Boston, 1982, pp. 177ff.

7 Ibid., p. 135ff.

8 As has already been shown, expressionism also makes use of quotations from primitive art and the art of the mentally ill, as well as mystic doctrines of colour, and so on. However, it is above all the concept of 'genius' that it appropriates as a ready-made.

Manet. Before the history of properly modern art began, however, the cultural-economic logic of innovation had already set the course of European art. Since the Renaissance, at the latest, the sacral realm of biblical history has been ever more closely identified with the natural, profane realm. Indeed, even earlier, in the Christian art of the Middle Ages, complicated artistic procedures for identifying the invisible God of revelation with the visible gods of the Hellenistic tradition had emerged, each of which could be regarded as profane from the standpoint of the other. The function of the work of art as a locus in which profane, worldly things are put on an equal footing with the valorized tradition thus not only characterizes the aesthetic of the ready-made or of the historical avant-garde overall, but also determines the entire dynamic of, at least, the European artistic tradition. Since the same holds for European literature and other kinds of European art, the innovative mechanism that we have described can be called the driving force behind all European culture.

One can bring to light, in this way, a valorized and a profane level in every work of art; they stand in an intricate interrelationship and sometimes even trade places when there is a shift in the cultural standpoint from which the work of art is viewed. Nowhere, however, do these levels fuse; nowhere do they form a genuine synthesis; nowhere does art overcome value oppositions, whether in the reality external to it or in its own internal structure. Nowhere does the work attain 'spiritualized nature' or 'incarnated spirit' or the 'manifestation of the invisible' or 'autonomous form' or the 'purely expressive gesture'. The innovative work of art mediates between valorized cultural memory and the profane realm, but cannot command or dominate them as the expression of some higher authority. Nor can it fully represent them, since it is itself structurally divided and cannot attain unity within itself.

Nor, again, does an innovative work of art originate in rebellion against the cultural tradition and the resolve to gain access to things

themselves. Rather, it springs from the cultural-economic logic that governs culture and finds expression in the form of a strategic combination of positive and negative adaptation to tradition – with the aim of producing the signifier of the present. A work of art fashioned in complete accordance with existing cultural models fails to extend valorized tradition into the present and future and is rejected as derivative by that tradition itself. Valorized tradition itself calls for originality, profaneness, and innovation. Thus the profane realm cannot be represented by innovative art, since every work of art radically distinguishes itself from the profane realm simply because it sets profane things in a determinate contrastive relation to valorized tradition.

A few theorists of Russian formalism such as Viktor Shklovsky or Yuri Tynyanov have, primarily with reference to the historical Russian avant-garde, proposed a general theory of the historical evolution of culture as a struggle between higher and lower genres and styles.[9] According to this theory, the 'lower genres' of a culture replace the 'higher' ones when the latter lose their power of attraction, become boring, or show wear, and are, in this way, 'automatized'. The 'lower genres' then take their place and sharpen, mobilize, 'de-automatize' perception. In his day, Mikhail Bakhtin rightly criticized this formalist theory as a hedonistic conception of art that made it wholly dependent on the intensity of aesthetic experience.[10]

Still more important when it comes to judging this theory is the circumstance that culture never canonizes the lower genres or profane things in and of themselves. Valorized or canonized are, rather, the works of art or the theories that bind these things to tradition. For that very reason, however, they are distinguished

9 Yuri Tynyanov, 'O literaturnoj evolutsii', in idem, *Poetika: Istorija literatury*, Moscow, 1977, pp. 270–81, and Viktor Shklovsky, *Gamburgskij sčet*, Moscow, 1989, pp. 120–38.

10 Published as P. N. Medvedev and M. M. Bakhtin, *The Formal Method in Literary Scholarship: A Critical Introduction to Sociological Poetics*, trans. Albert J. Wehrle, Baltimore, 1991.

from these things as much as they are from tradition itself. The same may be said about the political domain. Marxism valorized the proletariat, but this does not mean that the proletariat's social significance itself grew as a result. Rather, Marxism and the Communist Party acquired significance as theoretical and practical tools for valorizing the proletariat. Again, when Freud valorized the dream or madness, this did not mean that sleepers and the mad acquired higher social status; it meant, simply, that psychoanalysis had.

In order to be admitted to the cultural archive, then, a work of art or a theory must generate tension between the highest cultural value and the most profane of objects, the one to which such cultural value is ascribed. A work that does so demonstrates in the most radical way the possibility of gaining an overview of the whole cultural field and, simultaneously, the enormous risk that this possibility entails. The work of art or theoretical discourse in which valorized tradition and the profane realm are brought into reciprocal relation is consequently distinct from both that tradition and those profane things. In that sense, such works are truly new vis-à-vis everything that preceded them. This does not mean that something new has been discovered, seen, expressed, or created, something that was not there beforehand. Yet the revaluation of the value of what already exists does create a completely new situation, from which culture in its entirety can be observed, described, and glossed as if from a position outside it. It goes without saying that the externality of that position depends on how radically the revaluation of values is carried out, and is therefore never absolute. The new as the definitive transgression or synthesis which wholly overcomes all value boundaries is, in the end, impossible. If, however, it were possible, it would only form the point of departure for another absolute value hierarchy.

14

The Ecological Counter-Argument

The observation that hierarchical inequality cannot be wholly overcome by creative synthesis meets with no particular objections in our day. It is nonetheless widely believed, precisely today, that the new is no longer possible because hierarchical boundaries have by now disappeared by themselves – without being in any way creatively overcome. Indeed, our time is described as one of unrestricted pluralistic equality, a time of equality amid alterity that excludes all value distinctions. On this view, the boundary between valorized culture and the profane realm has broken down into a host of partial, non-hierarchical differences.[1] This conviction is not shaken even by the obvious fact that a good part of today's cultural production drowns in a mass of profane things, is considered trivial, and has no chance of gaining access to the museum or entering the cultural institutions' field of vision – of being noticed by the mass media, for example.

Meanwhile, valorized culture is being further centralized and institutionalized. One encounters the same names everywhere in today's world, in museums, at conferences, in concert halls. The

1 This is, for example, Gilles Lipovetsky's view: 'Rupture with the inaugural phase of modern, disciplinary-democratic, rigorous-univeralistic, coercive-ideological societies, such is the significance of the process of personalization' (Gilles Lipovetsky, *L'Ere du vide*, Paris, 1983, p. 10).

really existing inequality in culture, which goes hand in hand with
the worldwide integration of archivization and dissemination by
the media, is steadily increasing. At the same time, many theorists
describe the culture of the present – approvingly or disapprovingly
– as egalitarian, utterly pluralistic, and interchangeable. It would
be hard to imagine a stranger contradiction. So sharp a break
between the manifest appearance and theoretical description of
reality usually appears when an author is so bewitched by a single
theoretical argument that he blindly draws every conceivable
conclusion from it.

Contemporary theoretical descriptions of culture are informed
by an ecological argument, taking the word 'ecological' in the
broadest sense. It is of course not a question of sentimental love for
virgin nature here, but, rather, of the idea that the profane realm as
such has disappeared or, at least, is gradually disappearing under
the pressure of valorized culture. Even if the new was earlier
conceived of as an overcoming of the break between culture and the
profane realm and a manifestation of the principle that transcends
both, this unknown principle was in fact always sought in the
profane realm, not in culture. It had to be even more hidden, nonde-
script, and repressed than the profane itself. Being, thought, reality,
life, the unconscious, language – these are all concepts that appeal
to something other than culture, something beyond culture, and,
consequently, something profane.

Plato, in his day, criticized the sophists and the high tradition of
Greek poetry, invoking common sense and the profane conception
of knowledge, the good, and truth. In his view, this conception had
only to be supplemented by a special explanation and description.
However, this means, once again, that it had to be valorized at the
level of the very cultural tradition that Plato criticized. The
Enlightenment echoed Plato's appeal to common sense; psychoa-
nalysis concerns itself with the pathology of everyday life;
Wittgenstein and structuralism, for their part, take an interest in

normal everyday life. The art of modernity appeals constantly to life as the source of the creative – as the counterweight to tradition. If tradition is nevertheless accepted, it is accepted insofar as it can be considered an expression of life in some other period. Hence expectations of innovation were always focused on the vast, infinite profane realm and the forces pulsing through it. The assumption was that it would in the very near future swallow up the little, limited, artificially created island of privileged, traditional culture, protected only by old, weak conventions and norms, and that the new age of universal equality would then dawn.

In fact, something altogether different happened: thanks to technology, a centralized school system, and the mass media, normative culture began to spread through the profane realm environing it. The equality sought thus came about against the will of art and philosophy, as it were – not because the dominant tradition was overcome and replaced by hidden profane knowledge, but, rather, thanks to culture's striving to expand in the opposite direction. The postmodern sentiment that utopia is no longer possible likewise has its source here, since utopia has already been realized in a different way, one that is not even anti-utopian, but, rather, a-utopian. Culture has not ceased to exist; the profane has disappeared. Culture has not proven to be an island of privilege guarded by the powers-that-be; it is the profane which has demanded protection. The term 'protection of the environment' is, in itself, richly paradoxical. One cannot protect the environment, only that which is environed. The profane is increasingly thought of as an island in the sea of culture, one that has to be protected against culture's inrushing tide. A broad ecological consciousness has duly noted this gradual disappearance of the profane. Yet because, on a widespread view, only the profane realm can be a source of the creative, the conclusion to which this absorption by culture leads is that, today, all innovation must cease.

Until recently, it still seemed that we had to venture only a short step past the boundaries of privileged culture and break its taboos in

order to find ourselves in the exotic, innovative realm of the poor, other, uncivilized, marginal, and primitive, which could then be effortlessly put to further use in the cultural context.[2] Today, however, the opposite conception prevails, according to which these reserves of cultural raw material have been or, at any rate, are gradually being depleted, just as, in a parallel process, the reserves of natural resources are. The current expansion of culture has put an end to the isolation of primitive or non-European cultures, but also to the distinctive lifestyle of those strata of the European population that were once partially isolated from dominant cultural values. Thus there is no longer anything outside valorized culture, according to the ecological argument.[3] If that were in fact true, innovation, as it occurs according to the model described here, would also have to come to an end. For when there are no longer any boundaries between the culturally valorized and profane realms, any kind of innovative operation in which things are manipulated in the vicinity of this boundary is likewise no longer possible. That is why the post-utopian ecological argument calls for separate investigation. This argument basically credits the expansion of culture following its natural course with accomplishing what no effort pursued in the opposite direction has managed to. This amounts to a claim that utopia has, as it were, come about by itself, effacing the border between culture and the real.[4]

The ecological line of argument has a twofold explanation for this effacement of the boundary between the valorized and the

2 On the concept of transgression as a breaking of taboos, Georges Bataille writes: 'Such temporary transgression is all the more free since the interdict is considered intangible' (Georges Bataille, *Literature and Evil*, p. 22).

3 Hence Wolfgang Welsch speaks of an over-saturation through aestheticization (Wolfgang Welsch, *Ästhetisches Denken*, Stuttgart, 1990, pp. 13ff.). Under these conditions, further aestheticization is pointless.

4 Thus Yves Michaud points to the lack of the heterogeneous in the cultural world of the mass media: 'The paradox is that, in the contemporary art-world, heterogeneity appears first of all in the guise of a homogeneity of diversity' (Yves Michaud, *L'artiste et les commissaires*, Nîmes, 1989, p. 77).

profane. First, as a result of greater tolerance and the growth of liberal, democratic ideas, everything in the profane realm has been gradually integrated into cultural memory: all taboos have been smashed; all the areas formerly occupied by the repressed, inconspicuous, and veiled have been clarified; and all repressive norms and criteria have been abolished. The upshot is that the profane realm has been wholly absorbed by valorized culture; its resources have been exhausted, its originality has been exploited and neutralized, and its original primitiveness has been transformed by culture. The new is no longer possible, for the boundary between the cultural and the profane is no longer protected, as it once was, by social repression and normative censorship. In this first version, then, the ecological problem of contemporary culture is characterized as a problem of the depletion of its profane resources.

The second reading of our culture's ecological crisis, which does not exclude the first, has it that in modernity, thanks to the contemporary mass media, valorized culture has invaded and repressed the profane realm. Culture has annihilated that realm, extirpating all its potential originality and cultural productivity. In question here is no longer valorized, privileged culture's tolerance, but its heightened aggressiveness. Not only has valorized culture exhausted the resources of the profane realm, it has also filled this realm with its own products and thus radically and irreversibly contaminated it. Since, in this way, all of profane reality is aestheticized, stylized, and remodelled in line with ruling tastes, we can no longer talk about the profane as such today. In the contemporary cultural situation, the profane has, rather, become a kind of simulacrum of its own profaneness or has become hyperreal, to use Baudrillard's term.[5]

5 'The end of the spectacle brings with it the collapse of reality into hyperrealism, the meticulous reduplication of the real, preferably through another reproductive medium such as advertising or photography. Through reproduction from one medium into another the real becomes volatile, it becomes the allegory of death, but it also draws strength from its own destruction,

To put it differently, culture's evocation of the profane as the innovative and authentic is today just one advertising trick among others, a means of enhancing the cultural status of a particular thing.[6] In the ecological crisis, the profane acquires, in a certain sense, a value even higher than that of the cultural – because it is more rare. Hence culture no longer assimilates the profane, but simulates it by passing off cultural objects as profane. Thus the tourist industry, for example, extols brand-new luxury hotels as oases of savage virgin nature.

If these two arguments are right, or even if only one of them is, we could truly say that not only creativity as Romanticism conceives of it, but also innovation as understood from the standpoint of the ready-made have become impossible in our time. We therefore have to take a closer look at these arguments, examining each in turn.

THE DISAPPEARANCE OF THE PROFANE

Let us first consider the argument that stresses contemporary culture's liberal, tolerant, democratic nature. This argument presupposes that, in our time, every profane thing can accede to any level of privileged, valorized culture; to do so, it has only to represent something different, but not something new, that is, not something separated from tradition by the value boundary. However, as we have already shown, things and signs from the profane realm do not accede to cultural memory in their original form. As soon as they are taken up in a theoretical discourse or a work of art, they are

becoming the real for its own sake . . . the hyperreal' (Jean Baudrillard, *Symbolic Exchange and Death*, trans. Hamilton Grant, Los Angeles, 1993, pp. 71–2).

6 'In an artificially reconstructed separate realm of high art, seemingly uncontaminated by any mass cultural or industrial evidence, these restorative acts are claimed as gestures of critical resistance against the fatal legacies of Warhol (and ultimately Duchamp), only to be reclaimed all the more urgently as . . . images of legitimation' (Benjamin Buchloh, 'The Andy Warhol Line', in Gary Garrels, ed., *The Work of Andy Warhol*, Dia Art Foundation Discussions in Contemporary Culture, no. 3, Seattle, 1989, pp. 66–7).

confronted by valorized tradition and its values and are simultaneously associated with them. Here the value equivalencies between them and previous cultural values are determined on the basis of certain features, while other features are completely ignored.

For example, when the French cubists valorized African masks in their art, they divested them of their originally sacral function. This function then fell outside the bounds of valorized culture, which ignored it. Later, for the surrealists or the ethnographers close to them, the same masks acquired a somewhat different meaning, since interest was now focused on their sacral role more than on their pure form. At the same time, however, the surrealists put African masks in the context of a particular theory of desire that, for its part, had little to do with the sacral role that these masks originally had in their own cultural context. All subsequent European interpretations of sacral objects taken from other cultures similarly bracket out something essential.

Every valorization of profane things and signs is above all determined by the valorizing tradition itself, because the profane is from the outset valorized in it as that tradition's other, in the sense of negative adaptation – and the decision as to what *is* other depends crucially on the cultural tradition's self-understanding. That is, the profane is first purged of everything that is not regarded as contrasting with valuable culture; it becomes a cultural artefact as a result. Thus the same African masks can be compared with the purely formal tradition of valorized European sculpture, a certain psychological type of cultivated European, or a certain religious ethos that has its origins in Hellenistic Christianity. The fact that sacral African masks are associated with certain psychological states that tend to stand, in the Christian tradition, in opposition to the positive pole of the sacral played a significant role in their reception.[7]

7 Rosalind E. Krauss, *The Originality of the Avant-Garde and Other Modernist Myths*, Cambridge, MA, 1988, pp. 59ff.

Yet the fact that African masks have been repeatedly valorized in European culture and have come to be considered acceptable with the advent of secularism in no sense means that they have not retained their sacral character outside that culture and cannot be valorized again in some other regard.

No valorization of the profane does away with its profaneness for good and all; even less does it efface the border between the valorized tradition and profane things. All valorizations are always simultaneously interpretations, and every interpretation alters the profane, for it introduces it into a system of references initially foreign to it. The difficult questions about interpretation – whether it is possible as finite or infinite – are well known, but they are not the heart of the problem. More important is the circumstance that every profane object has a determinate value in its own profane realm. In another culture, this can be a cultural value. It can be the value represented by a simple vital necessity in a particular every-day situation. Valorization of profane things and signs in a given cultural tradition presupposes, however, that these profane things first take their value from that tradition and in its context. If profane objects have a value in some other context, then they or the whole of their original context are first devalorized, so that, thereafter, they can be valorized anew in the system of cultural memory.

It might seem as if the tolerant, liberal, democratic attitude characteristic of contemporary culture, which accommodates every possible ideological or cultural practice, imposes limits on nothing but their claim to exclusivity and hegemony, leaving the conceptual and aesthetic contents of such practices untouched. But the claim to exclusivity and hegemony, that is, the assertion of one's own higher value [*Überwert*], is never something purely external for any ideology or artistic practice, something we could set aside while we come to know and understand that ideology or practice. Rather, the value claim of a given artistic practice is constitutive of its very contents. Many philosophical theses and artistic phenomena take on meaning

only when they lay claim to exclusivity and universality. The profane struggle for exclusivity, power, influence, and prestige significantly shapes cultural movements' theoretical or artistic contents. These movements often take various theoretical or aesthetic positions only because the positions they take ensure them tactical superiority in this struggle.[8]

If such cultural movements make their way into the context of liberal law, the museum, or the library, to be preserved and studied there as certain cultural phenomena among others, this means that they have lost their struggle and therefore also betrayed their natures in what is, for them, the most important respect. Nothing about this situation changes because these cultural movements are studied, not as neutral phenomena, but from the standpoint of a particular theory of power.[9] In themselves, they wish to be, not objects of study, but its point of departure, and they take on a completely different nature when robbed of this fundamental aspiration. For example, there is a very clear difference between, on the one hand, the tolerance that European culture shows African masks and the religious cults connected with them, and, on the other, the tolerance that African chieftains or medicine men might possibly bring themselves to show for the symbols of European Christianity. Basically, when a cultural principle renounces exclusivity, universality, and power, it ceases to be what it is. No cultural valorization can exhaust the profane, if only because no valorization can integrate its profane claim to power.

The profane's special claims to possess power independent of

8 Paul de Man highlights, for example, the profane dimension of the dialogue between different standpoints as opposed to the truth-oriented understanding of dialogism that prevails from Plato to Bakhtin. Paul de Man, 'Dialog and Dialogism', in Gary S. Morson and Caryl Emerson, eds., *Rethinking Bakhtin*, Evanston, 1989, pp. 113ff.

9 As, for example, in Michel Foucault, *Discipline and Punish: The Birth of the Prison*, trans. Alan Sheridan, 2nd ed., New York, 1995. On the irreducibility of violence, see Jacques Derrida, 'Violence and Metaphysics: An Essay on the Thought of Emmanuel Levinas', in *Writing and Difference*, trans. Alan Bass, Chicago, 1978, pp. 79–153.

cultural tradition are, moreover, not foreign to the mechanism by which profane things are valorized, since precisely these claims represent, for culture, a standing temptation to transcend its own value hierarchies. Time and again, voices claiming that all culture is deception, convention, and illusion make themselves heard in culture itself: one must turn, they say, to the real, the hidden, the vital – in other words, the profane. Here, consequently, it is not just the promise of another form or discourse or mode of life that plays the central role; what is decisive is the promise of another sort of power, strength, universality, and exclusivity. This promise of greater force and power induces the man of culture to turn to profane things as signs and instruments of the magic powers that lie concealed in the profane. All theories or cultural movements that claim to be immediate expressions of the profane and to represent the extra-cultural 'as it really is' derive their claim to power over culture from the profane's magic powers. If art or theoretical discourse cites objects belonging to other cultures or things, one of the reasons is that it would like to appropriate their magic power. The synthesis of culture and the profane is also the synthesis of knowledge and power. Naturally, this synthesis is never an unmitigated success.

Yet profaneness that has been raised to the level of culture forfeits its extra-cultural power as soon as it is culturally valorized. It then ceases to be a real threat to culture; taking a subordinate place within it, it is neutralized. The figure of the overcoming, accomplishment, and devalorization of traditional culture by means of theory or art – a motif that determines modernity's cultural dynamics from beginning to end – symbolically reproduces, in some sort, the threat to culture emanating from the powers of the profane: that is, the threat of a real, profane annihilation of all cultural archives, monuments, customs, rituals, and forms. The appeal to nature, the people, reason, life, desire, class, race, or simply to the other always presupposes something external to culture that is capable of

completely destroying it. At the same time, however, this appeal is confined to culture itself, although it brings about innovations in it. We might say that the nihilistic and universalist ideological movements of modernity act, their sometimes extremely violent assaults on culture notwithstanding, as conjuring rituals that symbolically effect its total destruction so as to check that destruction and, ultimately, ward it off.[10]

Typical of this attitude is, say, the collage in its aggressive, avant-garde (cubist or Dadaist) version. Representations of cultural objects that have been torn to pieces, smashed, or mutilated, or of traditional valorized art that has been symbolically desecrated – such as the *Mona Lisa* with a moustache and an obscene caption in Duchamp's picture – bring to mind, first and foremost, exercises in black magic that aim to kill the spirit of culture by inflicting various symbolic injuries on its physical incarnations. Today, however, these magical operations tend to be perceived as rituals thanks to which the profane forms produced by technicized mass civilization are integrated into the traditional cultural context. They are perceived, that is, as a kind of conjuring away of the evil spirits called up by civilization.

Thus the valorization of profane things in culture confers value status and equality on them only within the framework of a highly determinate relationship structured by the mechanisms of cultural memory. The profaneness of these things as well as the threat associated with them continues to subsist outside culture and can therefore always be reactivated under new circumstances and in a new relationship. No valorization of the profane can fully culturalize it and thus rule out the possibility of its being innovatively valorized again later. Indeed, profane things are, to the extent that they accede to representation in cultural memory, the more firmly

10 For a history of the 'anthropo-fugal thought' whose goal is a 'return to the inorganic', see Ulrich Horstmann, *Das Untier*, Frankfurt, 1985.

confined to their place. Many who go to museums of modern art and see bespattered rags, wrecked cars, or inverted toilet bowls there take what they see for proof that art has been thoroughly democratized. 'We or our kids could do that, too' is what they usually say.

In fact, introducing certain profane objects into the context of cultural memory makes further cultural use of them harder. No museum needs another upside-down toilet bowl once it has one. Someone who wishes to bring a profane thing into the valorized tradition again has first to demonstrate its real profaneness; he has, that is, to demonstrate the difference between it and everything that has been valorized earlier, making a potentially new place for it in the network of cultural identifications and differentiations. For example, one could exhibit another upside-down toilet bowl in the museum if one intends, say, to bring it into explicit relation with Duchamp's urinal, develop a theory of appropriation, conceptualize a lack of originality as a special sign of originality, and legitimate the derivative as a special form of the creative.[11]

No innovation which aims to put the valorized tradition and the profane realm on an equal footing, re-value values, and liberalize or democratize culture eliminates, for that reason, the hierarchical differences between the levels of the cultural and the profane. On the contrary, those differences are only further stabilized. Tolerance never effaces the boundary between cultural values and the profane realm; rather, it draws it still more sharply, for it rejects, without exception, all of the profane's demands for exclusivity, universality, and power – the demands constituting its profaneness. The temptation inherent in the profane cannot, of course, be eliminated once and for all by any sort of cultural domestication. Every profane element incorporated into culture reminds us of its wild, profane,

11 On the theory and art of appropriation, see Uli Bohnen, ed., *Hommage-Demontage*, Cologne, 1988.

free past, when boundless, absolute, intolerant, destructive, all-embracing claims could still be made without embarrassment. No ultimate cultural synthesis can absorb this profane remainder, which can consequently be re-activated at any moment. Yet the profane and its temptations are not necessarily to be sought outside culture's formal boundaries. The profane also continues to be present in culture – in the guise, precisely, of cultural values which do not fully coincide with the places assigned to them in cultural memory and are therefore capable of becoming, at any moment, absolute and destructive again.

CULTURAL POLLUTION OF THE PROFANE REALM

The second of the two arguments that deny the possibility of the new has it that the profane realm has today been completely restructured in line with certain cultural models and has thus forfeited all potential for alterity vis-à-vis the valorized cultural tradition. The relationship between the valorized tradition and the profane realm can indeed be understood as culture's gradual expansion into the profane realm (in modernity, in particular, it was often so understood) – as a remodelling of profane things on the pattern of acknowledged cultural values as well as a refinement of the profane's colloquial language and its tendential convergence with culture's valorized, canonical language.[12] Innovation staunchly resists this refinement and culturalization, since it does not aim to transform the profane realm on the model of traditional culture, but, rather, seeks to set it in contrast with cultural models. That is why, in the modern period, people have repeatedly voiced the fear that the growth and diffusion of normative culture would

12 The critique of cultural refinement as destruction of nature begins as early as Rousseau and is criticized in its turn in Jacques Derrida, *Of Grammatology*, trans. Gayatri Chakravorty Spivak, Baltimore, 1976, p. 103.

ultimately lead to the suppression of the entire profane realm and the thwarting of all cultural creativity. From the latter half of the nineteenth century on, technical innovations offered traditional culture previously unknown possibilities for mass diffusion, fuelling these apprehensions.[13]

However, neither the enlightened-optimistic nor the conservative-pessimistic assessment of the mass diffusion of cultural products took the following circumstance into account: cultural values that have entered the profane realm cease to be values and become profane. Conversely, profane objects that have entered the cultural context gain in value, but lose their profaneness and, with it, their reality, vitality, and strength, as well as their mystery and power. Thus valuable cultural things, when they enter mass consciousness or serial production, forfeit their specific place in the valorized cultural context, which, after all, basically determines their value.[14] Ideas, art forms, modes of thought, rituals of cultural life, or ideological convictions become fully undomesticated and profane again as soon as they break free of the valorized cultural context, lose their specific place in the complex network of cultural memory, and find themselves outside the system of cultural identifications and differentiations. They give up their original form and their original meaning. Like a plague, they begin to spread unchecked and then mutate in an environment that has no immunity to them. Religions such as Christianity, Islam, or Buddhism spread in this way – more recently, Marxism also did – changing to the point of becoming unrecognizable. Without a determinate place in the cultural context, directly confronted with the profane realm as 'truth', every value loses the identity guaranteed it by preservation in the archives.

13 Consider, for example, the opposition between culture and civilization in Oswald Spengler, *The Decline of the West*, trans. Charles F. Atkinson, New York, 1962, pp. 14ff.

14 These cultural values begin to 'float' (Baudrillard, *Symbolic Exchange and Death*, p. 92).

Walter Benjamin tried to show that the work of art, as a result of its mass diffusion, loses its specific place in the cultural realm and thus also its aura, the essential source of its fascination. Benjamin understands the tie binding cultural things to a certain place in a basically geographical sense – as their unique, real presence in a particular space.[15] Considerably more important for the work of art and, more generally, all cultural phenomena is their anchorage in the special realm of cultural memory. The whole critique of modernity animated by hostility to the idea of progress understands mass diffusion as, not an epiphany of traditional culture, but, rather, mechanical production of profane objects, whose outward similarity to cultural values merely masks the fundamental difference between them.

This critique of mass culture may seem elitist and undemocratic at first sight. Tellingly, however, it is precisely this critique that enables some mass-cultural phenomena to regain valorized cultural status as, now, profane things. If cultural values have been profaned for a time in mass culture, they can, once their profaneness has reached a certain point, be valorized again – as new cultural values compared with their previous models. Precisely the negative conception of mass culture as kitsch and something like the aesthetic refuse of civilization paves the way for mass culture's aestheticization and valorization in the system of cultural memory. The fact that extra-cultural imitations of high culture are characterized as absurd, ridiculous, worthless, ugly, trivial, flat, or parochial simply opens up the possibility of aestheticizing precisely these characteristics of such imitations.[16]

15 Walter Benjamin, 'The Work of Art in the Age of Mechanical Reproduction', in idem, *Illuminations*, trans. Harry Zohn, New York, 1969, p. 200.

16 In his famous essay 'Avant-garde and Kitsch', written in 1939, Clement Greenberg draws a sharp distinction between high or 'genuine' art and mass-produced art: 'To fill the demand of the new market, a new commodity was devised: ersatz culture, kitsch, destined for those who, insensible to the values of the genuine culture, are hungry nevertheless for the diversion that only culture of some sort can provide. Kitsch, using for raw material the debased and academicized simulacra of genuine

Thus pop art's critically distanced attitude to mass culture once served as the premise for its integration into the cultural tradition. Had mass culture been deemed truly valuable, that would have been impossible. From the beginnings of the European avant-garde on, artists utilized primarily those elements of the civilization of their day that were at the furthest remove from valorized culture. When the historical avant-garde used valorized cultural objects such as the *Mona Lisa* or a violin, it profaned, overpowered, and destroyed them before going on to aestheticize them. In contrast, contemporary art uses mass-cultural things virtually intact. Thanks to a long, tenacious critique, mass culture is now automatically felt to be profane. When, for example, Jeff Koons reproduces trivial or kitsch art forms using valuable, especially time-resistant supports, he can take it for granted that at least part of his audience will not perceive these forms as truly valuable and beautiful and will appreciate the irony involved. They will also appreciate the problem involved in the fact that these reproductions are made to last, which is pointedly posed here, since such kitsch forms are designed to be junked in the 'ordinary' contemporary cultural context. For that very reason, using expensive, non-perishable material to reproduce them can serve as a felicitous metaphor for the fear every culture has of being annihilated and sinking into oblivion.[17]

When, to take another example, Mike Bidlo copies Picasso in the context of the appropriationist aesthetic and exhibits these copies as originals of his own, we can of course say that what is valorized are copies ordinarily belonging to the profane realm. No less important, however, is the fact that it is enough to cite the Picasso cult directly – because of its mass diffusion – to show that it is a question

culture, welcomes and cultivates this insensibility . . . Kitsch is mechanical and operates by formulas. Kitsch is vicarious experience and faked sensation' (Clement Greenberg, *The Collected Essays and Criticism*, vol. 1, *Perceptions and Judgements, 1939–1944*, Chicago, 1988, p. 12).

17 See the interview with Jeff Koons in *Amerikanische Kunst der späten 80er Jahre*, Cologne, 1988, pp. 121–8.

of an already profaned level of culture here.[18] When contemporary artists use less thoroughly discredited artistic phenomena for their appropriations, they play a complicated game in order to bring out the profane levels in them. Cindy Sherman, for example, does this with the classical art of the past, availing herself of the possibilities offered by photography, which abandons certain traditional artistic aspirations.[19] In short, since nearly all contemporary art is in some way oriented to the aesthetic of the ready-made, and thus explicitly conceives of itself as work with the various levels of its valorization, contemporary works, when they are seriously produced, scrupulously respect the boundary between valorized and profane even in their purely formal structure. What is already profane in culture is taken up, in its entirety, in the form of citation, while what can still be apprehended as a value is prophylactically devalorized or deconstructed in the work itself, so that it may then be revalorized.

Here innovation is the antithetical process to the democratization of culture, understood as the broad dissemination of cultural values. Innovation valorizes the very aspects of the profane realm from which that realm would like to free itself in the course of its education [*Bildung*] – above all, the aspects it would like to overcome, since they constitute especially despised signs of its profaneness. By turning to the profane and making new, exclusive fashions out of the most profane things, elitist consciousness reproduces its elitist work in ever-new forms, because it ceaselessly takes its distance from the cultivated masses and their civilizing standards. This is, in turn, permanently called into question by the democratization and mass production of valorized culture. While the masses turn to that which has been recognized as culturally valuable, thereby devalorizing it, cultural-economic strategy

18 On Mike Bidlo, see, among other works, Uli Bohnen, 'Hommage-Demontage', in idem, *Hommage-Demontage*, pp. 37ff.

19 On Cindy Sherman's artistic strategy, see Hal Foster, 'The Expressive Fallacy', in idem, *Recordings: Art, Spectacle, Cultural Politics*, Seattle, 1985, pp. 59–78.

consists in compensating for this devalorization of cultural values by valorizing the valueless. Valorization of the valueless is thus a sign of the democratization of culture and, in equal measure, of resistance to that democratization.

The criticism often addressed to contemporary art is that it no longer innovates, repeatedly revisits the art of the past, is retrospective, and contents itself with refashioning what already exists. Much about this criticism is of course on the mark, but the same objections could be raised against the art of any period. The historical avant-garde is transformed into the salon when it is harnessed to purely decorative ends, as often happens today. But this way of handling art, culturally guaranteed from the outset, must be distinguished from work on past stylistic tendencies that have already undergone a process of profanation, to the extent that such work explicitly exposes this profane level to view. Here we can no longer speak of a simple, non-innovative utilization of old styles. In traversing the profane realm, these styles have in their turn acquired the seductive traits of the profane: magic charm, power, spontaneity, and a capacity immediately to evoke the extra-cultural.

We cannot, then, say a priori whether a given thing, form, language, or cultural custom belongs to valorized high culture or the profane realm. All cultural phenomena oscillate around this boundary and, as they do, alter their own position with regard to it. When culturally valorized models accede to the profane realm, they become profane and cease to be values. If, on the other hand, profane things make their way into culturally valorized memory, they cease to be profane. A fusion of valorized culture with the profane realm would be possible only if there existed criteria of quality or value capable of defining the value of a thing independently of its current position. But there are no such criteria. There are, for that reason, no profane things as such – neither reality nor nature nor being nor life nor common sense – just as there are no ideals of beauty in and of themselves.

AESTHETIC RECYCLING OF CULTURAL REFUSE

Let us once again emphasize that the question of the relationship between the culturally valuable and the profane sharply differs from the question of the relationship between culture and nature or culture and reality. When nature and reality were still regarded as valueless in comparison with culture, their promotion to the level of art or theory could still be considered a rise in rank. Today, there exists an unimaginably vast mass of trivial, culturally valueless art. At the same time, nature is today often assigned a higher value than the products of culture, and institutional safeguards are put in place to preserve it. Thus if the profane was earlier associated with nature, being, or reality, which it was culture's business to identify, the resulting value boundary, once metaphysically defined as that separating reality from its cultural representation, is now being steadily displaced in line with cultural-economic logic. What was earlier a sign is becoming a thing – and the other way around.

Hence the ecological crisis affects the profane much less profoundly than might appear at first glance. The profane realm is constantly renewed, because it is constantly filled with the refuse and waste products of valorized culture. The distinction between this refuse and the original, 'virgin', natural profane that is allegedly being destroyed by the influx of this refuse is arbitrary and purely ideological. A rubbish dump manifests the profane, reality, and life not less, but more, than Amazonia's virgin nature. It is no accident that ecological discourse stubbornly focuses on the problems of refuse when one might well expect that it would prefer to concern itself with untouched nature. Only with the emergence of ecology has cultural refuse acquired so important a place in the public mind. Yet twentieth-century artists had already aestheticized refuse before the ecological debate began, again and again transforming galleries and museums into rubbish dumps. At the very beginnings of

today's technologized civilization, these artists had already realized the profane potential contained in refuse.[20]

Refuse can, moreover, serve as a good example of the ambiguous role that the profane plays in culture. A thing that has been thrown away is, on the one hand, an emphatically valueless, profane, useless object. At first sight, its valorization in art therefore demonstrates all the power and freedom of art, which can lend the highest cultural significance to something that has the least hierarchical value. On the other hand, the act of throwing out refuse recalls sacral sacrifice, renunciation of property, ascetic self-denial, and ritual. In this regard, art appropriates only such potential for the sacral as is contained in the act of abandoning something to space, nature, or the void. Thus we find simultaneously present in refuse both of the value levels that confer the requisite tension on its cultural utilization.[21] In this perspective, ecological consciousness may represent a new step in the secularization of European man, for it integrates refuse into the recycling process. Refuse thereby loses the quality of sacral sacrifice made to an anonymous infinite. But, at the same time, the economic re-utilization of refuse is the continuation of its previous aesthetic or cultural-economic utilization.

20 Holger Bonus and Dieter Ronte, *Die Wa(h)re Kunst: Markt, Kultur und Illusion*, Erlangen, 1991.
21 See, for example, Boris Groys, 'Das Thema des Mülls in der Kunst Ilja Kabakows', in idem, *Zeitgenössische Kunst aus Moskau: Von der Neo-Avantgarde zum Poststalinismus*, Munich, 1991.

15

Valorization and Devalorization

The refuse of our civilization is due not only to the fact that the ongoing attempts to culturalize the extra-cultural world conduct the currents of cultural production into the profane realm, where they become refuse. The profane realm is filled with cultural things for another reason as well. Every more or less radical innovation reorganizes cultural memory, removing from it things previously preserved there. A culture's memory, like a computer's, may be divided into a permanent and working memory. The monuments of the past are seldom called into question by subsequent innovations. The case of cultural movements that develop parallel to one another, however, often confronts us with striking results. Artistic modernity was above all shocked and shaken by the rapid devalorization of salon painting, which was ejected from historical memory late in the nineteenth century by the parallel activities of the impressionist and early post-impressionist painters. This spawned the well-known Van Gogh complex, which motivates unknown artists to the present day and keeps famous ones from sleeping.

The Van Gogh complex explains, moreover, why cultural-economic logic is irreducible to a logic of the market. An artist's or theoretician's commercial success is, as a rule, grounds for the suspicion that her work is not innovative enough, since it was immediately understood by a mass public. The work is, as a result,

not admitted to the cultural archive and is thus exposed to the risk of losing its value with time. On the other hand, the fact that a work is a commercial failure is often interpreted as a sign of its innovative power and an indication that it will later be received in the context of valuable culture. Here commercial success becomes an index of cultural and, therefore, future commercial failure – while commercial failure becomes an index of possible future success. This configuration shows that market success as such has nothing objective to say about a work's cultural value and has first to be interpreted; such interpretation is in its turn subject to cultural-economic logic. Thus, while market value most assuredly does not differ qualitatively from cultural value, it is nevertheless separated from it by a time factor that can never be simply effaced.

To return to our example, innovation was by no means foreign to nineteenth-century salon painting. A few painters also made use of exotic styles or motifs, erotic subjects, decadent symbolist atmospheres, or profane realities in order to bring variety to their work. If a still more radical artistic movement had not sprung up alongside salon painting, these scattered innovations would have been quite sufficient to win many salon painters a lasting place in the history of art. However, every radical innovation devalorizes, if not the tradition itself, then at least a purely affirmative, non-innovative or only moderately innovative continuation of this tradition. After the practice of the ready-mades appeared, for example, it seemed naïve to claim that one was engaged in spontaneously creating things out of the void. This claim is made to some extent even today, but contemporary artists try to counterbalance it with references to their work's prefabricated, intra-cultural nature and its reliance on quotation.[1] Claims to being spontaneous, creative, and

1 This is how German New Expressionism, for example, proceeds. 'The new German painters do not seek unmediated expression, as their critics have thought. Rather, using an already existing code of natural expression which depends on the spontaneous union of opposites in a single gesture, the German painters attempt to provoke in us resistance to abstraction . . . There is no real appeal to

immediate come to seem like quotations and are thus in their turn justified only by the prevailing non-expressivist aesthetic. When the opposite is true, claims to immediacy seem naïve and even deceptive, since they take no account of past doubts about the possibility of realizing such claims. Interestingly, unreflected immediacy and spontaneity are in this case less authentic and less honest that the explicit use of set quotes and the related reflections.

Salon painting was also accused, in its day, of being deceitful, remote from real life, formalistic, and even hypocritical. Psychologically, of course, these accusations were wide of the mark. Salon painters no doubt sincerely believed in the beauty and cultural significance of their work, and in its meaningfulness and utility. Salon painting can be seen as insincere only against the background provided by impressionism, if we recognize impressionism as art that refers to a reality, internal or external. Yet late impressionism, too, was regarded as derivative and deceptive in the days in which it continued to exist alongside the still more radical artistic currents of the following period. The cultural conception of sincerity, immediacy, realism, and so on – which can seem to be psychological qualities – in fact points only to the place that a given work of art holds in the diachronically organized system of cultural memory. A work that seems quite sincere if it was produced in a certain year seems insincere when we learn that it originated later. The corresponding chronology is, most of the time, drawn up after the fact.

To say that a work of art is sincere, immediate, or realistic means that it refers to extra-cultural reality, to the profane and the new. Many people conceive this reference as the artist's subjective resolve to represent what really happens to him, what he believes, and what

instinct in this use of gesture. From the beginning it is socially determined, just as the figures are culturally conditioned' (Donald B. Kuspit, 'Flak from the "Radicals": The American Case against Current German Painting', in Brian Wallis, ed., *Art after Modernism: Rethinking Representation*, New York, 1984, pp. 141ff.).

he lives for. The extreme psychologization of many discourses about art stems from this, especially in modernity, in which subjective authenticity is contrasted with tradition, the academy, or obsolete art forms, and interpreted as the source of the new.[2] The same applies to theoretical or literary discourse. Authentic language, for instance, is often associated with a language that violates traditional logical or rhetorical criteria and appears to be confused, erratic, or inconsistent. Things, languages, and signs, however, like habits of thought or behavioural patterns, often change their position with respect to the boundary between valorized culture and the profane realm. Thus it can easily turn out that alogical language and spontaneous painting have long since been transferred from the profane realm to that of valorized culture and can no longer be understood as signs of authenticity – in other words, evocations of

2 'All these traits (non-identity, non-repeatability, creativity, unrecognizability, scientistic unmasterability) can, however, be attributed to our candidate [for individuality] only if they are considered . . . to be properties of the *subject*. And that is indeed what they must be considered to be . . . We are not familiar with subjectivity mediately, from an observer's or an introspective perspective; we are, rather, *immediately* familiar with the property of conscious life' (Manfred Frank, 'Individualität und Kreativität', in Akademie der bildenden Künste in Wien, *Wahrheit in der Malerei*, Vienna, 1988, p. 36). Frank goes on: 'Thus the new thing that comes into the world thanks to the intervention of an individual is, precisely, a modification of the rules or the system . . . To make the system itself responsible for the modification of the system would be to succumb to a fetishism of language which has it (not only) that language itself speaks, but even modifies itself by itself' (ibid., p. 38).

Frank conceives modification of the system as spontaneous, unintended, unconscious, and ineluctable. It is indeed true that individuality – understood as subjectivity – *may* not automatically obey the rules of the system: here individual deviations are inevitable. However, these deviations remain profane: while it is true that the new 'comes into the world' thanks to them, that new is not recognized as valuable and consequently does not enter *the cultural archives*. Revalorization of an ineluctable individual deviation as a new rule occurs only in the form of a modification of the system, the possibility and necessity of which is provided for by the system itself. For Frank, individuality is subjective because it is *modest*: it manifests itself only as deviant behaviour within the system, not as an epochal transformation of that system. Thus Frank goes on to say that 'we would do well, in concluding, to recall the caveat against overestimating individual creativity in the way in which it is overestimated in German idealism's subjective fantasies of omnipotence, as Nietzsche, Heidegger, and Heidegger's postmodern followers have pointed out. Individuality is not a sovereign authority responsible for the creation of worlds and meanings. It only ever emerges as a – sometimes barely perceptible – feature of a generality' (ibid.).

the profane, reality, and life – but function as conventional signs of valorized culture.

Sincerity in art thus has nothing in common with sincerity in life. Sincerity considered as a culturally relevant position results from as exact a conception as possible of the way the boundary between the valorized and the profane runs. Acquiring it calls for training at least as thorough as that required for straightforward reproduction of the tradition. Artists and writers who are, psychologically speaking, altogether sincere, and believe in the power of their tradition, are often precisely the ones who, in the cultural context, are perceived as insincere epigones clinging to convention – a tragic misunderstanding that stems from amalgamating culture and life.

In contrast, an artist is deemed sincere when he leaves his own cultural milieu behind and travels – in actual fact or symbolically – to Tahiti or Africa and creates an absolutely artificial, bogus, outlandish, or even 'false' situation for himself there. Even when an artist exploits his own life experience in his art, he has initially to observe it, as it were, from the outside, from the standpoint of valorized culture; otherwise, he would be subjectively and psychologically sincere, but not sincere in culture. His own life experience becomes an artefact as a result, since it obeys, from the very start, the logic of negative adaptation and is set in opposition to the dominant cultural values: with that, it is purged as thoroughly as possible of the presence of these values, although it is, in 'real life', necessarily influenced by them. Real-life experience is culturally always trivial, because it is shaped by the values of a culture in which one lives. This experience seems authentic and original only as an artefact purged of all these values.

Works of art or theoretical discourses that are unfamiliar with the innovation of their times or fail to take it into account are evicted from cultural memory and go over to the profane realm as mass-cultural objects, although they were projected as cultural values and may even, for a while, have functioned as such. Crucial here is not

the judgement of posterity, which is naturally no better at judging art or theory than contemporaries are; it is, rather, the fact that one's overall picture of the innovations of a given period appears more clearly in historical perspective. Of these innovations, those that are most innovative for historical memory are then singled out. It is not, accordingly, that which transcends its own time that is preserved in cultural memory: it is not that which represents the universal, extra-temporal, eternal, and true, but that which is most radically time-bound. Indeed, it is pointless to preserve the eternal in culture. Moreover, artists or theorists who remain unsuccessful in their own day can easily inhabit the profane realm for a while, only to be revalorized later. This is what has repeatedly happened to salon painting, precisely, and will probably happen to it often in the future as well.

The foregoing pinpoints the ecological argument's main weakness: it rests on the conviction that between culture and the profane realm – which is understood as life, nature, the spontaneous culture of the people, and so on – there exists, from the outset, a stable difference, so that culture could occupy and take possession of the whole of the profane realm, or else be wholly absorbed by it. The difference between valorized culture and the profane realm is, however, a function of positioning and therefore subject to constant change. What we only recently took to be culture turns out, after its mass diffusion, to be profane. Conversely, what was only recently profane and disdained is suddenly valorized and must be preserved with special care. No universal third force can guarantee that the boundary between the cultural and the profane will be overcome, nor is this boundary itself guaranteed by anything else. Quite the contrary: it constantly alters its course. The new as well, consequently, is always possible again, since the boundary with respect to which it is defined is new again every time – independently of the innovations that have preceded it.

PART III

INNOVATIVE EXCHANGE

16

The Cultural Economy of Exchange

It follows from the foregoing that innovation is carried out mainly in the cultural-economic form of exchange. This exchange takes place between the profane realm and valorized cultural memory, which comprises the sum of the cultural values preserved in museums, libraries, and other archives, as well as the habits, rituals, and traditions governing their utilization. One result of every innovation is that certain things in the profane realm are valorized and enter the cultural archive, while certain cultural works are devalorized and enter the profane realm. On first sight, it may seem odd to conceive of innovation as exchange, since the product of the creative act is usually considered to be absolutely incomparable and in no sense interchangeable, and to have no specifiable value. This traditional notion of innovation springs, however, from the conviction that a work of art or theoretical discourse represents a hidden reality superior to both culture and the profane realm. Yet if it is acknowledged that the border between the valorized and the profane always subsists, then this border can be bridged only by an exchange, not by the sublation and ultimate fusion of these two separate realms.

Moreover, since works of art themselves contain both a profane and a cultural stratum, they function, in some sense, as stages for the exchange between the two. The utilization of profane things in

twentieth-century art, for example, transformed these things into artistically normative objects. Gradually, profane design, commercial art, and mass production began to orient themselves to such things, after having previously oriented themselves to classical art.[1] Conversely, what had previously been classical art sank into the profane realm as outmoded kitsch; this subsequently made it possible to aestheticize and valorize it anew. Still later, it was geometrized mass design that could be revalorized by neo-geo art.[2] Strategies of valorization and commercialization are thus closely interrelated. Everything that is culturally valorized can subsequently be commercialized. Yet everything that is commercialized loses its cultural value. For this reason, it can and must be valorized as something profane. Valorization and commercialization do not merely compensate one another; each is also constantly exchanged for the other.

Theoretical discourse also provides interesting examples of this exchange. Thus Freud successfully valorized, and subsequently commercialized, elements of classical humanist education nearly forgotten in his day, such as the Oedipus myth. By situating the Oedipus complex in every individual human being's psyche, Freud was able to interest many people in reading texts they would otherwise have considered to be devoid of all interest. Freud here appeared as an intermediary between classical humanist education and the spirit of his times. The doctrine of the Oedipus complex, too, includes two different value levels, which together generate an internal, culturally productive tension.

From the standpoint of classical education, Freud's reading of the Oedipus tragedy was blasphemy of a kind. Freud introduced the profane interest in mass psychology and 'base', perverse desires into

1 Many different examples of the exchange between low-brow and high-brow art in the twentieth century are given in Kirk Varnedoe and Adam Gopnik, *High and Low: Modern Art and Popular Culture*, New York, 1991.

2 See Peter Halley, 'The Crisis in Geometry', in idem, *Collected Essays*, Zurich, 1988, pp. 75ff.

the high cultural tradition. In his work, the Oedipus tragedy sheds its exclusive, heroic aspects, its privileged character and irreducible historicity, in order to become a mere illustration of a universal law determining the unconscious. Freud thus incorporated into high culture a 'low-brow' reading of certain texts; this reading was to enjoy a brilliant career. On the other hand, average, democratic mass man was, for him, the immediate bearer of high Greek tragedy, knowledge of which had once been the privileged social classes' exclusive preserve. The upshot was that ancient Greek myth became available to a broad readership. Freud's theory is thus a good example of innovative exchange, which combines cultural valorization of the profane with profane commercialization of culture.

With the dichotomy between the Apollonian and the Dionysian, Friedrich Nietzsche had already provided a demonstration of the same process of universalizing classical humanist education by relocating it in the unconscious or 'life itself'. Still earlier, Marx had managed to save Hegel's dialectic, which was hard to understand and already on the verge of sinking into oblivion, and to commercialize it for a new age by connecting it with the question of raising wage workers' living standards. By the same token, he succeeded in inducing philosophers to concern themselves with profane, economic problems that they had earlier not considered on the traditionally high philosophical plane. We can trace this strategy down to our own day.

The relationship between cultural valorization and economic, financial, and commercial success should therefore not be understood as a kind of diabolical market activity that dogs creativity and absorbs, utilizes, and commodifies everything that was originally produced as a counterweight to the market – as something fundamentally other, an alternative space, a utopia that overcomes all hierarchies and inequalities.[3] This model of the reciprocal relation

3 'Socially the situation of art is today aporetic. If art cedes its autonomy, it delivers itself over

between artistic creativity and the market presupposes, as always, that creativity has its source in a beyond from which it emerges in some incomprehensible way, in order to be co-opted, utilized, and commercialized in all too comprehensible a way. However, if innovation operates only with the already existing and already possesses a certain value in valorized cultural memory or the profane realm, and if it seeks only to modify the relationship between these culturally valorized and profane values, that is, to effect a revaluation of values, then it is itself originally a kind of economic operation. There is therefore nothing unnatural about subsequent commercial exchanges of books or works of art. It is no accident that the term 'valorization' is used to describe innovation; the word refers not only to value in the ideal sense, but also to commercial value.

Money plays a major role in valorized culture as well, inasmuch as cultural memory has to be preserved in archives, and that costs money. The fact that cultural memory is preserved in a material archive and that money has to be spent to preserve it may be regarded as a sign of the secularization of European consciousness in the modern period. Cultural memory is, after all, a secularized version of the divine memory, which of course requires no financial expenditure. In moments of real religious exaltation, therefore, people often destroy cultural monuments; this usually strikes the more sceptical among their contemporaries and descendants as evidence of barbarity, fanaticism, and a lack of culture. In fact, believers who destroy cultural monuments are motivated by the conviction that God needs no superfluous material testimonies, the more so as such testimonies are themselves not eternal and he can read the soul of every single human being and preserve everything better and more reliably in his memory than any culture could.

to the machinations of the status quo; if art remains strictly for-itself, it nonetheless submits to integration as one harmless domain among others. The social totality appears in this aporia, swallowing whole whatever occurs' (Theodor Adorno, *Aesthetic Theory*, eds Gretel Adorno and Rolf Tiedemann, trans. Christian Lenhardt, London, 1984, p. 236).

Thus the attempt to dissolve the bond between valorized culture and profane, commercial value, as well as the one binding valorized culture to its privileged position and the social inequality associated with such privilege, is, like the attempt to free valorized culture from the institutions of control and domination that guarantee it, deeply rooted in the cultural tradition itself. Historically, such attempts have often degenerated and brought on the destruction of valuable culture in its entirety, for the purpose of liberating something ontologically imperishable, indestructible and, thus, valuable in and of itself.[4]

Moreover, if one grants that all things are organized on the basis of hierarchies and values and that there is nothing hidden outside them which their total destruction might make visible, then the destruction of the cultural archive can only lead to what actually is to be found outside them, namely, the profane. The attempt to find the indestructible, eternal, and elementary outside culture thus leads to a region of the profane still more perishable and mortal than that represented by art itself. That is why, with every move beyond culture, a new cycle of preservation begins: because that which was gained by the destruction of culture stands in greater need of being saved and preserved than does that which was destroyed.

4 See Boris Groys, *Konstruktion als Destruktion*, forthcoming.

Innovative Exchange and Christianity

Let us take the first Christians as an example. They abandoned pagan culture and its monuments and struck out for the lonely wilderness, the most profane realm of their day. This departure can be understood as a symbolic destruction of culture, but also as an introduction of the profane – specifically, of lonely places in the wilderness – into the cultural archive. Christian hermitic life is basically an innovation that valorizes the profane and devalorizes established values. A Christian hermit usually settles in extremely profane places, uses the most primitive tools there, subsists on the most basic of diets, and only rarely leaves written or artistic testimonies in the course of his existence. Toward the end of his life, however, or after his death, his lonely cell begins to attract other people. It becomes more valuable than older values. In time, ever more magnificent churches are built on this spot and decorated with frescoes and votive offerings. The greatest value, however, is always constituted by the saint's relics and a pair of quite simple, everyday things he once used – the ready-made of his holy life, as it were. These things have no original or culturally valorized form and must therefore be preserved with special care. What makes them new is the role they played in the hermit's quest for salvation, their special capacity to represent extra-cultural reality, and their very profaneness, which has now become the supreme cultural

value. The need to provide the objects of this holy life special protection and create a special context in which to preserve them originates, after all, precisely in the fact that it is hard to recognize them as valuable. A pagan temple adorned with statues and full of precious objects will immediately be recognized as such, even if it is discovered by accident during an excavation. We do not, at first sight, take the cave in which the saint lived for a Christian shrine, since that cave is outwardly no different from others in the vicinity. The need to protect and preserve this particular cave is, consequently, especially great.

The hermit's sojourn in the cave has thus valorized it in not just an ideal, but a profane and an economic sense as well, for especially intense efforts and big material expenditures are required to maintain the cave. Christian asceticism includes the same two value levels that characterize cultural innovation in general. The saintly hermit, who embodies the highest cultural ideal and highest cultural values of his time, crosses over into an extremely profane realm. The greater the distance between that which he represents as bearer of the highest religious knowledge and religious experience on the one hand, and the profane conditions in which he lives on the other, the more radically is the profane revalorized and culture devalorized, and the more comprehensive is the innovative exchange.

Christianity itself also issues, of course, from this exchange, sustained as it is by the coexistence in Jesus Christ of the essence of the divine and the human, inseparable, yet irreducible to a unity. Christ's divine essence is exchanged for the crucified criminal's singularly profane fate. Christ renounces not just the world's gifts, but also his own religious tradition: he exchanges presence in the temple for the cross. Not only do the Romans declare him to be a criminal; the Jews declare him to be a heretic. Hence the cross, too, in its twofold function as an instrument of punishment and salvation, is a locus in which the profane world can be exchanged for divine mercy. That is why the cross – again, as a ready-made, if one

likes – moves to the heart of European culture. Modern European culture, in its ongoing effort to overcome the valorized, primarily Christian values of the past, repeatedly reproduces the same figure of innovative exchange represented by Christianity itself, and thus never goes beyond the horizon of that exchange.[1]

The renunciation of culture, the destruction of culture, the overcoming of culture: these are the constantly recurring themes of the Christian European cultural tradition itself. The total doubt and total critique characteristic of modernity prolong this tradition even when they burst its bounds and seek to attain something outside it that is invulnerable to criticism, a spontaneous, self-evident truth that remains unaffected by mechanisms of social control or unequal property relations. Were this leap to the outside and the truth as such to succeed, the archive would indeed become superfluous. One could unhesitatingly destroy it, since the truth would subsist outside it. Reason, desire, the unconscious, life, or matter can be identified as this indestructible truth supposed to be independent of the archive. In modernity, consequently, it is often said that the old stands in the way of the new and that destroying the old will clear a path to the new. Yet the fact is that the need for the new and the possibility of the new are determined by the preservation of valorized cultural memory. If it were possible to forget past culture, the 'compulsion to produce the new' would indeed disappear. It would again be possible just 'to carry on with the old'. In practice, however, this will never happen, since the devalorization of culture brings the immediate revalorization of the profane in its wake. Whenever the cultural archive is destroyed, it is inevitably reconstructed.

The demand to destroy the cultural archive in order to emancipate the future was raised above all in the heyday of the historical

1 Thus, again in a Christian perspective, Rudolf Otto defines the sacred as the 'altogether Other, the mysterious, that which provokes a shudder and alienates' (Rudolf Otto, *Das Heilige*, Munich, 1963, pp. 28ff.).

avant-garde. After Malevich had produced his *Black Square*, he doubtless believed that he had negated all traditional values and that, behind them, the original black that is the truth of the world had been made manifest. Yet *Black Square*, precisely, can also be described as the introduction of a particular profane thing – a square – into the context of the preservation of valuable culture. Avant-garde art equated destruction and creation and assumed that, with the rejection of all conventions and the destruction of the tradition, the reality that had been concealed by these conventions, norms, and things would appear by itself. In this respect, it resembles European philosophy, which has since Descartes assumed that the authentic truth will penetrate consciousness on its own, if only traditional, conventional truth is called into doubt. What actually happened in avant-garde art, however, is that the devalorization of tradition was invariably followed by the valorization of profane things or ideas which did not emerge by themselves, but were imported into the traditional cultural context from the outside: the act of destruction did not make the hidden visible, but, rather, valorized the profane.

At the political level, the Russian writer Andrei Platonov exposes this basic error of avant-garde thought. In his novel *Chevengur*,[2] he describes a group of revolutionaries who take power in a small town during the civil war and try to bring the new communist society into existence by shooting different population groups one after the other, since they are contaminated by traditional, hierarchical cultural notions. The new society is consequently formed with, not the town's surviving inhabitants, but foreign immigrants. It creates a new hierarchy of its own, which is itself threatened with destruction and has to be culturally preserved. The upshot is that it cannot preserve itself and goes to wrack and ruin, since it knows only the logic of negation and annihilation. The strategy of self-negation

2 Andrei Platonov, *Chevengur*, trans. Anthony Olcott, New York, 2009.

and self-purification turns out to be weak and ineffective in the face of the threat of the profane and death itself.

Ascetic renunciation of traditional values for the profane is thus always a process of innovative exchange and, consequently, an instantiation of global economic logic. This renunciation leads to valorization of that zone of the profane realm in which it is carried out. Contrary to Max Weber's claim, such ascetic renunciation need by no means be the prelude to some useful activity in order to create new values. Weber assumed that Protestant asceticism's role consisted in gathering up capitalist Europe's forces and focusing them on production.[3] However, for the cultural and, consequently, commercial value of a thing to increase, it is altogether sufficient that a culturally valorized tradition be sacrificed for its sake. Supplementary productive efforts are not called for here.

3 Max Weber, *The Protestant Ethic and the Spirit of Capitalism*, trans. Talcott Parsons, New York, 1930.

18

Interpretations of Innovative Exchange

That one profane thing or another should suddenly acquire value status simply because the cultural tradition has been sacrificed is for many a shocking notion. That is why contemporary art continues to encounter mistrust, and that explains the constantly recurring attempts to produce interpretations justifying, grounding, or refuting the economy of sacrifice and innovation. Here innovative exchange itself is always set in a certain relation with the hidden reality in which its mechanisms are supposedly grounded. We shall now proceed to show that interpretations of innovative exchange are themselves subject to the cultural-economic logic of such exchange and can therefore neither ground nor refute it.

We can say about the artists of modernity that they practise asceticism by sacrificing their capacity to create traditional values: for example, by displaying the inverted bowl of a urinal, which acquires a value thanks to this ascetic sacrifice. It is not just the production of values in the sense of affirmative adaptation, in conformity with valorized cultural norms, which is capable of creating new value; so is the economy of sacrifice, that is, the rejection of production and traditional values in general, the simple abandonment of the cultural domain, and the real or symbolic destruction of the valuable.

To be sure, attempts are constantly made to unmask such an economy of sacrifice as a fraud. Thus Nietzsche contended, in his day, that

ascetics would probably be quite incapable of enjoying worldly pleasures even if given the opportunity to do so, and that this circumstance reduced the value of their asceticism to naught. Thus we might in our turn assume that a contemporary artist is just a bungler when it comes to traditional art and simply relies on innovation to hide his potential bungling, so that we might well consider his innovation, too, to be worthless. This critique is partly right. It makes it clear that every sacrifice presupposes the possibility of choosing to make a sacrifice. A shepherd who happens to stray into the same barren region in which the saintly hermit is struggling to save his soul does not thereby become saintly himself. Since we cannot objectively verify inner value, the critique continues, we should not really talk about asceticism or sacrifice or innovative exchange at all, for such exchange would only turn out to be clever dupery. At first sight, this critique is persuasive. We must therefore take a closer look at it.

The weak point in it resides in the fact that it considers the interpretation of the sacrifice qua sacrifice as something external to the sacrifice itself. Even if an artist were incapable of producing traditional values, his innovation would consist in the fact that he had introduced this incapability into valorized culture as a value by means of a certain interpretation: innovation here would be less the work of art as such, in its immediate materiality, than the interpretation immanent in this work of art, which confers the dignity of a cultural sign on a profane thing. Thanks to the culturally established interpretation that identifies a non-traditional or 'unsuccessful' work as a sacrifice of tradition, value is conferred on this work and its author – regardless of whether and to what extent the author has proven himself capable of producing traditional art.

It is common knowledge that Nietzsche did not inveigh against Christian asceticism light-heartedly. We know that he was a very sick man who was utterly incapable of enjoying bodily pleasures. That, however, means that his attacks on the ideals of asceticism were already, in and of themselves, a form of asceticism. Nietzsche

conquers in his imagination, as it were, the profane territory of the will to power, which, in its way, resembles the profane wilderness in which the saint seeks salvation. To be an ascetic in the Christian civilization that valorized asceticism is to reject asceticism. Nietzsche's rhetoric is as effective as it is because living in the world is, for him, intensified suffering – a still more radical kind of suffering than that endured in the relative security of Christian asceticism. Thus Nietzsche himself reproduces the figure of innovative exchange that he criticizes in others, by virtue of the way he criticizes it. It is only because he interprets the world as it is in a new way as a place of suffering that he introduces worldly existence, by means of this interpretation, into the ascetic tradition. That, however, means that the only way to make a critical exit from the figure of innovative exchange is to repeat it. Innovative exchange is sincere and authentic only when it can refer to the way the boundary between the valorized and the profane runs in a given place at a given time – but not in a belief in the 'truthfulness' of what is said. According to church doctrine, sacraments and rituals are valid regardless of whether the clergyman who performs them believes in them.

The modern artist, like the saint of times past, has no skills, specific talents, or social position. The mechanism of innovation allows him to attain cultural value in the absence of all 'pre-value', that is, without already being 'somebody'. In this respect, the artist differs from the scholar or manager, who has to prove his capabilities within the framework of a pre-established system. In that sense, the modern artist is an 'everyman', and that, precisely, is why his fate is paradigmatic. Yet the subjective suffering of martyrdom is also incapable of grounding the value of the new. The suffering that, in an earlier day, the *poète maudit* had to endure was still a sign of society's rejection of the new. Replacing public punishment, it constituted inner atonement for the new, making social persecution superfluous. The new, however, is also quite easily imaginable and justifiable without suffering.

For innovation can, in its turn, be interpreted on two different levels with equal justification. One is the level of valorized cultural tradition, on which it is conceived as sacral sacrifice, asceticism, and Christian purification; it exchanges the cultural tradition's values and goods for profane things lacking value. On the other level, innovation may be regarded as a speculative commercial operation that confers a new value on valueless things by expanding culture. Thus the Christian ascetic may be interpreted as a conqueror of new territories: the sacrifice of tradition accordingly becomes a conquest of the profane realm for tradition. Flight into the wilderness becomes conquest of the wilderness.[1] In this way, modern art, too, may be interpreted as, not an art that makes sacrifices, but, rather, one that conquers new fields of profane life.

Both these interpretative approaches may be found in every discourse about innovation. It is as impossible completely to eliminate one of them as it is to bring them to a synthesis. Every attempt to present sacral sacrifice as absolute founders on the incontrovertible fact that such sacrifice always presupposes recompense – not in the next world, but precisely in the context of existing culture. Thus the contemporary artist who sacrifices tradition is aware from the outset that his sacrifice will be rewarded – with commercial success as well – if only he manages to introduce something new into the valorized context. The interpretation of innovation as sacrifice is thus not the only possible one.

It is, however, quite as impossible to carry out the opposite programme, which aims to reduce innovative exchange to its commercial effect. In this perspective, innovation is conceived only as a clever form of deception that must be unmasked as such because it is supposed to create the illusion of sacrifice or to imitate it. Yet this

1 See the description of deterritorialization and reterritorialization in Gilles Deleuze and Félix Guattari, *Anti-Oedipus: Capitalism and Schizophrenia*, trans. Robert Hurley et al., Minneapolis, 1983, pp. 240–62.

unmasking proves unfruitful inasmuch as it always succeeds. Here the point is not that the unmasking of ideological deception repro- duces, since it replaces the 'high' explanation of cultural innovation with a 'lower' one, precisely the figure of innovative exchange that it aims to unmask. The point is, rather, that imitation of innovation is indistinguishable from innovation itself. This distinction, for its part, would only be possible if the collation of the culturally valor- ized and the profane could be endlessly repeated. For this reason, the operation of innovation itself contains two value levels, like the works of art or theoretical discourses that issue from it: every inno- vation is a sacrifice and, simultaneously, a conquest. These two value levels can, it is true, be distinguished, but neither can be elimi- nated, and they generate, in their turn, an inner tension that constitutes the real charm of all innovation.

The traditional hierarchy of these two levels of interpretation rests on the assumption that one way of consuming value is superior to others, or of greater value. Valorized value consumption is imag- ined as luxury, destruction, sacrifice, waste, or asceticism. Bataille has shown that there is something common to all the different ways of destroying or wasting and that they together constitute a sacral, aristocratic form of consumption.² Another, 'lower' way of consuming value consists in using it to productive ends, in using some things to produce others: instrumentalizing culture or treating it in utilitarian fashion. The utilitarian consumption of cultural values is especially contrary to the spirit of traditional culture, for

2 'What is important is to pass from a lasting order, in which all consumption of resources is subordinated to the need for duration, to the violence of an unconditional consumption . . . Sacrifice is the antithesis of production, which is accomplished with a view to the future; it is consumption that is concerned only with the moment . . . This is so clearly the precise meaning of sacrifice, that one sacrifices *what is useful*, one does not sacrifice luxurious objects . . . Now, depriving the labour of manufacture of its usefulness at the outset, luxury has already *destroyed* that labour; it has dissipated it in vainglory; in the very moment, it has lost it for good. To sacrifice a luxury object would be to sacrifice the same object twice' (Georges Bataille, *Theory of Religion*, trans. Robert Hurley, New York, 1992, pp. 49–50).

which outright destruction is less repugnant than profanation through instrumentalization. Be it added that Bataille regards the 'potlatch' as the archetype of the economy of sacrifice and shows that this economy, too, generates profit.[3]

In this economy, sacrifice is always rewarded, because it obliges the other to make a counter-sacrifice. Bataille, it is true, notes the decline of this type of economy in the contemporary world, but he fails to see that a similar sort of compensation continues to exist in culture, since the profane, valueless things that one receives in return for one's sacrifice become values themselves. The distinction that he draws nevertheless exactly pinpoints the two levels in the figure of innovation conceived as exchange, and simultaneously seizes the difference in value between them.

It might seem that, as a result of innovative exchange, which triumphed in early modernity, traditional, aristocratic cultural forms of the consumption or destruction of culture were definitively devalorized, while profane forms were valorized. Modernity has, therefore, frequently spawned critiques of 'monastic' and, more generally, all purely contemplative ways of life, which are today viewed in a purely negative light because they are associated with the unproductive use of energy and things. It is true that contemplative life does not produce new things, but, rather, uses or consumes already existing things differently. In modernity, consequently, contemplation is always opposed to creative work, which is understood as a particularly intensive kind of production.[4] On closer inspection, however, it appears that production itself is just a particular form of consumption, whereas pure contemplation, that is, pure consumption, is capable of generating new values.

3 See the chapter entitled 'The Historical Data I: The Society of Consumption' in Georges Bataille, *The Accursed Share*, trans. Robert Hurley, New York, 1991, pp. 45–81.

4 On the relationship between contemplation and creativity, see Boris Groys, 'Jenseits der Kreativität', in Hans Thomas, ed., *Chancen einer Kultur der Arbeit*, Cologne, 1990.

The main reason for this resides in the fact that it is only when new forms of consumption are created that the production required to provide for this consumption also comes about. In the final analysis, innovative practice is therefore not production, labour, or the creation of aesthetic forms – which is to be understood as a continuation of valorized culture – but a contemplative transformation in modes of consumption, a new way of handling things as well as a valorization/devalorization of them. Earlier, innovative exchange in the sphere of consumption was a matter for the aristocracy and for religion. Today, art carries it out in more professional fashion. The commercialization of this valorization spawns fashions, in reaction to which there takes place another innovative exchange that yields to commercialization in its turn. The contemplative treatment of cultural values, which means the pure consumption, destruction, and wasting of them, thus continues to matter even in our production-oriented culture. The deeper reason for this surely resides in the fact that the process of production embodies a constant threat, which is conjured away in contemplative cultural forms. As has already been shown, the profane is an inexhaustible source of anxiety about the total destruction of culture and all its values as well as the complete elimination of every cultural hierarchy. Every critique of culture, including the most radical, is therefore hailed and valorized by culture itself, for such critiques remain, after all, intra-cultural. It has long since been established that the most destructive, diabolical, aggressive, negative, and profane cultural texts are welcomed by culture, whereas no 'affirmative', well-meaning, conformist text can have real cultural success.

The man of culture, who basically lives in constant fear that the whole of culture will one day disappear for good and all and that, as a result, all historical memory of him will be lost after his biological death, is happy to identify, symbolically, with the profane forces that might destroy culture so that, just as symbolically, he may survive the coming destruction of cultural values along with these

forces. Primitive peoples identify with the natural forces that threaten them so that, thanks to this magic ruse, they will be those forces' allies when the decisive moment comes. That is why contemporary culture, too, is filled with things and signs of the valueless, profane, anonymous, aggressive, repressed, and negligible – with everything, precisely, that threatens to deceive its attention, take it by surprise, and ruin it. All these things are valorized as ways of magically conjuring away the imagined catastrophe and the disappearance of culture in the profane realm. The zone of danger can of course never be exhausted once and for all, and even old, familiar cultural manifestations can become dangerous again if they are subjected to commercialization and profanation, that is, if they lose the power of conjuration that was originally theirs. The new is thus no new form that one or another external feature distinguishes from old forms. The new is a new object of fear, a new danger, a new valorized, dangerous profane.

Danger always proceeds from something that people fail to see, something against which they are not forearmed, something that is not at the centre of their attention. Yet it is precisely from this hidden source that salvation can also come. Life in the cultural system is guided by fixed rules. When we play chess, we do not assume that we or our opponent can suddenly be killed by one of the chessmen during the match. The structuralists, Wittgenstein, and many others both before and after them regard the whole gamut of human activities as a game with rules that are unconsciously determinant, albeit not always objects of reflection. Reality, however, differs from games in that the danger of an illicit move lurks within it, so that we have to be prepared for surprise attacks launched from unperceived profane zones. The structuralists or Wittgenstein himself, be it added, were hardly playing by the ordinary rules when they declared that following the rules was not a conscious, but an unconscious operation, thereby putting philosophical discourse and everyday language on the same level.

When an artist or a philosopher turns to the profane and valorizes it, he not only confers cultural value on the profane, valueless, democratic, hidden, and repressed, but also neutralizes the danger of total destruction and death emanating from it. This triumph over danger does not have to be specially described and mythologized. It suffices to show that culture withstands the aggression of the profane and survives it. The Marquis de Sade, for example, ranks as one of the cultural heroes of modern times because, in his texts, literature withstands something that it fails to in other texts. So does Goya, because painting, in his case, comes to terms with more than it did previously.[5] Of course, the threat to cultural memory does not emanate from brute force alone, but also from the stupid, dull, pedestrian, and kitsch, in all of which that memory disintegrates. Depiction of the banal and pedestrian is, therefore, a favourite theme in modernity, especially from the latter half of the nineteenth century down to our own day.[6] Yet the more directly and explicitly violence or banality are criticized, the less successfully they are valorized. A feeling of dissatisfaction arises, because we sense that the author has availed himself of already valorized criteria and means in order to diminish the mighty force of the profane and that, as a result, he has not sufficiently immunized culture against the threat of the profane. Critical distance of any kind brings the whole enterprise to ruin. Only if the artist loves the profane in its utter

5 For a theory of modern literature as both a thematization and, because it deviates from traditional aesthetic models, an incarnation of evil, see Mario Praz, *The Romantic Agony*, New York, 1956. For another significant theory of romantic poetry as an 'evil' intergenerational struggle waged with the weapons of rhetoric, see Harold Bloom, *The Anxiety of Influence: A Theory of Poetry*, New York, 1973.

On transgression in Sade and Goya, see Bataille, *Literature and Evil*, pp. 103–30, and idem, *The Tears of Eros*, trans. Peter Connor, San Francisco, 1989, pp. 103–37.

6 'It is our duty to take into account the various motives which may decide a man to go and live among such vulgar and imbecile personages, as satire and comedy require. In the case of Flaubert, to go no farther than he, "style" was not the whole of the story. Like any Christian martyr, he went and established himself in the centre of the bourgeois body' (Wyndham Lewis, 'The Greatest Satire is Non-Moral', in Julian Symons, ed., *The Essential Wyndham Lewis*, London, 1989, p. 230).

profaneness, loathsomeness, triviality, or cruelty, and induces us to let ourselves be captivated by the profane, to love it, wax enthusiastic over it, and experience it as a veritable cultural value, only then is his victory over the threat emanating from the profane so significant that culture ranks him among its heroes.

This new religion's shrines are the art museums in modern Western city centres, which are gradually absorbing the Christian churches and imperceptibly transforming them into subdivisions of themselves. It is the religion of historical transcendence, of the survival, unscathed, of the individual human being in historical archives, since that is the sole form of personal immortality within most people's reach in today's technicized world. That is why modern art museums are full of testimonials to asceticism and sacrifices endured for the sake of this historical immortality – full, that is, of refuse, ugly representations of violence or ecstasy, uninspired geometrism, and runny colours. That is why contemporary philosophy and literature, too, are full of comparable texts. This artistic presentation of the traces of torment and the soul's suffering is reminiscent of the icons representing Christian saints together with the instruments of their martyrdom. The secularization of art in the modern period has led to a situation in which art must take martyrdom and asceticism upon itself, whereas it only illustrated them in the past. It has no choice but to love its enemies.[7]

Of course, no single innovative act can definitively save a soul. For cultural values and profane things never form the kind of indestructible synthesis that might once and for all free culture of its anxiety and stabilize its valorized memory. As we have said, every work of art is always internally divided into two different value levels and thus constitutes, as it were, a conjuration of the profane

7 On the transition from the image of martyrdom to the martyrdom of the image, see Boris Groys, 'Das leidende Bild', in Peter Weibel and Christian Meyer, eds., *Das Bild nach dem letzten Bild*, Cologne, 1991, pp. 102ff.

as well as a vivid attestation of the failure and futility of every martyrdom. Still more, every innovative work of art presents itself, as we have said, not only as a redemptive sacrifice, but also as a worthwhile exchange, in which formerly profane things acquire a value in culture and become the fashion or even the norm, while other things are rendered profane, fall out of fashion, and are defined as kitsch – until the next innovation comes along. Hence a museum can also be described as a kind of bank for cultural values that keeps these values in constant circulation and has to exchange them for profane things in order to guarantee their market value, just as money would lose value if it were left in a bank account and were never put into circulation.

To advance this second description of innovation in terms of the market economy is not to deny the validity of the first, neo-sacral presentation of it. The commercial aspect of exchange has accompanied every sacral cult. The priestly caste has in all periods been accused of greed and deception. Chasing the merchants from the temple has always been the most common form of innovation, and has always led to their return to the new temple built to replace the old one. Criticism of the art market was typical of the early avant-garde period in particular, when the pathos of sacrifice was most immediately felt. Somewhat later, in contrast, a valorization of the commercial aspect of art could be observed. Today, for example, it is completely old-fashioned to believe that artists are motivated to produce art by a holy love of art and the wish to save humanity. Even if an artist is occasionally visited by such notions, he suppresses them and says nothing about them, since they are considered corny, banal, and presumptuous in our day and age. Today, as a rule, artists present themselves as businessmen and entrepreneurs with more business acumen than the average entrepreneur. Thus the commercial aspect of innovation is repeatedly valorized over against its sacral aspect. In this way, both aspects are incessantly exchanged one for the other, thanks to all sorts of innovative

interpretations. It is quite conceivable that a new neo-sacral mood will one day arise in art. If it does, it will be pedestrian and passé to talk about money, and up-to-date and valorized to talk about spirit, asceticism, and sacrifice. Thus interpretations of innovative exchange are also hierarchically ordered and integrated into the strategy of innovative exchange that they seek to describe.

This becomes especially obvious when innovative exchange is made out to be an instantiation of ordinary cultural exchange by extrapolating the modified ecological argument to an interpretation of innovative exchange. Here the threat emanating from the profane, which was so intensively felt in modernity, disappears. What ensues is the end of the end, the apocalypse of the apocalypse: the profane and its menace are drowned in the infinite, quasi-cultural network of unconscious differences.

Derrida, for example, defines the archive, not as values explicitly preserved in museums, libraries, or similar cultural strongholds, but, rather, as endless textuality, in which the hierarchical difference between the culturally valorized and the profane is effaced. It then appears that the explicitly organized cultural memory is just the tip of the iceberg: the profane realm comprising the iceberg proper is not organized any differently than valorized cultural memory; the profane, in its endlessness, is always already structured, differentiated, 'written'.[8] For Baudrillard, the exchange of the simulacra is all-inclusive and does not admit of a distinction between reality and simulation, or culture, with the result that innovative exchange here again becomes part of this generalized exchange of simulacra. Many other postmodern theories deploy a similar strategy, dissolving innovation in unconscious cultural differences.

We have, however, already shown that equality amid alterity is, in its turn, an effect of innovative exchange thanks to which the profane

8 For poststructuralist theory, what is not-text is also textual, what is not-sign is also sign, what is not-structure is also structured.

has the same structural organization on the unconscious level as valorized cultural memory has on the conscious level. Postmodern theories rob innovation of its acuity, yet are themselves events that comprise an innovation – supposedly the last possible innovation, as they try to demonstrate in very traditional fashion. This demonstration associates the culturally valuable with consciousness, signs, the identical, and the true, while associating the profane with the unconscious, the material, and the different. Postmodern theories carry out a revaluation of values – or are themselves a part of this revaluation, insofar as they appeal to a textuality or a simulation that contains both value levels. For textuality or simulation are structured like culture and are profane because they are material. It has, however, already been shown that the culturally valorized and the profane cannot be brought into one-to-one relation with metaphysical oppositions such as consciousness vs. the unconscious, sign vs. matter, inside vs. outside, or signifier vs. signified. The revaluation of metaphysical values means simply that cultural value boundaries have been displaced, not definitively overcome or dissolved.

In postmodern theories, the attempt is made, in very elegant and in fact very traditional fashion, to reconcile the two value levels of interpretation. Thus it is claimed that the external threat emanating from the profane or 'the real', the threat because of which sacral sacrifices are made, is illusory. This amounts to opting for the second 'low' or profane interpretative mode, which considers the conjuration of the external threat to be ideological deception. Yet it is also affirmed that this illusion of a threat emanating from the real is 'necessary' to the extent that, far from representing a malicious invention by an artist or a theoretician, it is inevitably engendered by culture itself.[9] The author deceives, but he is necessarily also

9 'The enjoyment of the *thing itself* is thus undermined, in its act and in its essence, by frustration . . . Something promises itself as it escapes, gives itself as it moves away, and strictly speaking it cannot even be called presence. Such is the constraint of the supplement, such, exceeding all the language of metaphysics, is this structure "almost inconceivable to reason." *Almost*

deceived. Whereas the classical avant-garde hero was sometimes represented as an evil genius who violated culture's laws and traditions in order to test its capacity for resistance, today it is a question, rather, of the compulsive desire to leave the realm of valorized culture behind, under the influence of the illusion, produced by culture itself, of an extra-cultural meaning, referent, or being.

However, just as imitation of innovation in no way differs from 'authentic' innovation, so the fantasy of annihilation of cultural memory in no way differs from the danger of its real annihilation. If one admits the possibility of an infinite textuality, an infinite play of simulacra, an infinite desire, an infinite difference, and an infinite process of interpretation, all without beginning or end, apocalypse does indeed turn out to be illusory. But it can also be said, with greater justification, that all these infinities are themselves fantasies. That is, the infinity of textuality or difference has the same function of protecting culture from destruction that reason or transcendental subjectivity once did. If reason once laid claim to an absolute self-evidence that was not threatened by any destruction of culture, today cultural discourse claims that it is itself such a destructive, deconstructive, critical force that no reality can resist, not even the reality of profane destruction. But then, ultimately, the discourse about reality again assumes higher value and rank than reality itself.

inconceivable: simple irrationality, the opposite of reason, are less irritating and waylaying for classical logic. The supplement is maddening because it is neither presence nor absence and because it consequently breaches both our pleasure and our virginity' (Jacques Derrida, *Of Grammatology*, trans. Gayatri Chakravorty Spivak, Baltimore, 1976, p. 154).

The sign leads us into temptation inasmuch as it refers to the signified and simultaneously hides and replaces it. The signifier is thus a sign of the defeat, deferral, différance of desire – above all, of the desire for truth. Thus Derrida has yet to consider the possibility, announced by Nietzsche, that desire *wants*, not the signified, but, precisely, the signifier, and is therefore not frustrated or obliged to make do with a surrogate because, from the very beginning, it was in quest of a surrogate, the sign, value (see Chapter 20, n. 2).

19

Cultural Value Boundaries and Social Inequality

The relative stability of the hierarchical boundaries between culture and the profane in every act of innovative exchange of whatever kind is often interpreted as the stability of the system of social inequality. Here valorized culture is identified with the culture of the privileged social classes, and the profane realm with that of the oppressed classes.[1] This model of the inequality of values is well known and should not be associated with Marxism alone. This model has it that the ruling culture is the culture of the ruling class and reflects the worldview specific to it. The unprivileged classes accordingly fail to appear in the cultural archive, since they are culturally oppressed by certain power mechanisms. In this way, the aristocracy's or bourgeoisie's culture is counterposed to that of

1 'The current "postmodernist" debate is first and foremost a product of significant First World reflections upon the decentering of Europe that take such forms as the demystification of European cultural predominance and the deconstruction of European philosophical edifices . . . Derrida's own marginal status as an Algerian (a special kind of French colonial subject) and a Jew may indeed lead him to highlight the transgressive and disruptive aspects of Nietzsche and Heidegger, Mallarmé and Artaud. Yet his project remains a thoroughly Eurocentric and modernist one. It could signify the absence and silence of those viewed as other, alien, marginal – Third World peoples, women, gays, lesbians – as well as their relative political impotence in creatively transforming the legacy of the age of Europe' (Cornel West, 'Black Culture and Postmodernism', in Barbara Kruger and Phil Mariani, eds., *Remaking History*, Dia Art Foundation Discussions in Contemporary Culture, no. 4, Seattle, 1989, p. 88).

cultural minorities, which are defined in various ways, depending on the preferences of the theoretician involved. The conclusion runs that an effort must be made to secure representation for these minorities in order to democratize the cultural archive.

The relationship between valorized culture and the profane realm is thus naturalized, or, rather, sociologically defined. Cultural individuality is made to depend on natural, social, 'human' individuality. In this politicized form, the old Romantic precept lives on in our times, too: become who you are.

Here we may begin by noting that individuality is, in and of itself, the result of a certain form of repression, violence, or constraint.[2] Hence the demand to 'liberate individuality' is paradoxical, because it presupposes the suppression of all the constraints and distinctions that in fact engender individuality. Liberated individuality automatically ceases to be individual. All attempts to depict the cultural archive as a system for representing natural or social distinctions anterior to it are inevitably caught up in contradictions.

Every cultural initiation begins by clarifying what is, on the one hand, culturally privileged, admissible, valuable, and established, what is preserved and reproduced, and, on the other, what lies outside culture. All the members of a society who belong to a given culture are equally familiar with this distinction, although they may not all have equally thorough knowledge of it. They all know that culture comprises museums, theatres, concert halls, libraries, and universities, while everything else is 'just life'. A society's more affluent component can of course become a bigger consumer of valorized culture and identify more closely with it. But that does not at all mean that this

2 'The problem is, however, that when we discard hierarchies we also discard *difference* in this case, and it is difference, the interplay of dissimilarities, that gives meaning and significance of every kind: linguistic, social, political, and ethical' (Lars Nittve, 'From "Implosion" to "Trans/ Mission": Notes Surrounding a Project', in *Kunst & Museumjournaal* 3:1, 1991, p. 32).

traditional valorized culture expresses, in any way, shape, or form, the privileged classes' spontaneous worldview, spontaneous taste, or spontaneous interests. The representatives of these classes find traditional culture ready to hand and appropriate it through education and training.

The unprivileged classes, for their part, naturally receive the corresponding education to a lesser degree. Their cultural habits consequently diverge more or less sharply from valorized notions and norms. They are not, however, conscious of this difference as constituting a specific cultural type; rather, they think of their cultural praxis as 'non-culture' or 'partial culture', as one leg of the path leading to culture. Thus someone who cannot yet draw well usually considers his botched drawings, not as a specific type of drawing that is, qualitatively speaking, the equal of any other, but only as a more or less successful attempt to approximate an ideal of drawing that he holds in common with all the rest of society.

In order to understand profane 'non-culture' as a special, innovative type of culture that can be put on a level with tradition, one has to aestheticize, from the outside, the cultural practice of unprivileged social classes, primitive peoples, or people who deviate psychically from the valorized norm, and contrast it with traditional models by deploying the strategy of negative adaptation. When the various subcultures are raised to the level of valorized culture, this valorized representation usually provokes – not accidentally – a sharp negative reaction from, in particular, those who are supposed to be represented by it. Thus avant-garde art was not accepted by a broad public early in the twentieth century, because it raised elements from the sphere of everyday life to the level of cultural values, elements that this public, which had to do with them on a daily basis, regarded as 'uncultural' and therefore sought to put behind it. An artist who gives a certain form to the profanity of the profane realm, to its bad taste,

banality, ineptitude, indigence, and primitiveness, thereby deprives the public of the cherished illusion that it can close the distance between itself and coveted valorized culture, graphically demonstrating that public's lack of success on this path. Avant-garde art, which attempted to represent the unprivileged social classes' subcultures in the valorized context, was for that very reason often accused of denigrating these subcultures. For representation of a given subculture presupposes that the accent be put on the real distance between it and the valorized culture that appears before it as an ideal. Only in this way is it possible to demonstrate the alterity of this subculture vis-à-vis valorized culture. The Russian avant-garde's fate is especially typical: after the revolution, avant-garde art was rejected as denigration by the very worker and peasant masses whose specific culture the avant-garde had sought to represent.[3] These masses wanted, rather, to rise above their actual cultural station and stand on the same cultural level as the recently overthrown privileged classes.

When such opposition to attempts to represent the unprivileged classes' subculture comes from those classes themselves, avant-garde criticism often makes fun of it as yet another symptom of their lack of culture. This is a tell-tale criticism. It shows that these classes, with their negative attitude toward a democratic politics of representation that seemingly seeks to promote their own welfare, are not so wrong after all. For such representation does indeed deprive the unprivileged classes of their chance to accede to valorized culture for good and all. An unprivileged position in culture gives rise to the dream of overcoming that position. Hence one often hears the remark: 'I don't only want to see what already exists in life; I want something different, something finer and more beautiful.' Then, however, it suddenly appears that the valorized culture

3 For a discussion of this issue, see, for example, Regine Robin, 'Stalinism and Popular Culture', in Hans Guenther, ed., *The Culture of the Stalin Period*, London, 1990, pp. 15–40.

thus aspired to is no longer any such thing and that all effort was vain, because the revalorization of the profane and devalorization of the cultural and beautiful have already occurred. With that, the 'little man' is permanently deprived of his cultural perspective. The other, that is, valorized culture, has appropriated his own practice, so that he sees only his own, alienated image in it, which he is now no longer able to overcome. Hence only the agents of valorized culture benefit from the new cultural fashions that incessantly appear, employing, time and again, various things and signs drawn from unprivileged, subcultural practices; for only agents of valorized culture utilize those subcultural practices as the new in the valorized, elitist context of the cultural archive. This circumstance has, to be sure, not gone unnoticed. A number of authors have recently pointed out that a kind of aesthetic exploitation of unprivileged subculture is common practice in contemporary culture.[4] The unprivileged social strata are, the argument runs, exploited not only economically, socially, and politically, but culturally as well, when the things and signs of their cultural practices are used for exclusive cultural fashions from which they themselves are

4 'The avant-garde's function, then, is to serve the culture industry as a kind of research and development department: it looks for new fields of social practice that are not yet completely subject to efficient exploitation and makes it possible to recognize and extract them . . . Thus the work of the middlemen between high and low, between the legitimate and illegitimate, makes the avant-garde a crucially important mechanism of the culture industry organized along these lines . . . The cycle of exchange maintained by modernity proceeds in just one direction: appropriation of oppositional practices from above and restitution, to the lower levels, of cultural goods that have been emptied of meaning. When one or another element of the avant-garde's inventions makes its re-entry into the lower zone of mass culture, it does so in a pure form that has been stripped of its original power and genuineness [*Unverfälschtheit*]' (Thomas Crow, 'Moderne und Massenkultur in der bildenden Kunst', in *Texte zur Kunst* 1, 1990, pp. 79–81).
 Thus, for Crow, 'lower practices' stand in 'opposition' to 'high culture' from the outset. In fact, these practices become 'oppositional' only when the avant-garde sets them in opposition to valorized high cultural practices. Thus the avant-garde does not 'empty' lower practices 'of their meaning', but, rather, endows them with meaning by bringing them into meaningful relation with the cultural tradition. When these practices enter lower, mass culture again, they lose their meaning for precisely that reason. Be it added that they retain their 'power' – not, however, their genuineness, since, outside the high cultural context, they are absolutely incapable of passing for statements with truth value.

excluded. This consideration is, however, itself based on the conviction that the agents of valorized culture are likewise the agents of the ruling class.

This tends to be contradicted by, for example, the phenomenon known as Nietzscheanism and all of turn-of-the-century 'decadent' European culture. It was precisely the ruling classes' culture that was here valorized, stylized, and aestheticized. Before that could happen, however, the subculture of social privilege had first to be understood as a decadent, enervated subculture weary of life that was confronted by a dominant democratic, liberal, late nineteenth-century culture bent on profanation. In other words, the privileged classes' subculture had first to be recognized as culturally unprivileged in order then to be valorized. On closer examination, then, it becomes clear that it is precisely unprivileged cultural practices which are the most productive culturally, because they are more easily presented as new practices. The dominant classes' real subculture is likewise one of the profane practices that, precisely, have first to be valorized.

Thus innovative exchange can be understood in its turn as the democratization, liberalization, and pluralization of the cultural tradition and a radicalization of its elitist pretensions. The first interpretation underscores the rejection of the established criteria and norms that are the determinants of a traditionalistic culture. In the second, innovation is seen as an attempt to take one's distance from the mass diffusion of tradition through education: as soon as the high cultural tradition becomes public property and the cultural elite faces the threat of being swallowed up by the educated masses, this elite opts for the profane and so wins back its exclusive status. Both interpretations are equally relevant and generate tension and insecurity, which necessarily accompany every innovation.

The cultural archive is administered by certain institutions that originate in the past and are turned toward the future. That is why these institutions can also be regarded as a guarantee of sorts for

historical transcendence. The present, however, with all its classes, groups, and privileges, belongs to the profane realm and serves valorized art as no more than a source of raw material. Individuality in valorized culture's historical memory has very little in common with profane individuality and cannot be considered its 'expression': the 'dominant' or 'oppressed' profane is from the outset aestheticized, reduced, and transformed whether it is set in an affirmative or a negative, contrastive relation to valorized culture.

In either case, all those capable of meeting the demands that culture makes of innovative exchange emerge as agents of valorized culture. These agents can be drawn from the widest possible variety of social classes. Characteristic of all of them is a particular kind of betrayal of the classes they come from. The artists and theoreticians are opposed to the bourgeoisie that is the mainstay of the established values of culture, yet they cannot be more closely identified with the other social classes than is called for by their strategies of appropriation and valorization. Even if an artist or a theoretician utilizes things and signs of the social class from which she comes, she has always already detached herself from this class and acquired a capacity for observing it from without. Her sole advantage is the fact that she knows the basic material better, not that she identifies with what she manipulates at the aesthetic level. Indeed, when she makes use of this material, she experiences a twofold estrangement from her original subculture. A writer from the ranks of the proletariat who writes a proletarian novel ceases to be a proletarian in a twofold way. An artist from the Third World who brings what is 'original' and 'different' about her country onto the Western art market already sees her own country through a Western cultural agent's eyes.[5] An innovative artist always comports herself in a

5 On the aesthetic valorization of one's own reality, see Ilya Kabakow and Boris Groys, *Die Kunst des Fliehens*, Munich, 1991, pp. 53ff.

critical, negative, offensive way in the context of her own culture: she transcends its limits, constructing another, foreign, alternative identity. Placed in the context of a different culture, however, the innovative artist begins to revalorize her own culture affirmatively, contrasting it with that of her new cultural surroundings.[6]

The constant exchange between affirmative and critical strategies means only that culture is not by any means the immediate representation of certain social classes or groups. Quite the opposite is the case: the way these groups express themselves depends on the way the boundary between the valorized and the profane happens to run at the time. The tendency to naturalize or sociologize cultural hierarchies is based on the quite naïve belief that the world can be described neutrally, from a position outside culture. We can supposedly study social classes as well as the distribution of power and privilege only in the light of such a description. Yet every description of culture modifies culture itself, which, after the description has been made, looks altogether different than it did before. That is, every descriptive or interpretative activity in culture so modifies the object described that it can no longer be described in the same way after this description, to which it may previously have answered. The difference between valorized culture and the profane realm cannot, consequently, be stabilized sociologically any more than it can be stabilized metaphysically. The truth of any description of culture is included in the innovative exchange, since truth is defined as a relation to the other, the profane, the real. The description of society as a structure that is hierarchically graduated and organized in a particular way, and also subdivided into various classes, races, and social and sexual

6 Thus the avant-garde's valorization of Russian icons and Russian folk art, carried out under the Western avant-garde's influence, had soon bred the feeling that Russian art was superior to the West's: 'It is no exaggeration to say that the new Russian art of the non-objective school, far from "trailing in the West's wake", represented an avant-garde factor in European artistic culture' (Nikolai Taraboukine, *Le dernier tableau: Du chevalet à la machine*, Paris, 1968, p. 45).

groups, thus itself proves to be a cultural fact: the society described in this way is no longer profane, but itself becomes, by virtue of this description, an artefact or a cultural value. The profane is constantly exchanged for culture: that is why the profane is no more an independent variable than culture itself.

20

Thought as Innovative Exchange

Since Descartes, at the latest, thought has been understood in the modern period as a neutral principle that subordinates all value hierarchies to itself. Religious convictions, traditional wisdom, the socially established principles of law, and ethical and aesthetic norms alike are treated as contents for thought or modes of thought, as are everyday affairs and profane life strategies and opinions. It is important here that thought be grasped as an independent principle which is indifferent toward what is thought and which thus establishes – if not in the real, then at least in itself – equality between entities traditionally held to be unequal.

However, as was shown above with the example of the interpretations of innovative exchange, thought, far from constituting a uniform, homogeneous, neutral process, involves two different operations. The fact that the word 'thought' is used to designate both simply masks their heterogeneity. These two operations are, once again, devalorization of the valuable and valorization of the valueless. When traditional, authoritative values are thought, they are devalorized, because they are reduced to 'just thoughts'. When valueless, profane, everyday phenomena are thought, they are elevated to the level of 'thoughts', their value rises, and they are valorized. Thinking the culturally valuable and thinking the profane are thus two processes oriented in fundamentally different

directions; these processes should not, in fact, be designated by the same word and so homogenized.

To confer homogeneity upon thought, it is usually anchored in one or another set of principles transcending culture: the ego, transcendental or phenomenological subjectivity, absolute spirit, or various formal-logical systems. These and like ways of grounding thought cannot, however, be justified by thought itself: if they could be, they would be devalorized as soon as they were thought. Thus thought is ultimately incapable of grounding itself. If, however, we grant that thinking is no neutral, homogeneous process, but a heterogeneous process that is carried out as an innovative exchange, there is no need whatever to ground thought in a supplementary principle that holds sway outside culture. Thought is already sufficiently justified by the fact that it obeys cultural-economic logic. Every innovative exchange reiterates, in a certain sense, all other instantiations of innovative exchange, which is therefore itself not original, even if it brings the new into being. Since innovative exchange is not original, it, too, requires no special justification.

When Descartes proclaimed the primacy of thought, which he conceived as methodological doubt, he devalorized traditional sacral knowledge and revalorized the new type of scientific-mathematical thought that had previously ranked lower in the value hierarchy. With that, there emerged a new zone of the profane encompassing all the traditional cultural notions of all countries and peoples, which, in Enlightenment perspective, appeared to be curious aberrations. After this total devalorization, however, earlier cultural forms of thought could be revalorized again, this time as historical testimonials. Hegelian historicism then emerged, for which even opinions that positive science considered false acquired value owing to the fact that they represented particular, historically necessary forms of thought.

The subsequent critique of both Enlightenment and historicist conceptions of thought was bound up with the nascent concept of

the unconscious. An attempt was now made to anchor thought in a domain that could no longer be thought by thought, because it was now regarded as certain that thought inevitably invalidates every higher principle as soon as it begins to think it. Thus the unconscious is here understood as a hidden reality. This reality is no longer described as one that can be cognized by thought, no longer as something identical, present, and given, but, rather, as something hidden, absent, and other – as difference. However, hardly had the unconscious supplanted thought than it, too, began to function like thought, that is, precisely, as innovative exchange.

Thus Nietzsche assumes that thought is heterogeneous and flows from two fundamentally different sources – noble, valuable sources and base, valueless life forms. It is Nietzsche's great merit to have pointed out this internal heterogeneity of thought.[1] Yet while Nietzsche considers thought to be heterogeneous, he regards 'life' as homogeneous, as the universal will to power. For him, 'life' is the successor to thought. By way of an appeal to 'life', he devalorizes the Christian, democratic, liberal values of his day and revalorizes the aristocratic, decadent, marginal life forms that then constituted part of the profane realm. Thus life presents itself as thought's doppelgänger and itself becomes the result of the innovative exchange between normative, rational forms of thought and the deviant, extra-logical ones that are bound up with the experience of ecstasy or self-forgetting and are regarded as profane in the classical conception of thought.[2]

In Freud, the concept of the libido plays this role. It devalorizes classical, logically bound forms of thought, describing them as obsessive or as rationalizations and psychic self-defence.

1 The main question that Nietzsche puts to philosophical thought is: 'What is aristocratic, what is vulgar?' (Friedrich Nietzsche, *Beyond Good and Evil*, trans. Helen Zimmern, New York, 1907, p. 237, no. 263).

2 'Granted that we want the truth: why not rather untruth? And uncertainty? Even ignorance? The problem of the value of truth presented itself before us' (Nietzsche, *Beyond Good and Evil*, p. 5, no. 1).

Simultaneously, the profane forms of everyday language and deviant sexual behaviour are revalorized as keys to the investigation of unconscious life. Theories of the linguistic unconscious work the same way. In them, rational thought is just one form of language among many others, with the result that rational thought is devalorized, while 'irrational' forms of language are valorized because they make it easier to perceive the labour accomplished by language as such. In Marx, in turn, it is the economic unconscious which devalorizes traditional culture as ideological camouflage for economic exploitation while valorizing the proletariat as the embodiment of the principle of economic production.

Thus the various theories of the unconscious, which are themselves forms of innovative exchange, take on the role traditionally played by thought: they simultaneously contain two value levels that refer to both the cultural tradition and the profane realm. The status of the unconscious was assigned to language, the libido, the economy, or life because all these concepts seemed, at first sight, to be more realistic than 'thought', which was criticized for being 'immaterial' and 'idealistic'. At the same time, however, these concepts acquired, in the course of their transformation into the unconscious, the universality once possessed by thought alone, and, consequently, lost their 'realistic', profane dimension. Naturally, what had earlier happened to thought now happened to the unconscious: inevitably, the appeal to the unconscious began to devalorize the very principles that had been invoked to ground the unconscious. The linguistic unconscious devalorized language by treating it as one particular external practice among others: silence became the domain proper to it.[3] The libido destroyed the prevail-

3 Thus the linguistic unconscious, which, on the assumption of the surrealist theory of language, finds expression in automatic writing (*écriture automatique*), becomes, in Blanchot, the writing of silence: 'Yes, it is endless, it speaks, it does not cease speaking, a language with no silence, for in it silence is spoken' (Maurice Blanchot, *The Space of Literature*, trans. Ann Smock, Lincoln, NE, 1982, p. 181).

ing notion of eros: in Freud, hate and repugnance, too, became manifestations of the libido. Now the proletarian was in power and a hero's death was the supreme form of life. Phenomenological evidence, *aletheia*, became, in Heidegger, the obscurity of the hidden. The consequence was that the unconscious − like thought before it − gradually lost all of its recognizable features.

Today we are obviously experiencing the end of the history of thought and the unconscious. After Heidegger, and under his influence, the unconscious is no longer sought in 'the real', but in the absent, the other, in that which 'ceaselessly eludes the grasp of the concept'. Yet the appeal to the other and to that which is hidden beyond culture is surely still metaphysical, regardless of whether or not it is granted that the other can manifest itself in culture. *Destruktion* or deconstruction of the metaphysical tradition is, tellingly, described as the metaphysical Platonic figure of rememoration of the beyond of valorized cultural memory.[4] Plato manages to accomplish this rememoration, whereas, for Heidegger, it is possible only as a rememoration of the forgottenness of being, which is nevertheless still valorized vis-à-vis the forgetting of this forgottenness. In any case, Heidegger, too, understands the rememoration of extra-cultural reality as such as an overcoming of culture, even if this reality is the hidden that eludes us.[5] With that, however,

4 On Plato's theory of remembering, see especially Plato, 'Meno', 81b–e; idem, 'Phaedo', 72e–77d, especially 73a–e; and idem, 'Phaedrus', 249b–253c. For Derrida, Plato's figuration of memory as reminiscence of the origin leads, precisely because it is impossible to realize, to the discovery of writing: 'Thus, even though writing is external to (internal) memory, it affects memory and hypnotizes it in its very inside. And yet, just as Rousseau and Saussure will do in response to the same necessity, yet without discovering other relations between the intimate and the alien, Plato maintains *both* the exteriority of writing *and* its power of maleficent penetration, its ability to affect or infect what lies deepest inside' (Jacques Derrida, *Dissemination*, trans. Barbara Johnson, New York, 2004, p. 113). Derrida alludes to 'the sage Thoth' in Plato's 'Phaedrus' (274a–277a).

5 'Only what *aletheia* as clearing grants is experienced and thought, not what it is as such. This remains concealed. Does that happen by chance? . . . Or does it happen because self-concealing, concealment, *lethe*, belongs to *a-letheia* . . . as the heart of *aletheia*? If this were so, then only with these questions would we reach the path to the task of thinking at the end of philosophy' (Martin Heidegger, 'The End of Philosophy and the Task of Thinking', trans. Joan Stambaugh, in David

Heidegger merely introduces the profane into the cultural tradition in his turn, as all his terminology indicates: boredom, thrownness, care, decision. For Derrida, difference and textuality play the role thought once did: every discourse about presence, no matter what philosophical school it stems from, is devalorized and deconstructed, but also revalorized after this deconstruction – this time as a discourse about non-presence.[6] Correspondingly, deconstructive reading valorizes everything in these discourses that earlier, as the purely profane, was not an explicit theme in them. Now traces of the other are sought precisely in unspectacular metaphors or grammatical forms. Thus, here too, the other turns out to be the valorized profane, which, because it cannot be subsumed under any cultural concept, holds out the prospect of infinite deconstructive labour.

Many contemporary authors talk about infinite desire, infinite discourse, infinite dialogue, the infinity of possible interpretations, the infinitely sublime, and so on. All these infinities play, as always, the traditional role of devalorization of the valuable and valorization of the valueless and aberrant, for there can of course be no inequality in the face of the infinite. In reality, we no longer have to do with the infinitely hidden at all, but only with intracultural conjurations of the hidden and the other – with the concrete discourses of Derrida, Deleuze, Lyotard, or Baudrillard, which valorize various zones of the profane. If these discourses are culturally effective and productive – and they certainly are – it is only because they obey the cultural-economic logic of innovative exchange.

Farrell Krell, ed., *Basic Writings from* Being and Time *(1927) to* The Task of Thinking *(1964)*, 2nd ed., London, 1993, p. 448).

6 In this sense, deconstruction is not a critique that aims to reach truth by overcoming the text. Derrida reads Rousseau's text, for example, as a chain of supplements that follows the movement of différance: 'The concept of the supplement is a sort of blind spot in Rousseau's text, the not-seen that opens and limits visibility' (Derrida, *Of Grammatology*, p. 163). And, in this sense, no writer or interpreter is in a better or a worse position than Rousseau himself.

That every system of thought lacks an external guarantee means that, at all levels, it is exposed to a risk that can be eliminated neither by some ultimate truth nor by an appeal to the infinity of commentaries, interpretations, discussions, or investigations, since the event of thought is always a finite event. This risk is inevitable, but it is by no means merely negative: it also constitutes the condition for the intensity and appeal of thought. Above all, thought runs the permanent risk of simply ceasing to be innovative and becoming boring. In the moment in which a discourse is fascinating and innovative, it is also true, because it refers to the profane, the extra-cultural, the other. True thought is eventful – and transitory.

A discourse that is still true at one moment is no longer true the next, at the moment it is made public, for it is precisely then that it ceases to refer to the profane which, thanks to it, is no longer profane, but culturally valorized. Simply by referring to the profane, a true discourse alters its status and position with respect to the boundary of culture. This paves the way for a new true discourse that describes a new configuration of this boundary and thereby alters it once again, thus paving the way for the next true description, and so on. The fact that no true description can be definitive is thus due, not to the permanent failure of this description, but, on the contrary, to its relatively frequent success. A successful true description modifies the boundary between the valorized and the profane, divesting itself of its truth by its very success.

Truth is commonly understood as a sign that adequately designates a particular reality. Every sign both refers to and conceals reality, substituting itself for it and masking its non-presence. If the sign completely bares reality, rendering it manifest and uncealed, this sign can pass for the fullness of the truth. If the sign, by itself, completely conceals reality, it is reality's mask, a simulacrum and total illusion. Classical metaphysics was oriented toward the complete unveiling of truth and the complete correspondence of signifier with signified. For the critically oriented theories of

poststructuralism, such a transcendent signifier and correspondence with it constitute an illusion generated by the play of signifiers that endlessly refer to each other. In any case, the relationship between valorized culture and the profane, between consciousness and the other, is here conceived as a signifying relationship – regardless of whether it works or not.

Understood semiotically, however, signification is only a variant of the value boundary between culture and the profane. Higher value is sometimes ascribed to the signified, that is, the profane, and sometimes to the signifier, in other words, culture. Yet when the things of the profane world enter the cultural context, they cease to be signifieds and become signifiers. With that, the famous presupposition of the semiotic perspective is refuted. It runs: although, in culture, diverse sign systems, such as ideologies, languages, artistic systems, and worldviews ceaselessly replace one another, the 'world' or 'reality' always remains the same, or ceaselessly eludes us. Reality, however, itself constantly changes, in that it is exchanged for cultural signs. The sign's duality stems from the fact that it has a culturally valorized dimension, that is to say, designates something, and is, at the same time, a profane thing, that is to say, designates nothing. Depending on the historical period, one or the other dimension is actualized. For poststructuralist theory, the sign is always still a sign – even when that which it designates eludes us. However, a signifier that has lost its signified simply becomes a profane thing. It no longer designates anything, or, to put it another way, itself becomes reality.

A valuable object of culture is meaningful [*bedeutend*], important, and on prominent display. It is not, however, meaningful because it has a meaning in the semiotic sense, that is, because it designates something extra-cultural. Having a significant meaning is not the reason something is meaningful. The opposite is the case: when an object is valuable and meaningful, we ascribe a 'deep' or 'lofty' signifying [*signifikativ*] function to it. In terms of

signification, however, meaning is not a distinction of any particular importance: to designate something is utterly trivial, banal, and profane. Valuable, truly meaningful cultural things actually designate nothing at all – they possess a value of their own. And profane texts or things are often valorized precisely because they are nonsensical, absurd, and meaningless in the semiotic sense. It is only *ex post facto* that we ascribe to them the capacity to designate culture's other, the unconscious, the ineffable – and that comes down, in fact, to profaning them.

In the theories of the unconscious, the interaction between culture and the profane realm often takes on the character of a mythical struggle. Marx describes the way reality engenders ideological illusions in consciousness so that it may go unrecognized and pursue the dark business of the exploitation of man by man. Nietzsche and Freud later elaborate similar theories using other material. Yet they, too, fail to see that, in valorizing the unconscious, they devalorize consciousness, leaving it behind them as the burned, profaned earth of traditional culture. Heidegger describes the struggle between culture and the profane, which he calls being, in still more expressive fashion. He forges a full-fledged myth of being, in which being conceals itself precisely at the moment of its unconcealment [*Entbergung*], as something that leaves traces behind and simultaneously effaces them, and also as something that leaves these traces behind by effacing them, and so on. According to Derrida, writing follows similar – and even more complicated – twists and turns. Here the will, desire, life, the unconscious, being, the text, and so on are assigned magical powers and malicious ways. They operate in secret against man and wage a complicated, tactically and strategically wily struggle against culture and thought. Ultimately, even the aspiration to truth turns out to be a deceptive trace that the other leaves behind the better to hide its own absence. These images of struggle are of course much more dramatic, interesting, and fascinating than the sight of

monotonous progress advancing on a set path toward an immobile goal. Yet all this, too, stems from the boundary between culture and its valorized values on the one hand and the profane on the other. It is only thanks to this boundary that culture and the other endlessly succeed one another, doffing and donning disguises in a complicated game as they do.

The theory of innovative exchange put forward in the present book has at least one advantage: it spawns no new mythology. Every time, culture and its other are distinguished anew. There exists no stable, natural difference between them. Every time, we find ourselves facing a world that is hierarchically split up into valorized culture and the profane realm. Every time, we try to mediate between the two and overcome this split. And, every time, the boundary between culture and the profane shifts as a result of this attempt at mediation, without, however, being effaced. The profane is conceived of, and aestheticized, as a prolongation of the cultural tradition itself. Our thinking does indeed attain the profane every time; yet, every time, precisely because it does, it modifies reality and leaves it behind in a state different from what it was when our thought thought it. If thought were neutral and homogeneous, it would have overcome the split between culture and the real. Since, however, the event known as thought is itself heterogeneous, it is not only true, but also always repressive and violent; it therefore always engenders a new profane, a new other, a new real out of the devalorized signs of culture, which may then themselves serve as raw material for thought and, thus, another innovation.

The Author

Despite all that has been said so far, we have not yet provided a satisfactory answer to the following question: Who innovates? Who initiates innovative exchange? It cannot, of course, be the subject of classical philosophy, which, as the word 'sub-ject' in itself indicates, is hidden beneath cultural activity and consequently part of the profane that must itself first be valorized. For a related reason, however, it likewise cannot be the impersonal forces of nature, the unconscious, or the material, which must also first be valorized.

We could give a rather banal answer to the question thus posed – namely, 'the author' – if the concept of authorship were not so controversial in contemporary thought. Everyone has in mind Foucault's remark about the death of man as the author of thought or the creator of new forms and culture.[1] For Heidegger, what speaks is language itself but, by no means, a concrete speaker. The one who speaks tries to lend his words a particular meaning and to 'say' what he 'means',[2] but language does not obey him. No individual can bring

1 See Chapter 11, n. 5.

2 Using Husserl as his example, Derrida criticizes the conception of language as expressivity. He describes this conception as follows: 'If things are thus, discourse will only transport to the exterior a sense that is constituted before it and without it' (Jacques Derrida, 'Form and Meaning: A Note on the Phenomenology of Language', in idem, *Margins of Philosophy*, trans. Alan Bass, Chicago, 1982, pp. 162–3). He goes on to show that the expressive *vouloir-dire* is, from the outset, contaminated by language.

language under his control or lend words his own, arbitrary meanings; at the same time, no one can exhaustively describe, understand, and master the semantic play of language itself. Language is infinite and cannot be described by a determinate, finite semantics, contrary to the assumption of classical structuralism. Everyone who speaks is embedded in language. Language articulates itself in the speaker; the speaker does not articulate himself in language.

Not even that which a speaker takes to be his own 'thoughts' or 'opinions', that which he wishes to express, is his personal property, according to postmodern theory. The body, desire, and the racial and class unconscious speak by way of human beings. The individual's thought swims in the ocean of language games, which are collective and social in nature, yet, at the same time, cannot be controlled by any finite collectivity. This likewise condemns any socialist, totalitarian project to failure. All these projects, vectors of unconscious, corporal, erotic tensions which they seek to overcome, find themselves dissolved by the infinite play of language, writing, and textuality. At issue is not the possibility that the individual's thoughts, opinions, and judgements might be wrong; at issue is the fact that they are not his at all, but, rather, part of a single, constantly developing play of differences, in view of which the concepts of the true and false lose all meaning. Nothing can be exactly repeated or imitated. In this sense, difference automatically guarantees the formal creativity and innovativeness of every new school's founding gesture, even when the latter 'subjectively' aspires to repeat a traditional model. In the same measure, however,

Elsewhere, Derrida writes: '*On the one hand*, expressivism is never simply surpassable . . . The representation of language as "expression" is not an accidental prejudice, but rather a kind of structural lure, what Kant would have called a transcendental illusion . . . *On the other hand*, expressivity is in fact always already surpassed, whether one wishes it or not, whether one knows it or not. In the extent to which . . . there is already a *text*, a network of textual referrals to *other* texts, a textual transformation in which each allegedly "simple term" is marked by the trace of another term, [and] the presumed interiority of meaning is already worked upon by its own exteriority' (Jacques Derrida, *Positions*, trans. Alan Bass, Chicago, 1982, p. 33).

nothing can really be 'original', for no utterance and no text repre-sents more than a moment in the endless play of language, a moment that cannot pretend to detach itself from that play and, conse-quently, dominate it.

The anti-individualist thought of our time as just sketched commands spontaneous assent, whatever the strength of its theo-retical arguments, because it formulates in theoretical terms an experience basic to contemporary civilization. In that civilization, which obviously can no longer be controlled by any human consciousness because of its size, complexity, and specialization, every individual truth claim seems silly and naïve. In contempo-rary civilization, doubtless no discourse can be lordly, sovereign, authoritative, or have the force of law. Yet man's defeat in present-day civilization elicits no particular protest from contemporaries. All have in mind the claim of various individuals and social groups to possess the truth in the last instance, and know only too well what that claim can breed. In view of the theoretical critique, the sovereign individuality of classical philosophy not only has no justification, it also elicits no moral sympathy. That is why this tendency in contemporary thought, which finds its most compre-hensive, consistent expression in poststructuralist French philosophy, seems, on first blush, to be so convincing.

Classical philosophy likewise did not hold that a single human being could, solely by dint of his individual, finite understanding, attain absolute truth. It anchored truth in the infinite – in the idea, reason, absolute spirit, transcendental or phenomenological subjec-tivity, pure logic, or the like – in which finite, individual reason participated only to a limited extent. This participation of finite human reason in an infinite principle was, to be sure, deemed possi-ble, as was the validity of certain criteria by which such participation could be ascertained. To the extent that the participation of the finite in the infinite was recognized as accomplished, the authority of concrete individual thought increased.

In its critique of classical philosophy, modern thought set out from precisely this point. Human existence was acknowledged to be radically finite and the infinite dimension of human consciousness or reason was declared to be an ideological fantasy designed to stabilize the institutions of power, for, the argument ran, the individual could secure his mastery of nature and society thanks only to the appeal to the infinite dimension of his thinking. The critique of ideology attempted to show, in contrast, that every human being was radically limited by his social rank, his position in language, the structure of his unconscious, and the peculiar nature of his desire, so that no one could lay claim to any sort of infinity. The human individual's radical finiteness and the struggle against human reason's claims to infinity comprise the abiding theme of the critical philosophy of modernity in its entirety. This is plain in Marx, Kierkegaard, Nietzsche, and Freud. In Heidegger, it constitutes the main argument against the contemporary technicized thinking that leads us to forget the difference, understood here as the most general designation for finiteness, between the existent and being.

Against the background of this basically critical argument against classical metaphysics, it seems particularly odd and, at the same time, characteristic that the same critique should talk constantly about the infinite: infinite desire, infinite corporality, and the infinite character of interpretation, writing, textuality, deconstruction, laughter, and irony. When we read critical philosophy from Nietzsche to Derrida, we see that it represents life, language, being, the body, the text, and death itself as endlessly laughing at philosophy's pretension to infinity and truth; here the individual philosopher can be nothing more than one instantiation of this infinite laughter. It follows that the philosopher, here as earlier, takes part in an infinite process in a finite way, with the sole difference that it is no longer a matter of an infinite quest for truth, but, rather, of the endless deconstruction of the pretension to truth. An individual text of Derrida's presents itself as not having been written by the author

himself – indeed, as having been produced by no one. All it wants to show is how the text it analyses and deconstructs gets tripped up by its own metaphors, proves incapable of honouring its own claims, and dissolves in the infinite play of differences.[3]

Thus we can see that the basic figure of contemporary criticism does not fundamentally differ from the basic figure of classical thought. This figure is, in both cases, the finite's participation in the infinite. Contemporary critics' texts by no means deny that they are the work of an author out of modesty, but only in order to present themselves as, so to speak, individual manifestations of the infinite powers of the unconscious. To similar ends, philosophers of an earlier day denied that they were the authors of their own thoughts, which they attributed to inspiration by God, nature, the voice of reason, the contemplation of an idea, or the like. Contemporary criticism talks about the fact that it contests every truth claim, every authority, all moralistic, repressive pathos, every tradition and institution of power, without putting any specific new truth – which also means, for this critique, a new value – in their place. The fact that it renounces all claims to value for itself is generally interpreted as proof of special modesty. In practice, however, any claim to value will inevitably be examined and criticized and thus expose the author to danger. If, on the other hand, he makes no claim to being innovative, but only functions as one instantiation of a critique that is actually conducted by life, the text, language, the unconscious, or

3 For Derrida, the text deconstructs itself. It can nonetheless be argued that deconstructive logic, too, does violence to the text: ' "Deconstruction" . . . is another philosophical sublimation of the Oedipal drama of the forced inquiry: text, language, writing oversees its own intentional disintegration. The "text" plays the role of Oedipus, undoing itself for a general sacrificial peace; though it can be argued that Oedipus' inquisitorial self-eradication is a dramatic version of what in fact writing does. But in any case all deconstructions, as Derrida writing about force half-indicates, have eristic elements, and, though "playful", are shaded by inquisition. To "make" the other's text decenter by a reading of disjunctive metaphors reenacts Socrates' forcing of the other into logical self-contradiction – elenchus' (Aaron Fogel, 'Coerced Speech and the Oedipus Dialogue Complex', in Gary S. Morson and Caryl Emerson, eds., *Rethinking Bakhtin*, Evanston, 1989, pp. 179–80).

desire as such, he divests himself of all responsibility – for it is, of course, not all that easy to criticize life itself.

Here the concept of the fragmentary, which has replaced the earlier concept of the example, plays a magical role. Earlier, when developing an idea, one adduced a concrete example. The methodology informing this example was then supposed to be extrapolated to other, similar cases. This practice was later rightly criticized on the grounds that it neglected the specificity of each particular case. Today, criticism is carried out fragmentarily, by way of aphorisms, fragments, or 'open-ended texts', and is supposed, as it were, to be pursued in the same spirit. As was the case earlier, too, the essential closure, finiteness, and mortality of every text, every body, and every desire is thereby denied. No one, for example, can carry on with deconstruction as practised by Derrida: his work is too brilliant, too original, too idiosyncratic, too finite, too mortal. The texts of deconstruction, which quite modestly propose to do no more than fragmentarily reveal the work of a text's unconscious, are in fact brilliant, emphatically individualistic mises-en-scène which associate things that are ordinarily not associated in culture. These associations are surprising, instructive, and innovative, but they are by no means demonstrations of a linguistic or textual unconscious as it is 'in itself'. They have meaning only within the limits of Derrida's own texts. It is always a concrete reader who produces an alternate, 'different' reading of a text, and his interpretation cannot stand as merely one example of a potentially infinite set of possible interpretations. For as long as these interpretations have not been made, there is no saying whether they are possible or not.

Critical philosophy has robbed reason, spirit, and the idea of the value status of infinity and thus devalorized them. In so doing, however, it has invested the body, desire, and the text with the status of the infinite, thus valorizing them. Classical philosophy in the person of Hegel had assumed that valorization without devalorization was possible and that philosophy could permeate the

whole of the profane world. Critical theory today assumes that devalorization without valorization is possible and that one can make fun of everything, deconstruct everything, and treat everything ironically without simultaneously valorizing something else. In practice, this, too, proves impossible. To convince ourselves of it, we need only consider critical philosophy's phenomenally triumphant march through the institutions and its commercial success, as well as the philosophical career of the concepts and methods it has introduced. Taking Freud as his example, Voloshinov shows, for his part, that what psychoanalysis passes off as the voice of the unconscious is just the doctor's or the psychoanalyst's voice.[4] This observation does not imply rejection of the methods and discourse of psychoanalysis. It means only that they bear their author's stamp and have a personal character. What is in question in them is simply their author's artificial, finite mise-en-scène, never the work of the unconscious itself.

This is precisely what classical philosophy was never willing to acknowledge: the personal, purely human nature of every theoretical discourse. The new critical theory, however, is also unwilling to acknowledge it. In its struggle against authorship conceived as authority, poststructuralist criticism carries out a sort of socialization [*Vergesellschaftigung*] of language, the text, and the body. It confiscates them, as it were, seizing what was formerly an individual speaker's or writer's private property. This strategy of socialization has, among other things, a political character and may be traced back to classical socialist ideology: language is for critical theory exactly as impersonal as land or air is in socialist doctrine. The cardinal error of both consists in not seeing that the socialization of language leads not only to the defeat of the dominant individualistic discourse, power institutions, and lordly, sovereign, imperious ideology, but also to that of every individualistic

4 V. N. Voloshinov, *Freudianism*, trans. I. R. Titutnik, ed. Neal H. Bruss, London, 2012.

discourse pursuing, not power, but simply a peaceful, free life on the limited terrain that it has personally wrested from society. Critical theory does not seek a peaceful life for a personal discourse of this kind, but, rather, dispossesses that discourse of its private terrain, declares it public property, and mocks the individual's efforts to claim a linguistic space of his own. The linguistic terrain thus confiscated is not in fact put to public use, but comes under the control of critical theory itself, which administers it on behalf of the absolutely other and hidden.

The question of authorship is indeed unanswerable if one brings the author's works into relation with the profane, the real, or reality. The profane is indeterminate – it is simply outside. One can, with equal justification, say that it is finite or infinite, chaotic or structured like a text. When we view the work in the context of a finite cultural archive, however, we can also talk meaningfully about its finite author and his strategies: Does he engage in positive or negative adaptation to a determinate tradition? Does he engage in some combination of the two? Or does he attempt to involve different traditions?

The question of the work's value is the question of its relation to traditional models, not to the extra-cultural profane; it is not, that is, the question of its truth or meaning. Truth does not ground value; rather, a work's value also makes its relation to the truth interesting. The work's cultural significance [*kulturelle Bedeutung*] alone draws attention to its signifying signification [*signifikante Bedeutung*] as a reference to the extra-cultural signified. Belief in a particular signifier's ability to designate reality better than all others does not introduce inequality among signifiers; this inequality exists prior to any question of truth. That is why withdrawal of the other and doubt about signification also do not lead to the abolition of hierarchical boundaries.

Recognizing an author's value likewise does not mean granting him a privileged place in the profane; privileged access to

extra-cultural reality; a dominant position in culture; or the status of an outstanding personality or even genius. It means, rather, considering him irreplaceable when it comes to ensuring the cultural tradition's continuity. We cannot prove that the profane can become homogeneous or that a single author can represent it in its entirety. But we also cannot prove that the profane is always already heterogeneous and structured as culture, text, or sign-system, so that man is altogether superfluous as a mediator between the cultural and the profane. The author is an agent of both tradition and innovation: he is sufficiently well defined by this role, the one he plays in cultural-economic strategy. Beyond that role and outside it, the question 'What is man?' is irrelevant to an understanding of cultural authorship.

The continuation of the tradition as innovative exchange can appeal to no fixed equivalent here. To be sure, innovation is always first and foremost a repetition of tradition, as we have shown. Hence this recurrent innovative strategy can itself serve, after a fashion, as an equivalent for innovative exchange; but that does not tell us what may be or should be exchanged in each concrete instance, or how. Every innovative exchange calls for a decision and involves an irreducible risk. The author is, here, the individual who takes this risk. That is why the cultural economy is not the same thing as the market, if the market is understood as a system: in the cultural economy, exchange takes place first, and only thereafter is the equivalent of this exchange defined, accepted, or rejected.

Thus no innovative exchange unambiguously ensures a new work a place in the cultural archives, for every innovative work always contains both value levels at once. Since the profane realm comprises all that is non-normative, unvalorized, unsuccessful, valueless, incomplete, non-signifying, and so on, the negatively normative, negatively classic, or negatively adapted work can always simply be judged bad – even when, at another level, it is conceived as original, other, or alternative, and accordingly accepted as an innovative exchange. Thus Duchamp's *Fountain* or

Malevich's *Black Square* may also be interpreted as a bad, ugly, unsuccessful work of art, but, at the same time, as original, new, and path-breaking. Both judgements are equally legitimate; both depend on a particular interpretation, according to which the corresponding things are interpreted either as new or as bad. Neither of these interpretations is guaranteed by anything whatsoever, inasmuch as there exists neither an ontological ground for the norm nor an ontological ground for alterity and non-normativity in general.

The personal nature of innovative exchange is probably its central moment. Hence we should, in closing, bring it out as clearly as we can. Every innovative exchange is carried out in a determinate situation; the author, here, acts as a mediator. If this author wishes to carry on a cultural tradition in order to win a place for herself in that tradition, she has to choose her personal strategy. She can, for instance, learn to master existing cultural norms and perpetuate them in an affirmative sense. Yet, in that case, too, her work will inevitably deviate from the cultural norm, because every human being necessarily makes a personal, and thus partially profane, interpretation of that norm.[5] But she can also perpetuate these norms negatively. Even then, however, her work will be only partly original, for it stands, from the outset, in a relationship to the tradition. She can pursue a consistently innovative strategy and continue the tradition both affirmatively and negatively with a view to creating new value – but in this case as well, nothing guarantees the desired inner tension, since such tension is necessarily evenmental [*ereignishaft*]: it depends on where the boundary between the culturally valuable and the profane lies at any given moment, and that is something no author can see in all its aspects, or fully control.

Thus every cultural strategy is inevitably in jeopardy. An interpretation can always, with good reason, declare a work to be

5 For a comparison of Derridean *différance* with the problematic of rules and respect for rules in Wittgenstein, see Henry Staten, *Wittgenstein and Derrida*, Lincoln, NE, 1984.

without value, along with its author. The author, too, always remains rather profane, attaining immortality in the archive of culture only in isolated cases and conditional fashion, all her cultural efforts notwithstanding. As an author, she is just as self-divided as the products of her traditionalist or innovative practices. No skill, no knowledge, and no social privileges guarantee her success, nor does any sort of authenticity or closeness to the real, profane, and true. An author finds herself bound hand and foot to cultural-economic logic, and quite helpless indeed in the face of it. That is why cultural innovation, precisely, represents the most consistent manifestation of that logic, which operates just as mercilessly, but in secret, in other spheres of life.

Index

abstraction/abstract art, 3, 106
adaptation, positive and negative,
 16–17, 102–3
Adorno, Theodor, 11n
African masks, 116–17
alterity, 44, 110, 122; equality amid,
 45, 160; pluralist, 49; radical, 35;
 utopia of, 51
appropriation, 97, 98, 121, 125
Art and the Aesthetic (Dickie), 88
Artaud, Antonin, 77n3, 163n
asceticism, 129, 153, 160; Christian
 (Protestant), 145, 148, 150–2;
 economy of sacrifice, 149–50;
 secularization of art and, 158
authenticity, 35–6, 38, 45, 133–4, 192
authorship, 182, 190
avant-garde, 8n, 14, 95, 97, 107; art as
 manifestation of hidden reality,
 105; creation out of void and, 75,
 76; cultural objects destroyed
 by, 125; decorative art and, 127;
 destruction equated with

creation, 146–7; everyday life
 and, 165; hero as evil genius,
 162; industrial mass production
 and, 102; Russian, 108, 166
'Avant-garde and Kitsch'
 (Greenberg), 124n16

Bakhtin, Mikhail, 108
Barthes, Roland, 69, 98n
Bataille, Georges, 12n, 113n2, 153–4
Baudelaire, Charles, 22–3n
Baudrillard, Jean, 15n, 16n, 46n, 114,
 160, 177
Benjamin, Walter, 46n, 97, 124
Beuys, Joseph, 94
Bidlo, Mike, 97, 125
Black Square (Malevich), 104, 105,
 147, 191
Boltanski, Christian, 94
Broodthaers, Marcel, 94
Buddhism, 103, 123
Buren, Daniel, 8n

Cameron, Dan, 2n
Chevengur (Platonov), 147
Christianity, 116, 118, 123, 145–6;
 Christian art, 107; churches
 absorbed by art museums, 158;
 hermits, 144–5; renunciation of
 culture and, 146
class struggle, 27
commercial art, 140
communism, 3, 147
constructivism, 76
creativity, 75, 82, 112, 121
critical theory, 188, 189
critics, 41, 82
Crow, Thomas, 167n
cubism, 116, 120
culture, 12, 27, 37, 79, 109, 161–2;
 aesthetic recycling of cultural
 refuse, 128–9; boundary with
 profane realm, 133, 179;
 commercialization of, 141; dead
 cultures, 29; democratization of,
 126–7; destruction of, 74, 143;
 devalorization of, 80, 119, 145,
 175; disappearance of the
 profane and, 112, 119; life and,
 164; nonprivileged classes and,
 165–7; of privileged social
 classes, 163, 165; profane
 exchanged for, 171; semiotic
 perspective and, 179;
 subordinated to economic
 constraints, 10; utilitarian
 consumption of cultural values,
 153–4

Dadaism, 76, 120
Danto, Arthur, 88, 89n2, 90
de Man, Paul, 36n4, 118n8
deconstruction, 6n7, 26, 177, 187
Deleuze, Gilles, 177
Demon of Progress in the Arts, The
 (Lewis), 4n2
Derrida, Jacques, 2n, 4n3, 27, 69,
 163n, 185–6; on apocalypse,
 74n; on cultural archive as
 endless textuality, 160;
 deconstruction and, 43n, 187; on
 difference and textuality, 177;
 on masturbation and thinking,
 55; on writing, 180
Descartes, René, 24, 147, 172
desire, 27, 30, 37, 79, 146; creative act
 and, 77; decadent, 83; fashion
 and theory of desire, 50; infinite,
 162, 187
Dickie, George, 88, 89, 90
différance, 5n3, 6n7, 27, 79–80
difference, 29, 30, 32, 46, 174; between
 cultural and profane realms, 69,
 80; cultural value and, 33, 45, 58;
 fashion and, 49, 50–1; hidden
 other and, 31; infinite, 162;
 novelty and, 38; play of
 differences, 54, 68, 186; profane
 realm and, 70; subjectivity and,
 53; textuality and, 177; theory of
 original difference, 52; time and,
 47, 52; unconscious, 160
Duchamp, Marcel, 14, 68, 92–3,
 190–1; aesthetic of the

ready-made, 95, 100; innovation
practiced by, 85, 90–1; as 'man
without an unconscious', 86–7;
Mona Lisa reproduction and, 55,
65, 73, 98, 120; profane non-art
and, 72; strategic choice of urinal
for ready-made, 102
Duve, Thierry de, 55n4, 93n6

Enlightenment, 3, 37, 44, 74n, 173
existentialism, 26
expressionism, 106

fashion, 49–52, 55, 159
Filliou, Robert, 94
Flaubert, Gustave, 157n6
formalism, Russian, 108
Foster, Hal, 1–2n
Foucault, Michel, 54n3, 69, 182
Fountain (Duchamp), 93, 94, 100–2,
103, 190–1
Frank, Manfred, 133n
Freud, Sigmund, 15n, 24, 109, 140–1,
180, 185; libido concept of, 174,
176; psychoanalyst's voice and
the unconscious, 188

Gehlen, Arnold, 4n2, 82n, 97n
Gnosticism, 77
Goya, Francisco de, 157
Greenberg, Clement, 124n16

Haacke, Hans, 94
Halley, Peter, 2n
Hegel, G.W.F., 26, 27, 141, 187

Heidegger, Martin, 2n, 26, 27, 78n3,
163n, 176–7; argument against
technicized thinking, 185; on
language as speaker, 182; on
struggle between culture and
profane, 180
hermeneutics, 26
historicism, Hegelian, 25, 173
history, 3, 23, 27
Horn, Rebecca, 94
Husserl, Edmund, 6n6, 182n2

identity, 45, 51, 53, 70, 170
ideology, critique of, 185
imitation, 42, 46n2, 124, 153, 162
individuality, 29, 32, 44, 95; in
classical philosophy, 184;
historical memory and, 169;
liberation of, 164;
pre-established, 53
innovation, 12, 71, 80, 84, 98, 99;
authentic and inauthentic, 7,
35, 162; author as agent of, 190;
Christian hermetic life as, 144;
commercial aspect of, 159;
cultural value and, 17, 151;
cultural-economic exchange
and, 139, 149; as devalorization
of values, 72–3; economy of,
13, 74, 82; as exchange between
value hierarchies, 65; insecurity
associated with, 168;
interpretation and, 57; market
as motor of, 35; profane realm
and, 71, 73, 126; revaluation of

of the old and, 146; everyday
life as counterweight to
tradition, 112; fashion
compulsion in, 50; industrial
mass production and, 101;
innovative exchange and, 154;
originarity and, 43; other and,
30; repression of the profane
and, 114; utopianism of, 23
Mona Lisa (da Vinci), 80, 83;
devalorization of, 67, 72, 120;
mutilated reproduction of, 55,
65–6, 68, 98, 101; status of, 73
Mondrian, Piet, 25, 77
museums, 42, 63, 88, 118; aesthetic
styles preserved in, 102; archive
as textuality and, 160; as
religious shrines, 158; valorized
culture and, 110, 139, 164

National Socialism, 3
natural sciences, 3, 59
nature, 27, 30, 37, 68, 135; creative act
and, 77; mimetic representation
of, 21; Renaissance paintings
and, 80–1
neo-Platonism, 77
new, concept of the: authentic and
inauthentic newness, 37;
distinguished from the different,
31–3, 47; fashion and, 49–52;
market orientation and, 34;
newness for newness' sake, 7;
quest for newness, 5; society's
rejection of, 151; transition to

modernity and, 22–3; utopia
and, 1, 41
Newman, Barnett, 8n
Newton, Isaac, 29
Nietzsche, Friedrich, 24, 86, 141,
163n, 180, 185; on asceticism,
149–51; on heterogeneity of
thought, 174; on value of truth, 9
nihilism, 57, 67, 120

Oedipus myth, 140–1
On Spirituality in Art (Kandinsky),
106
originality, 11n, 24, 38, 42; abstraction
and, 106; appropriation and, 121;
fear for historical originality, 51;
intra-cultural, 43; profane realm
and, 114; reproduction and
original, 46; theory of original
difference, 52; tradition and, 108
originarity, 43–4
Other, the, 26, 27, 30, 31, 170

phenomenology, 6n6
Philosophical Investigations
(Wittgenstein), 15n
philosophy, 24, 58, 156, 182, 184–5
photography, 126
Picasso, Pablo, 125
Plato, 24, 54n2, 76, 111, 176
Platonov, Andrei, 147
poète maudit, 151
post-impressionism, 130
postmodernism, 1–3, 31, 160–1;
alterity discourse of, 45; critique